I, JACK RUSSELL

A Photographer and a Dog's Eye View

I, JACK RUSSELL

A Photographer and a Dog's Eye View
Photographs by Andy Hughes

Booth-Clibborn Editions

Contents

A dog is a bond between strangers.

JOHN STEINBECK

Jack Russell owners across the world will tell tall tales of heroic antics, personality traits, and all manner of dog-related stories. There are Jack Russell Terrier Trials from South Africa to Canada, England to America. All have in common a shared enthusiasm and an absolute, unfettered love and admiration for this type of dog. Originally bred as a hunting dog in England in the nineteenth century and still used as working dogs today, they are sturdy, tough, tenacious, intelligent, athletic, fearless, and vocal dogs. The Jack Russell is also well known as a family dog. They have been crossed with other popular family breeds including Corgis, Yorkshire Terriers, Poodles, Chihuahuas and other terriers such as the Fox Terrier and the Staffordshire Bull Terrier. The changes in form and function have resulted in many variants of short-legged terriers called Russell Terriers, Shortie Jacks, Puddin' Dogs, Jack Russlies and Jack-o-Poodles.

With Scamp, 1976

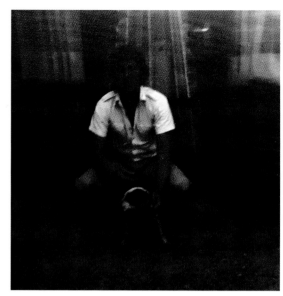

My dad and Scamp, 1979

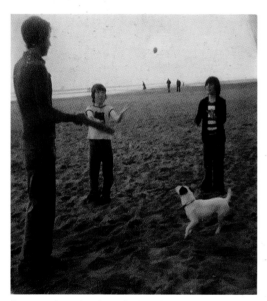

Scamp with my family on the beach in
Skegness, 1975

Tigga in garden, 1980

Artists live by curiosity and enthusiasm, qualities readily evident as inspiration in dogs.

Why People Photograph
Robert Adams, Aperture.

I have read this passage often, it reminds me that some of the key themes explored in this collection of photographs are based on those qualities and that my life has, like many artists, been shaped by my dogs, another of Adams' interesting observations.

My two Jack Russell dogs are called Lily and Maui, both are rather scrappy and unkempt. They are my trusty companions, often walking with me along the coast near to my home in Cornwall, England. Through the ups and downs of life they have been by my side, they have helped me search for beach trash, provided much needed comfort in times of distress and believe it or not assisted me with my own photographic work. How so? Adams describes it perfectly in the last sentence of his essay *Dogs* "A photographer down on his or her knees picturing a dog has found pleasure enough to make many things possible".

I have been wondering why I have very few images of friends and family but rather a lot of my two dogs. Perhaps there is a psychological reason for this or is it simply that I only make use of a camera when I am making 'creative photographs'? I decided to find my earliest family snaps and most seemed to include the Jack Russells I had as a child.

There were three dogs in the Hughes family, two of which were Jack Russells. The first was called Scamp. A great character Scamp was much loved, not only by his immediate family but also by everyone that knew him. In the 1970s in Castleford, Yorkshire, England, where I grew up, it was normal to let your dog roam free around the neighbourhood.

On one very hot summer's day, during the drought of 1976, our tortoise disappeared from the garden. We searched high and low, but the tortoise was nowhere to be found. A few weeks passed by and then one afternoon Scamp trotted up the garden path with the tortoise between his jaws, alive and well. We never figured out where the tortoise had been and how Scamp managed to find and recover it.

Another famous exploit of Scamp's happened one day when my mother, accompanied by Scamp, went to visit her close friend Pam, whose husband had recently died. In those days people left their houses unlocked and my mother found Pam was out. Later that afternoon a distressed Pam telephoned to say that she had returned home and was in her bedroom when she saw the duvet move, she screamed as she knew the house was empty, only to discover that it was Scamp in her bed. He had slipped in whilst my mum wasn't looking and fallen asleep only to awake much later and had given Pam the fright of her life!

ANDY HUGHES
Why I Love Jack Russells

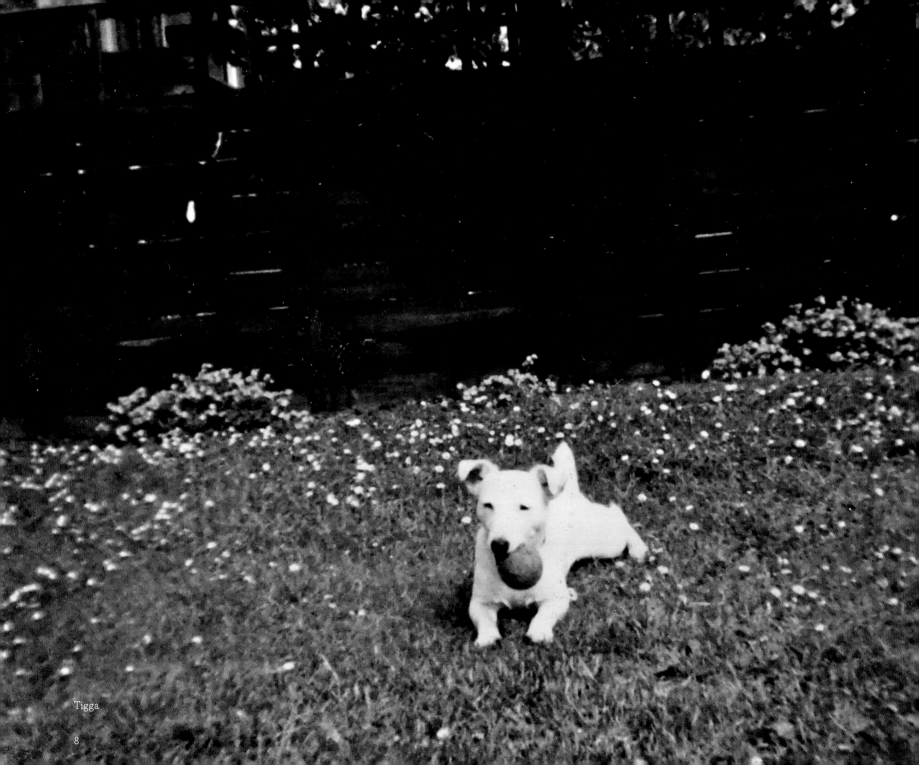

Tigga

8

Scamp lived a long life, he died next to my bed whilst I was asleep, I was twelve years old and it was the most upsetting experience I had ever had. Soon after, we had another Jack Russell we called Tigga. He was a very different dog, a bit wild, noisy and fond of nipping ankles. After only a few years he came to a sticky end, he was hit by a car whilst running across a road. I remember holding him in my lap whilst we drove to the vets, trickles of blood running from his nose. He died very quickly. Both dogs are buried at the bottom of the garden of the house where I grew up.

While looking back for photographs of childhood Jack Russell Terriers for this book I came across a print made from one of my first rolls of film from student days at Wakefield Art College. Imagine my surprise to discover a picture of an old man on his doorstep with his Jack Russell chewing on a bone.

The picture was taken at the village of Ferry Fryston, the miner's strike of 1984 was raging and my grandfather had been a miner there many years before. By chance, in the street I met an old photographer in his dressing gown and slippers. It was Jack Hulme, whose documentary photographs of local life are now kept in the Wakefield Museum. I couldn't resist including a picture of his, taken forty years before we met, of a Jack Russell sat proud on the front of a bike.

So it's fate, these dogs have always been part of my life.

Walking my dogs along the coast in Cornwall, where I now live and work, is one my greatest pleasures. Many of you who read this book will, I am sure, also have tall tales about your own Jack Russells and will no doubt love them just as much as I do mine.

9

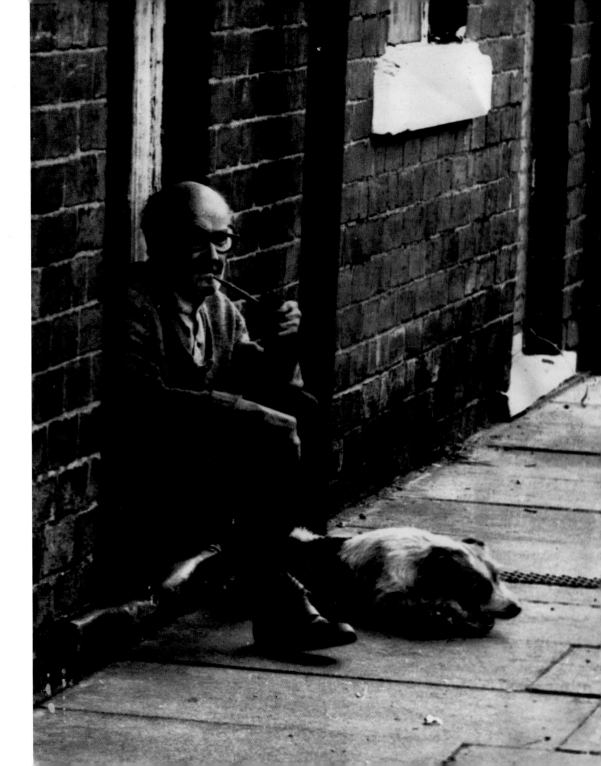

One of my first-ever photographs taken in
the pit village Ferry Fryston.

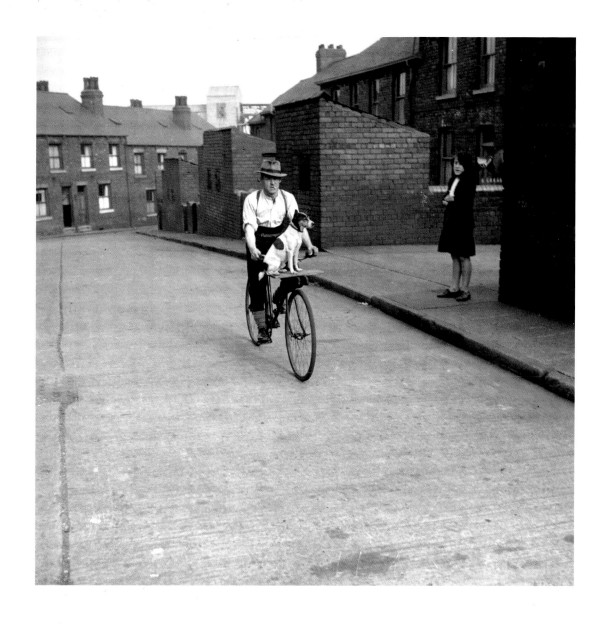

George Wagstaff with his Jack Russell
1945–1955
taken by Jack Hulme

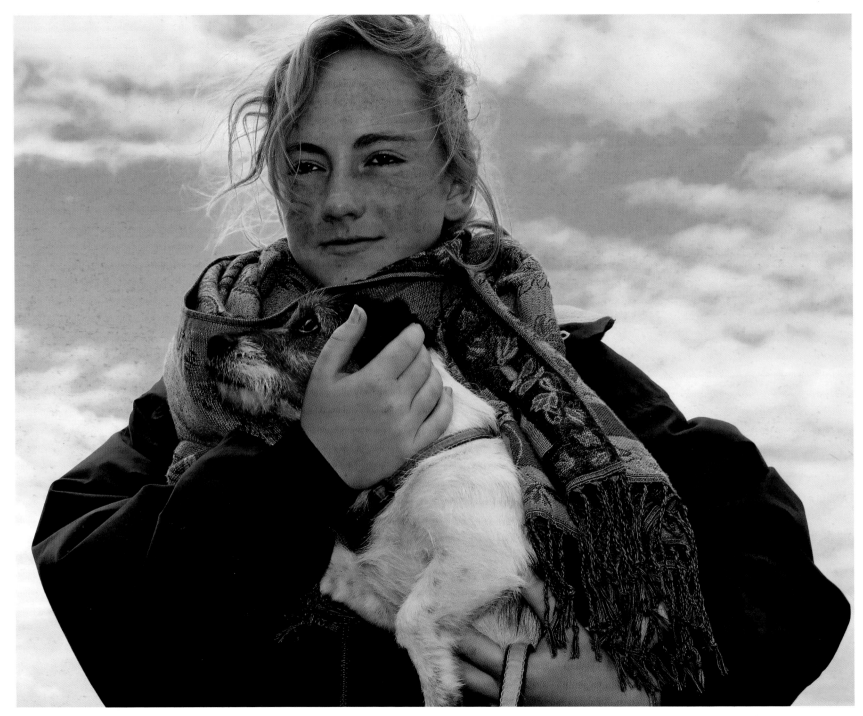

JOHN BRADSHAW

Does your dog love you?

What is it about dogs that makes me so convinced that they love us? Every now and again another scientist will ask me "How can you be so sure that dogs feel love for their owners, while in almost the same breath, you warn against the dangers of treating them as little people?" And when I speak to dog owners, they seem first surprised, and then relieved, to hear that science has finally embraced the thorny problem of animal emotion.

Taking one step back, it's worth starting with the matter of animal emotion in general. Scientists concerned about animal welfare have been forced to confront this issue, for if animals have no emotional lives, can they be said to suffer? Fortunately, modern imaging techniques have given us a window into animals' emotions, and we now know which part of the brain lights up when an animal is happy, when it's anxious, and so on. Crucially, each area of the brain is the same for all mammals, so although we can never be certain that their subjective experience is the same as ours, we cannot deny that dogs experience all the same basic emotions that we do — love, joy, fear, anxiety, anger.

So animals (mammals, anyway) can love. But why do dogs love us? They seem to be unusual, possibly even unique, in this respect (cats may be another, but there's no room for cats in a book about terriers). Most other animals reserve their affection for their own kind, apart from a few individuals that have been hand-reared and have never met any of their own species. And there lies the clue — most mammals are not born with a fully-formed sense of their own identity, they have to learn what kind of animal they are, so they can direct their affections correctly. Somehow, dogs have evolved to learn two identities at one and the same time — one for the four-legged creatures around them, their mother and littermates, and the other for the two-legged creatures that share in their care. And remarkably, very few ever confuse these two. Puppies seem to have the ability to construct at least two sets of social 'rules', one for other dogs, the other for people (and more if they grow up in a household full of other animals). It's this extraordinary ability that suits them so well to life as man's companion, enabling them to adapt to our many and varied needs, from hunting aid to pampered pet. When and how they evolved this ability we still don't know, but this one thing is now certain — it's their affection for mankind that binds them to us.

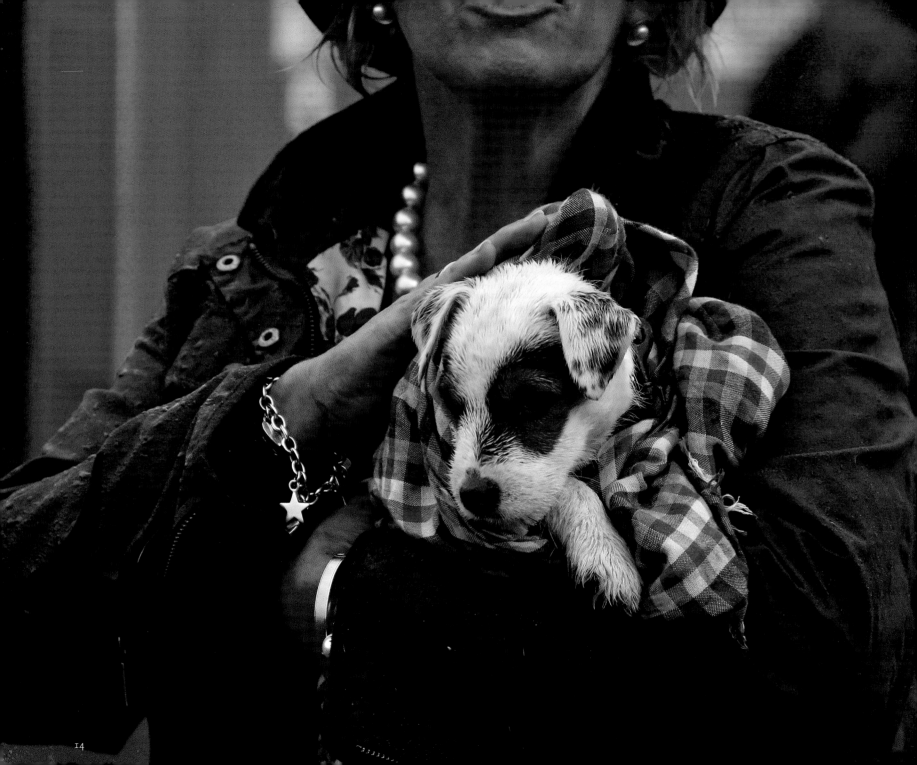

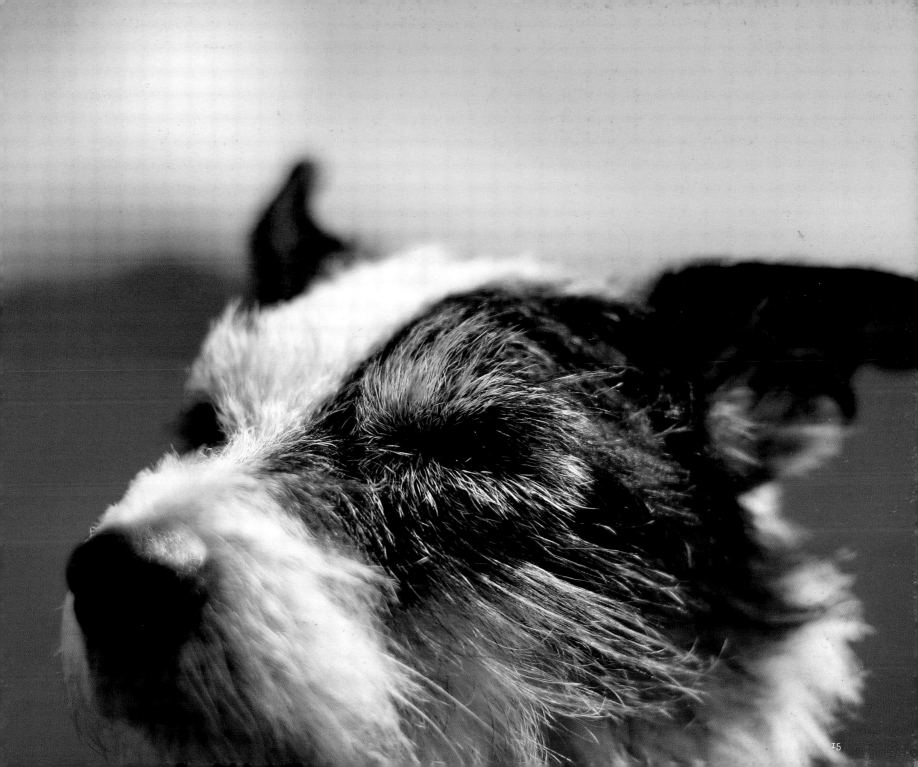

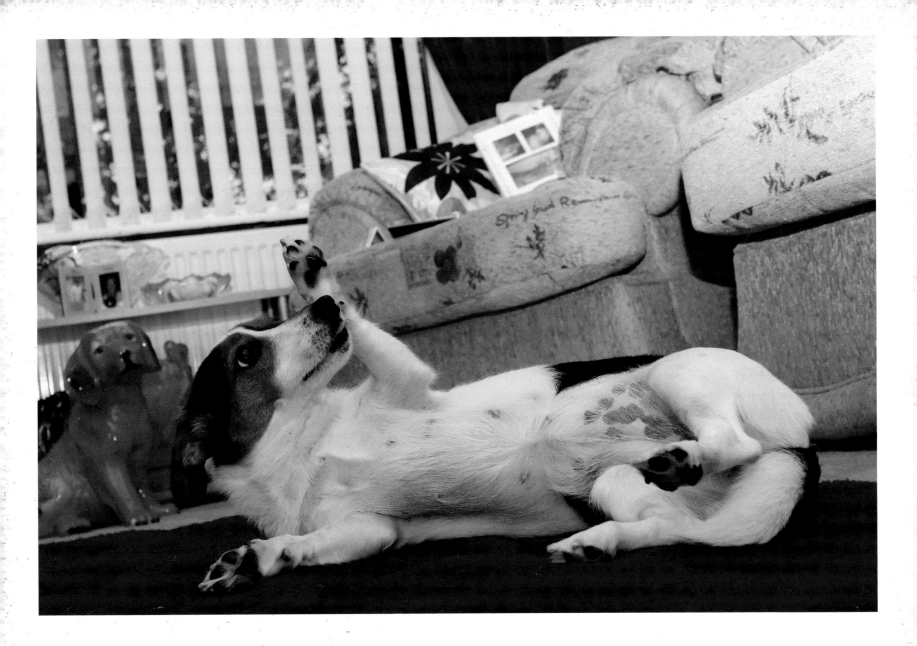

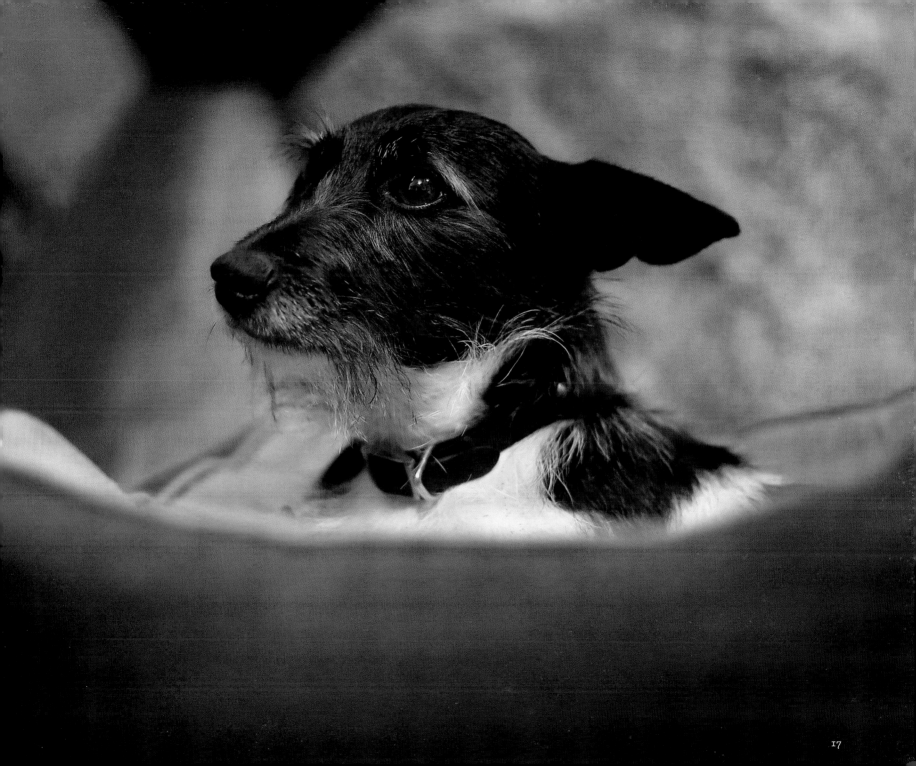

The Jack Russell terrier was originally
bred by the Reverend John Russell in the
nineteenth century from a bitch named
Trump, whom he bought from a milkman.
He liked her distinctive colouring, white
with tan spots at the tips of her ears, tail
and around her eyes. A founder member
of The Kennel Club who wrote the breed
description for Fox Terriers, Reverend
Russell would never show his own dogs.
He said that the difference between a Fox
Terrier and his own 'Jack Russell' dogs
was similar to the one between a
cultivated flower and a wild flower.

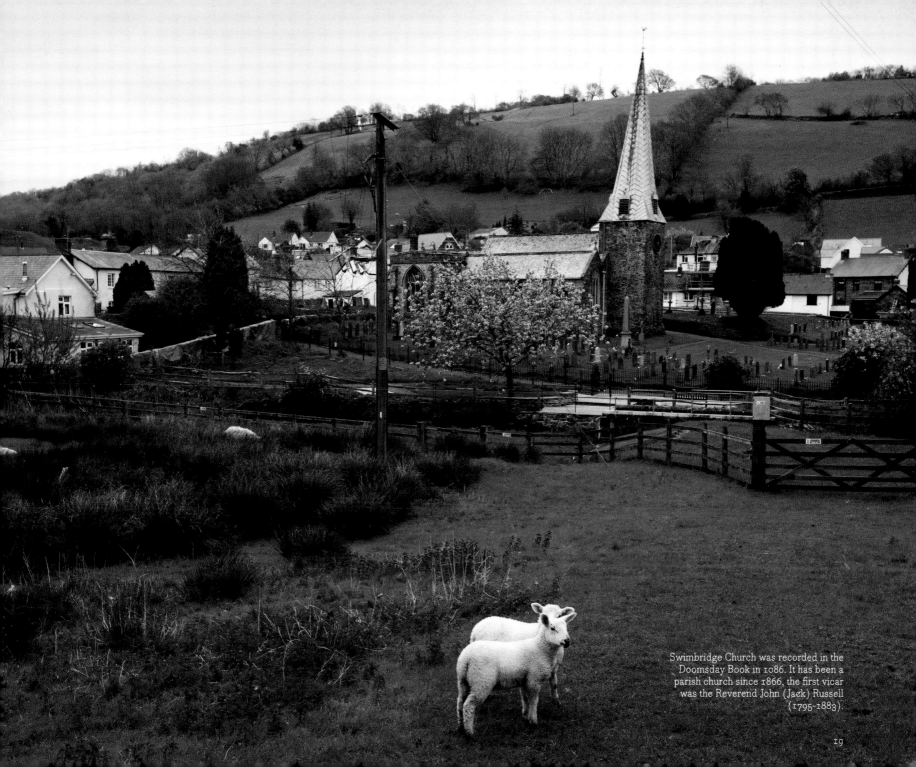

Swimbridge Church was recorded in the
Doomsday Book in 1086. It has been a
parish church since 1866, the first vicar
was the Reverend John (Jack) Russell
(1795-1883).

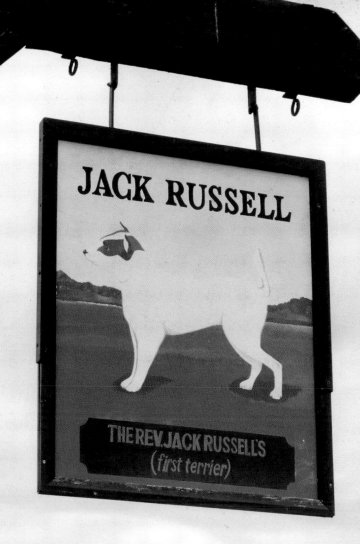

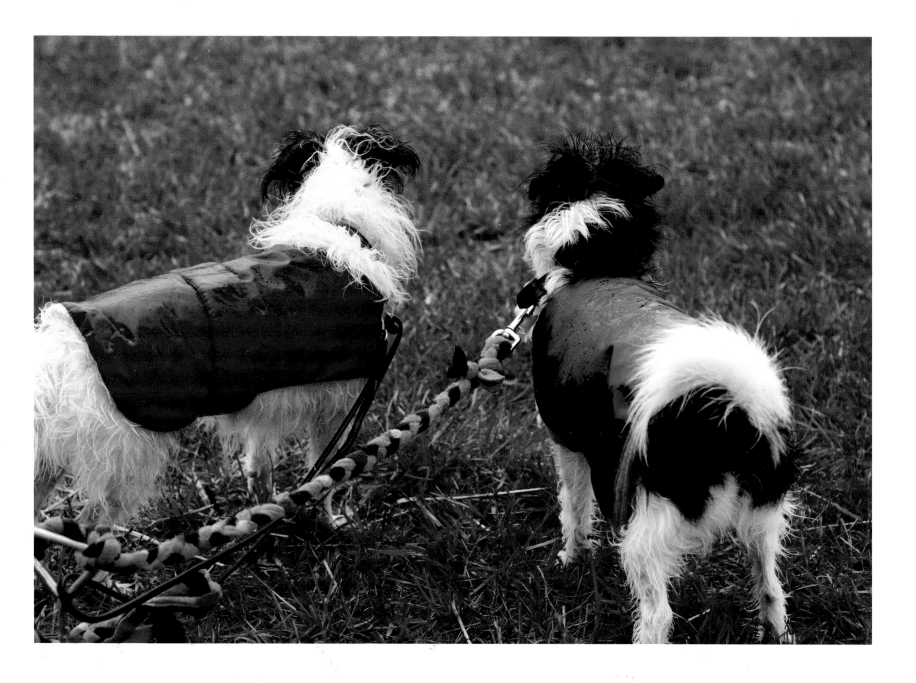

There is evidence of distinct dog breeds as early as five thousand years ago. In drawings from ancient Egypt, at least two kinds of dog are depicted: mastiff-looking dogs, big of head and body, and slim dogs with curled tails. The mastiffs may have been guard dogs; the slender dogs appear to have been hunting companions. And so the designing of dogs for particular purposes began — and continued along these lines for a long while. By the sixteenth century, there were added other hounds, bird dogs, terriers, and shepherds. By the nineteenth century, clubs and competitions sprouted and the naming and monitoring of breeds exploded.

A HOROWITZ

As a photographer I instinctively wanted to explore the relationships between dogs and their owners. My interest really peaked after I had read *Inside of a Dog* by Alexandra Horowitz. Her explanation about dogs' heightened sensitivities to movement and smell helped me appreciate that it is their super sensitivity that makes them so in tune to their surroundings and to their owners.

Bred as hunting companions, for Jack Russell Terriers, a trial is an opportunity to follow their natural instincts. Totally different from the formal shows where pampered dogs are paraded and inspected, at terrier trials dogs compete in a range of activities including obedience, go-to-ground, agility and racing. They show off their stamina and character and the thrill they take in the chase.

An opportunity came for me to travel to Florida to the Sunshine State Terrier Trials in Williston, it was too good to miss. As I approached the showground, I wound down the window of my car and heard hundreds of excited barks. Dogs enjoy the trials! Owners enjoy the trials! I met so many people as passionate about Jack Russells as me. They had come from all over the State with their dogs. Some had driven up from Miami, five hours away and one couple Gator Bradshaw and his wife invited me to meet their two Jack Russells at their home. I was delighted when they presented me with a mug (p95), which echoes my own sentiments about Jack Russells!

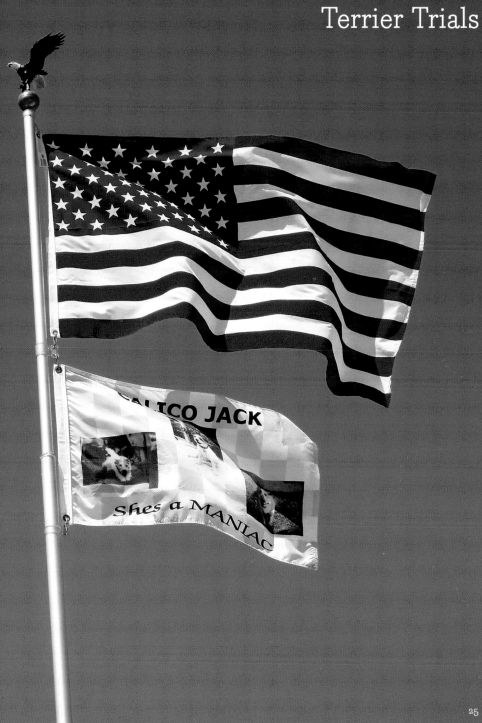

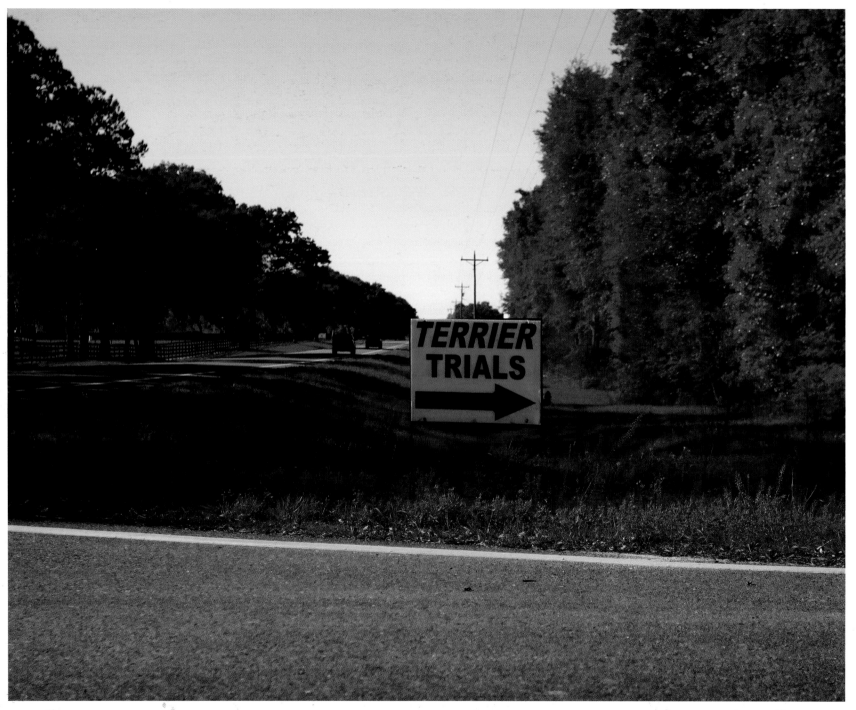

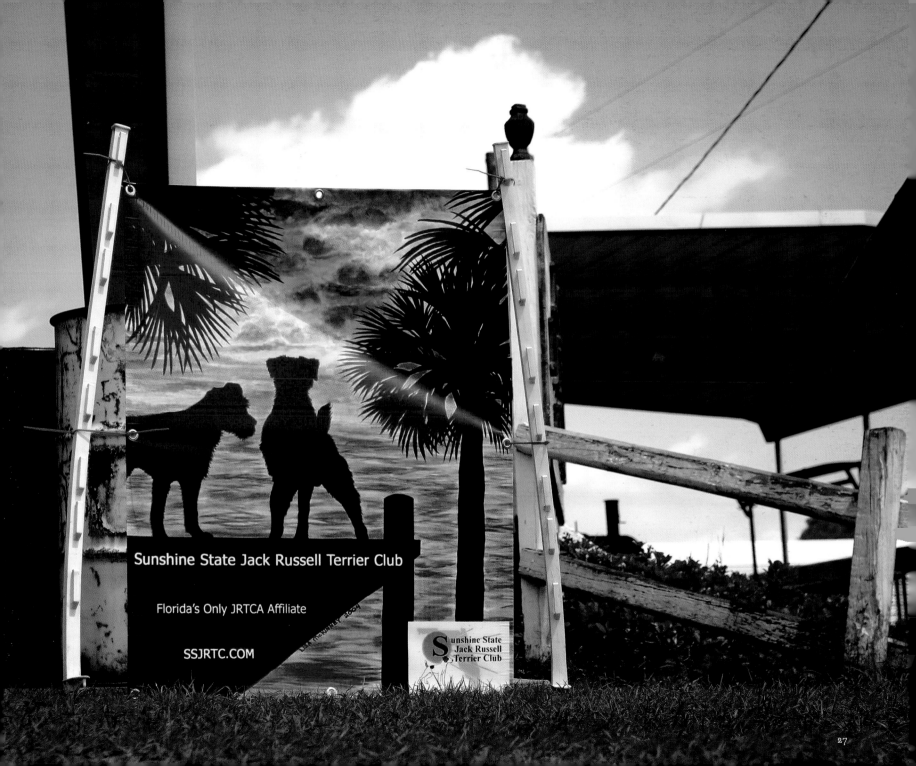

Sunshine State Jack Russell Terrier Club

Florida's Only JRTCA Affiliate

SSJRTC.COM

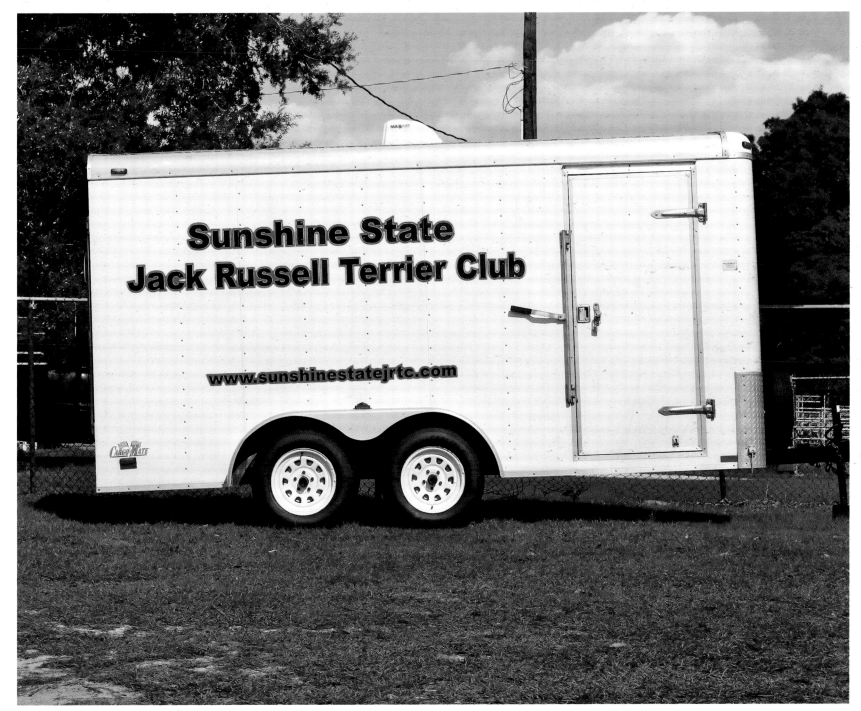

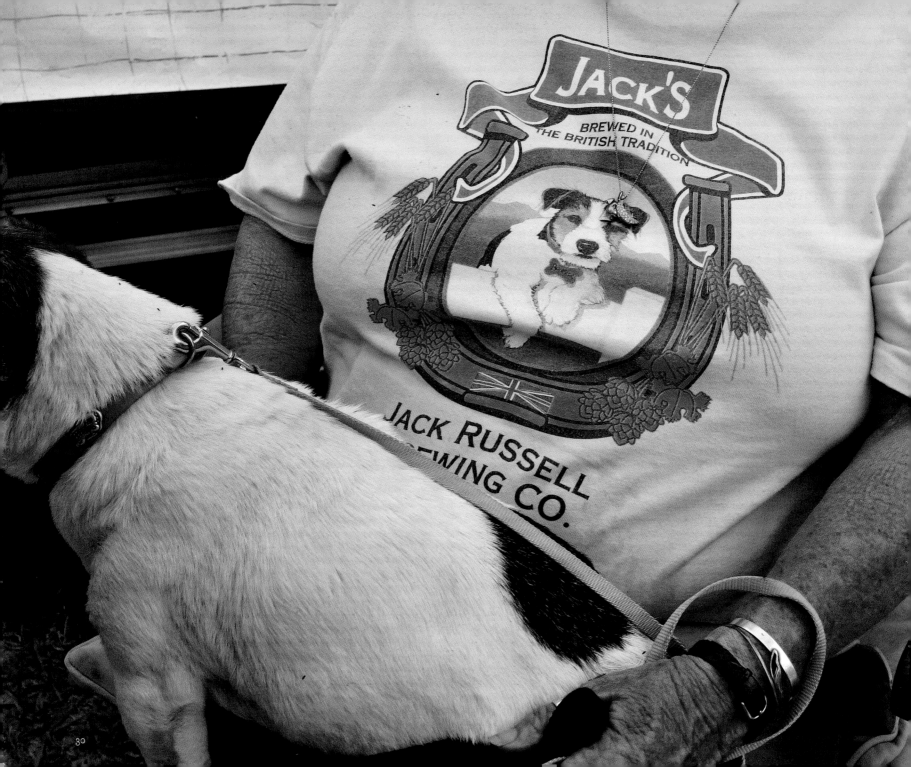

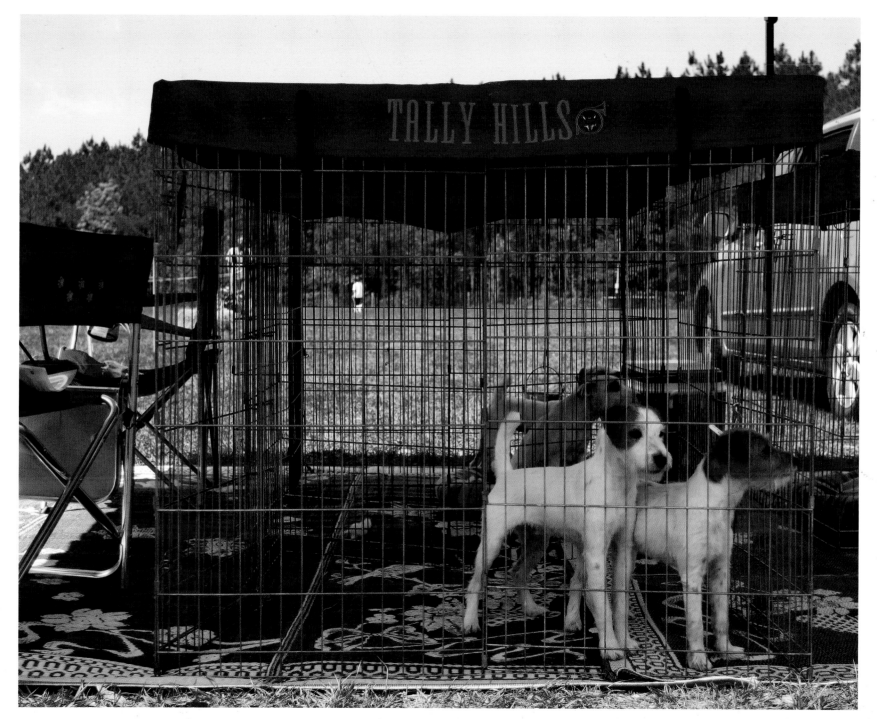

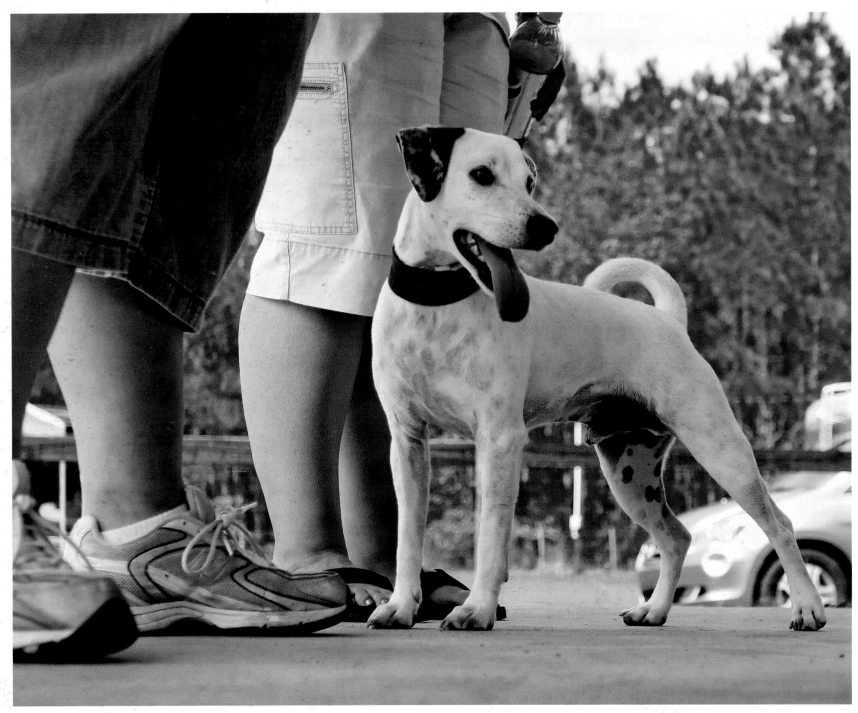

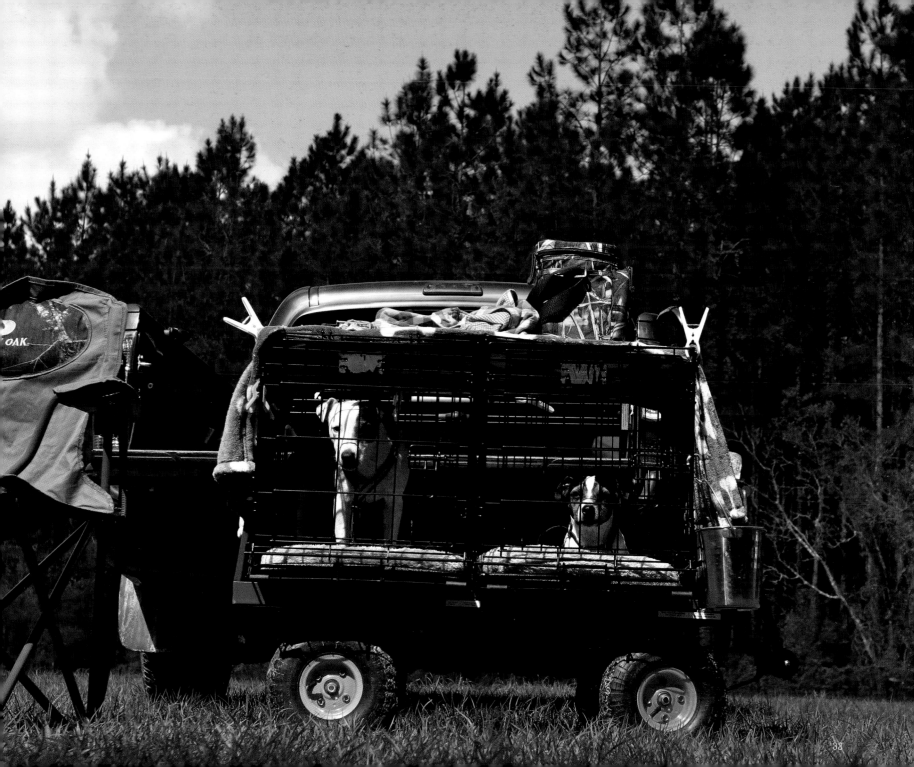

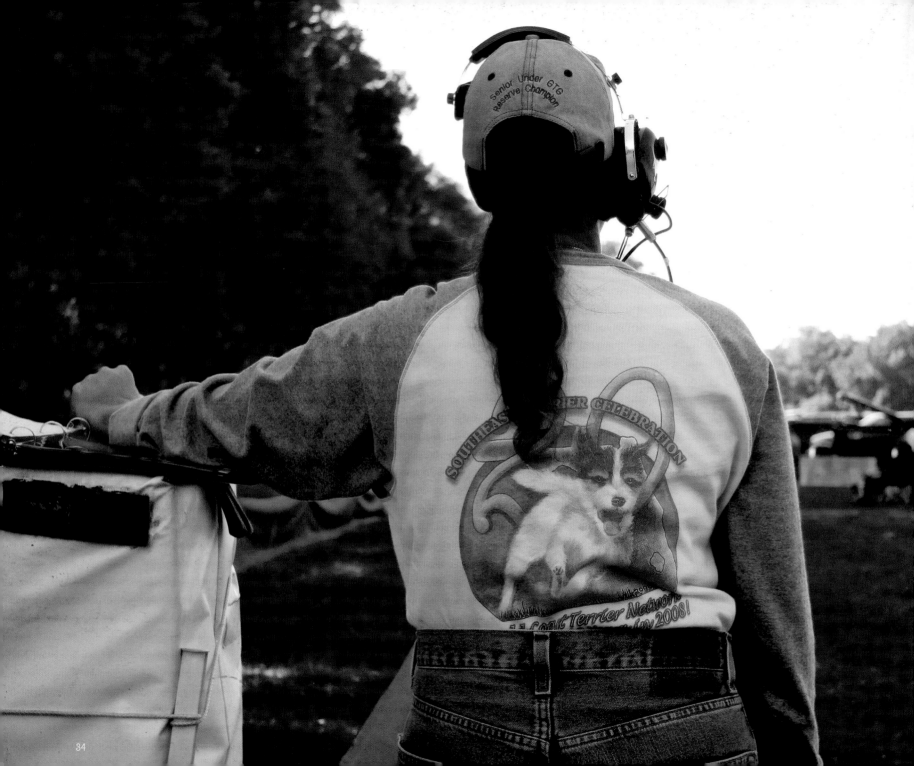

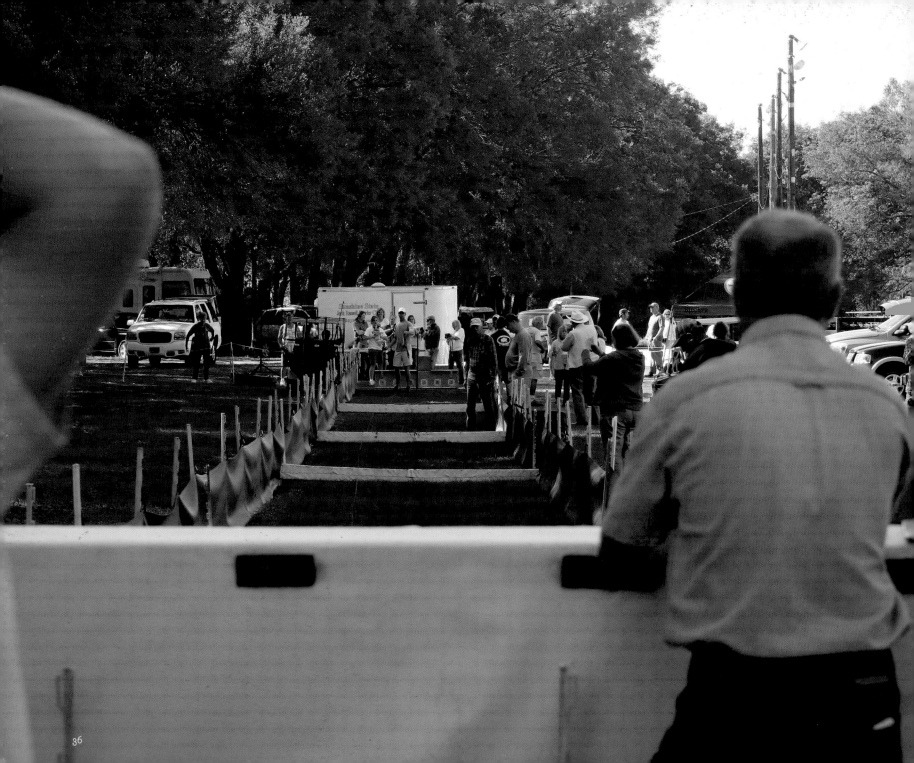

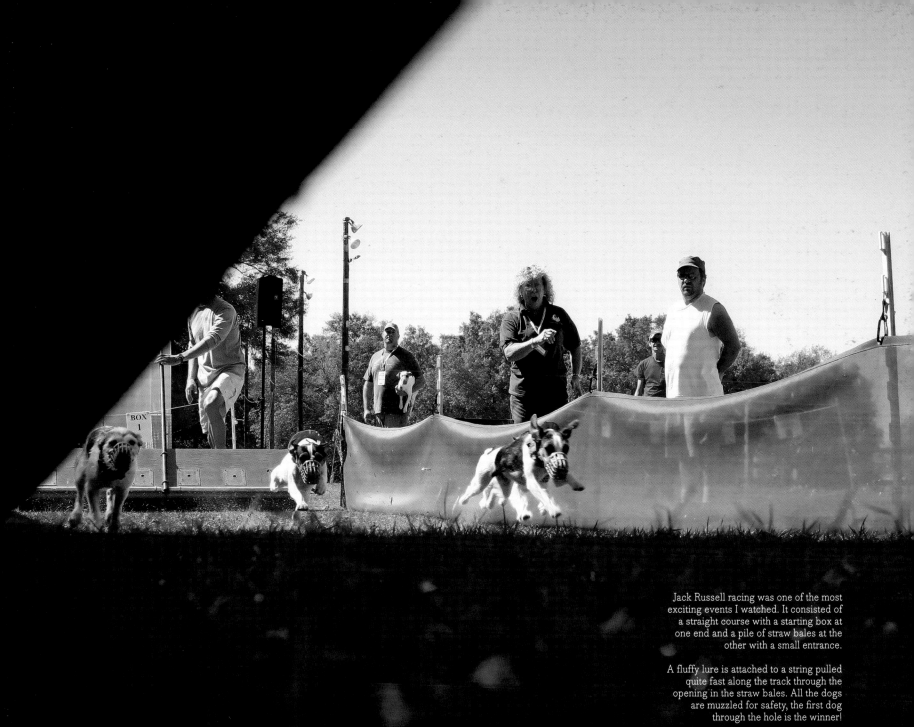

Jack Russell racing was one of the most exciting events I watched. It consisted of a straight course with a starting box at one end and a pile of straw bales at the other with a small entrance.

A fluffy lure is attached to a string pulled quite fast along the track through the opening in the straw bales. All the dogs are muzzled for safety, the first dog through the hole is the winner!

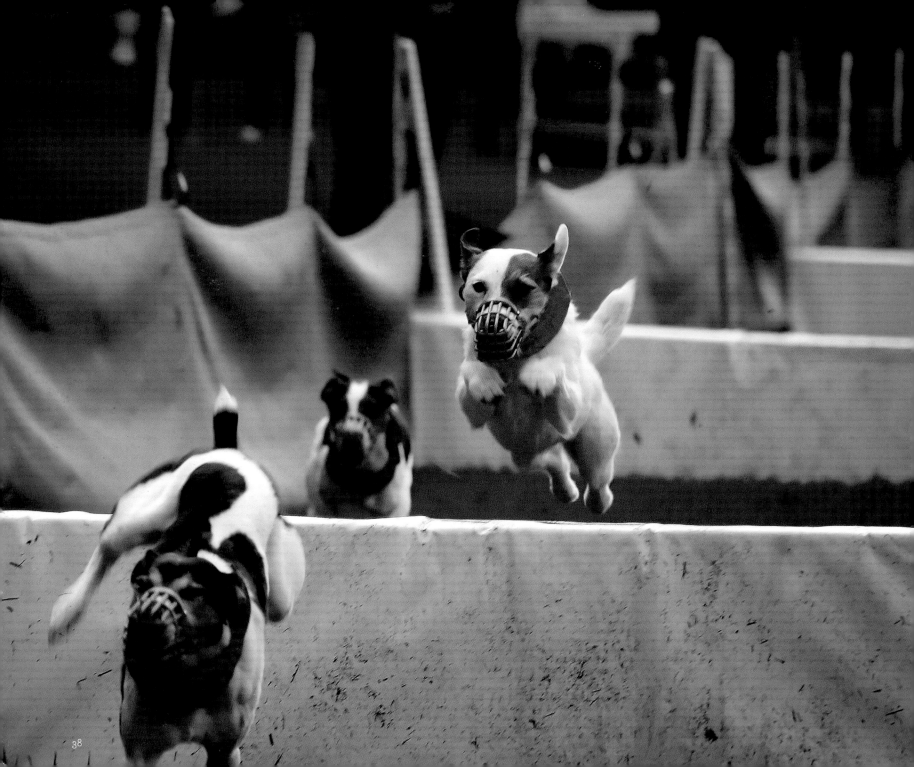

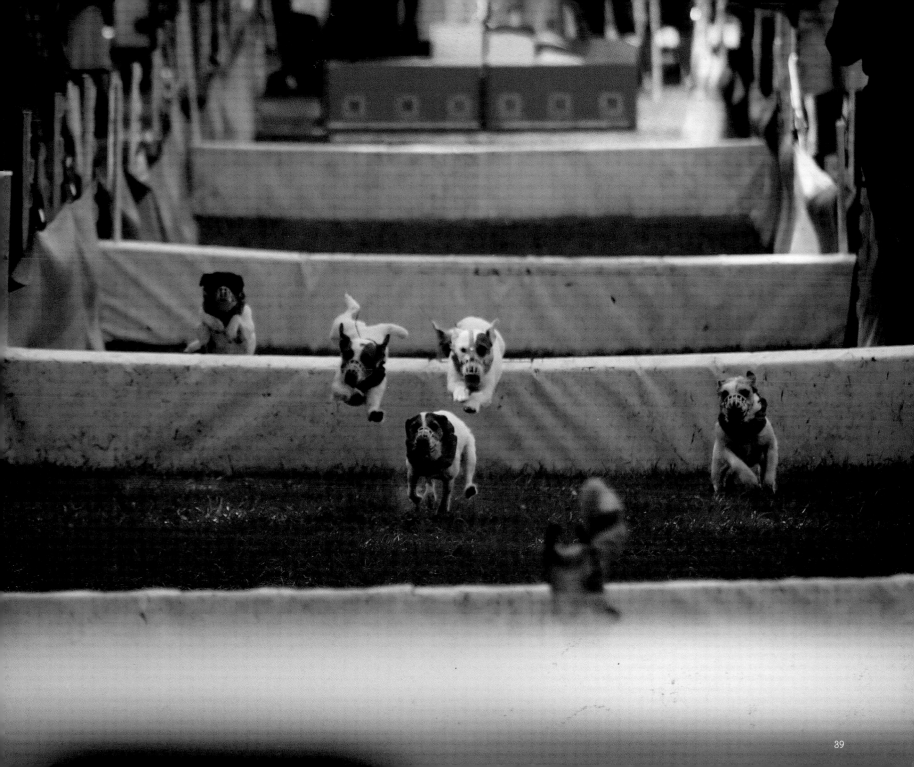

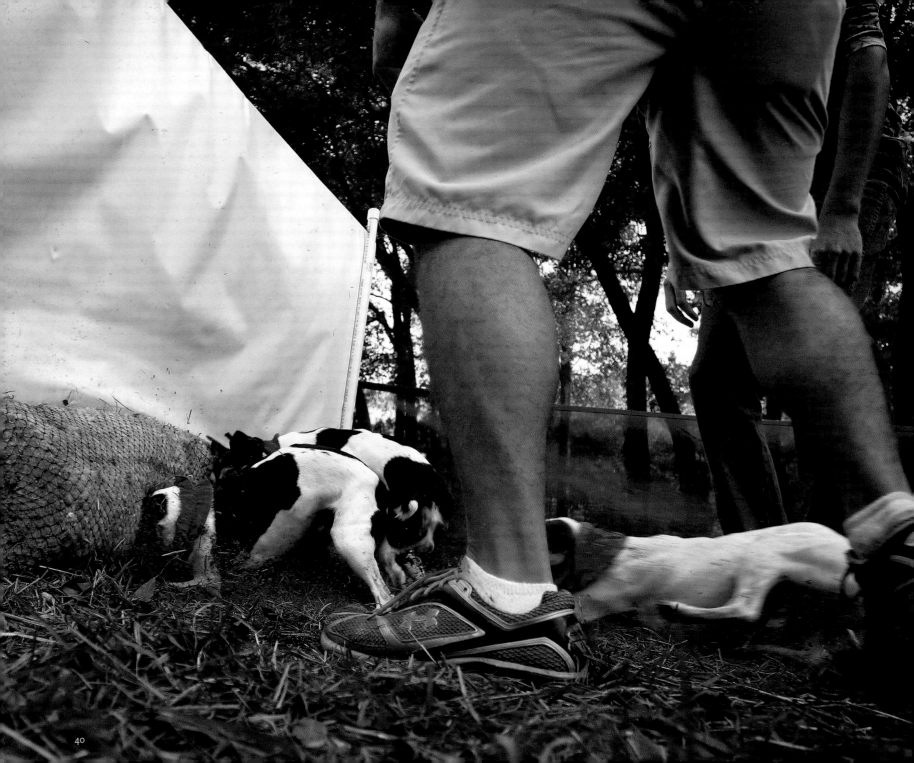

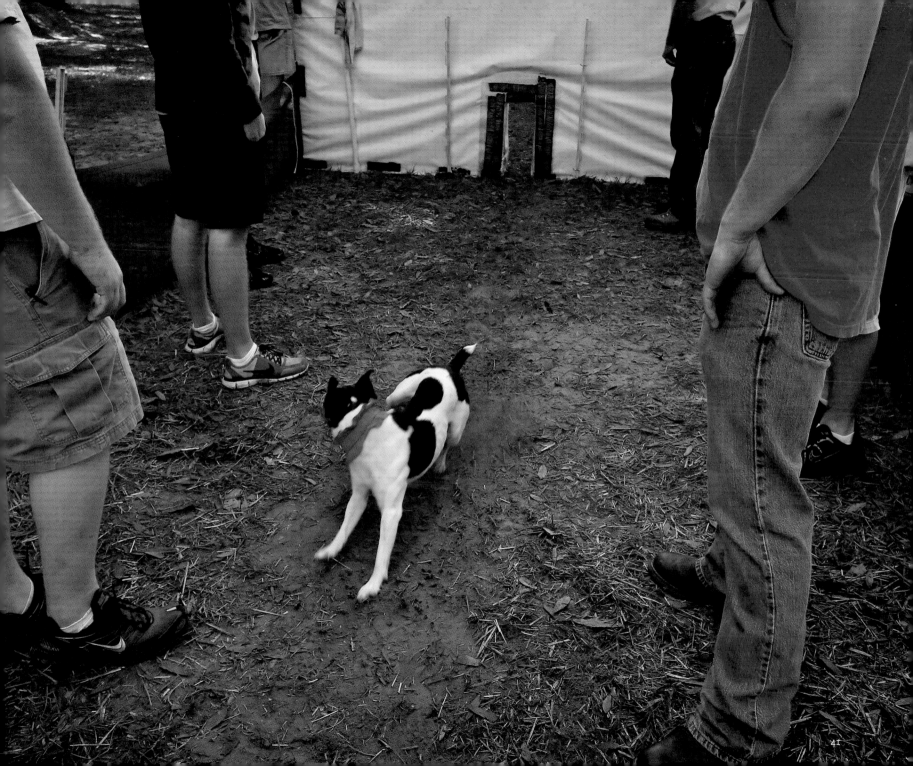

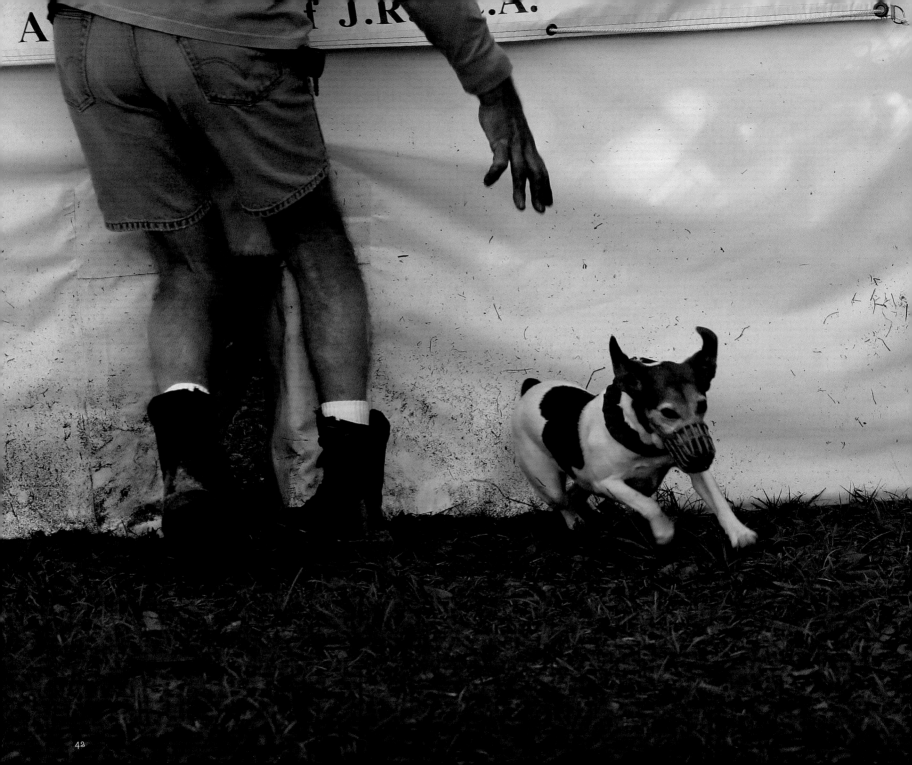

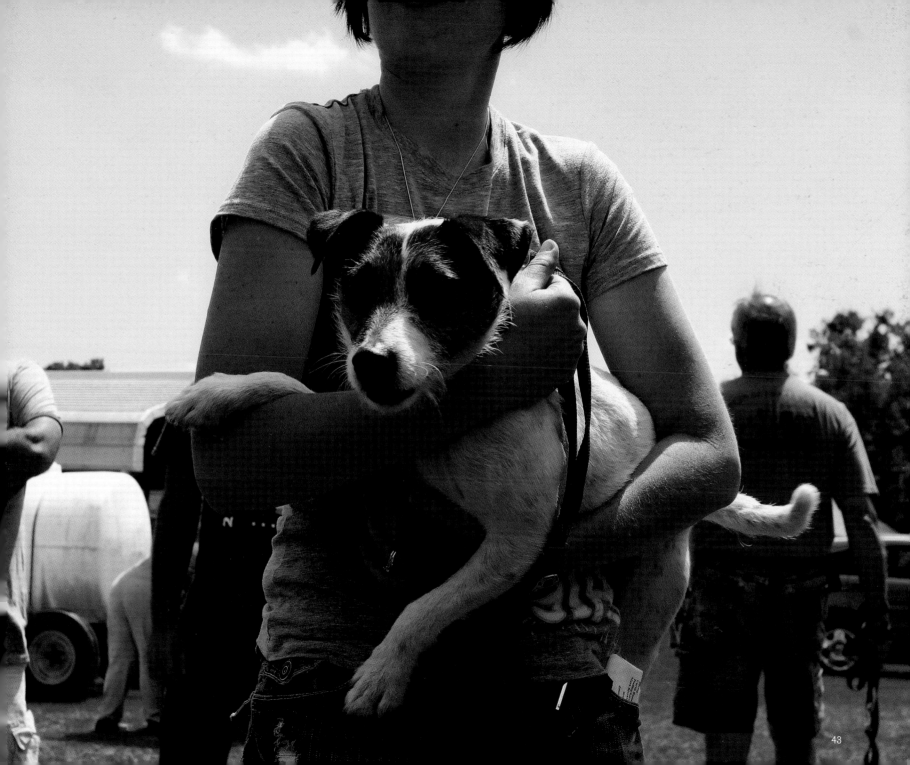

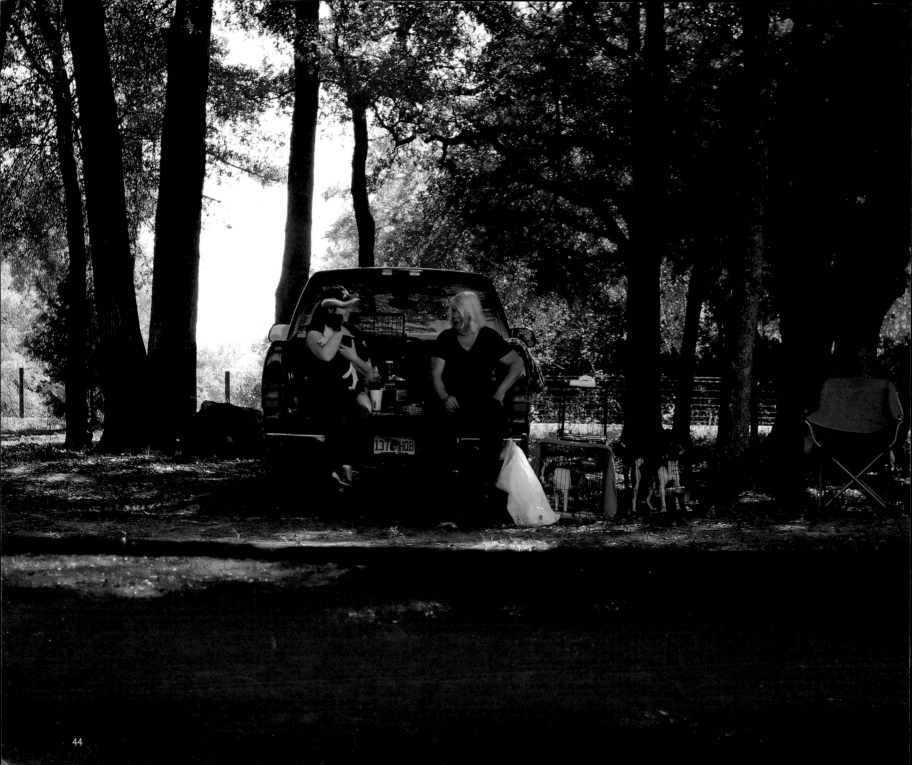

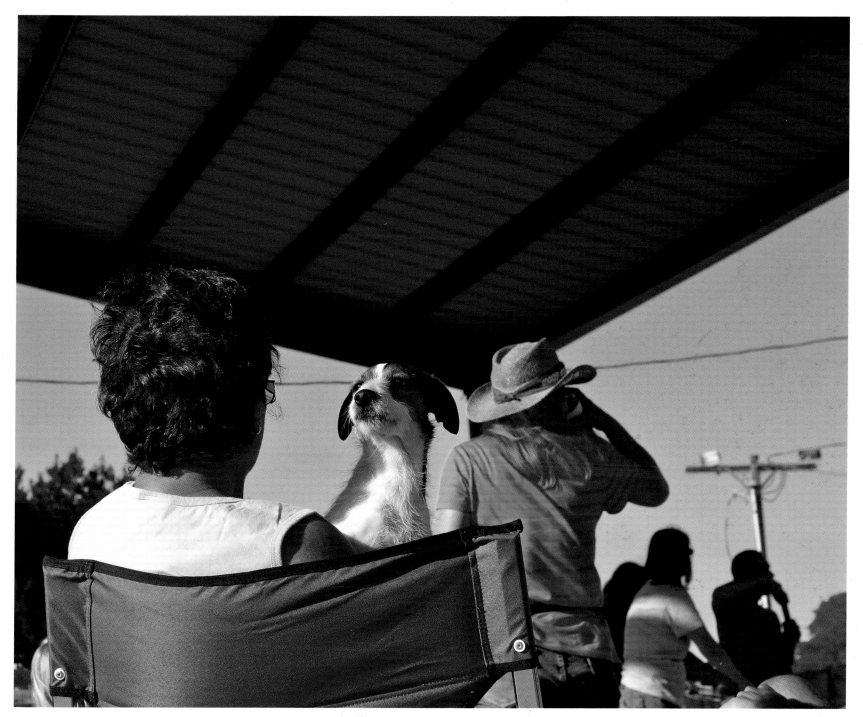

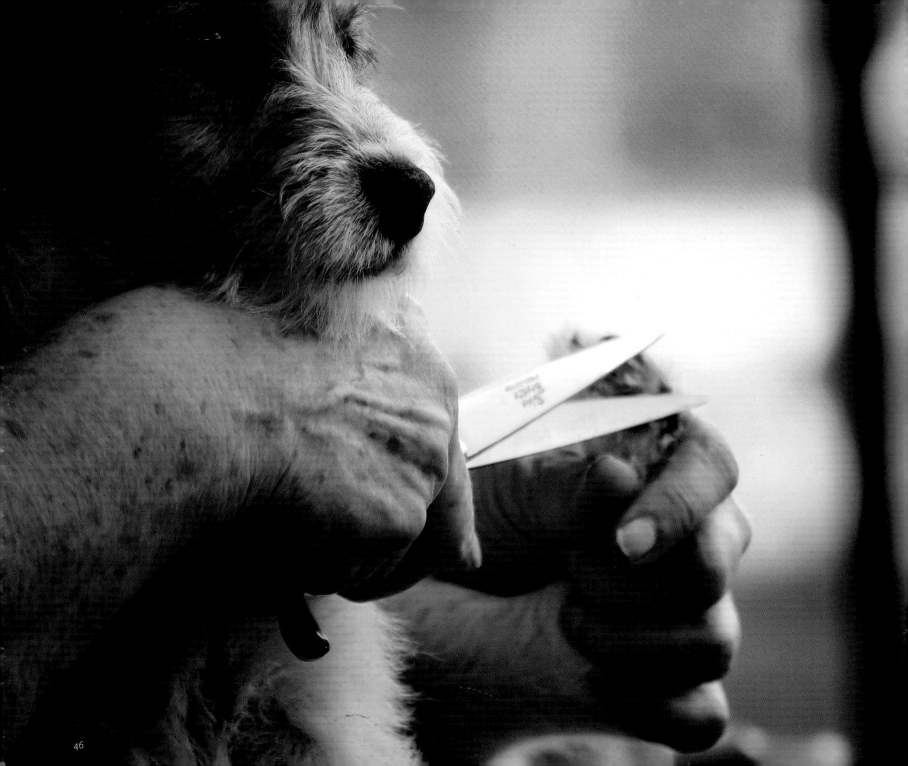

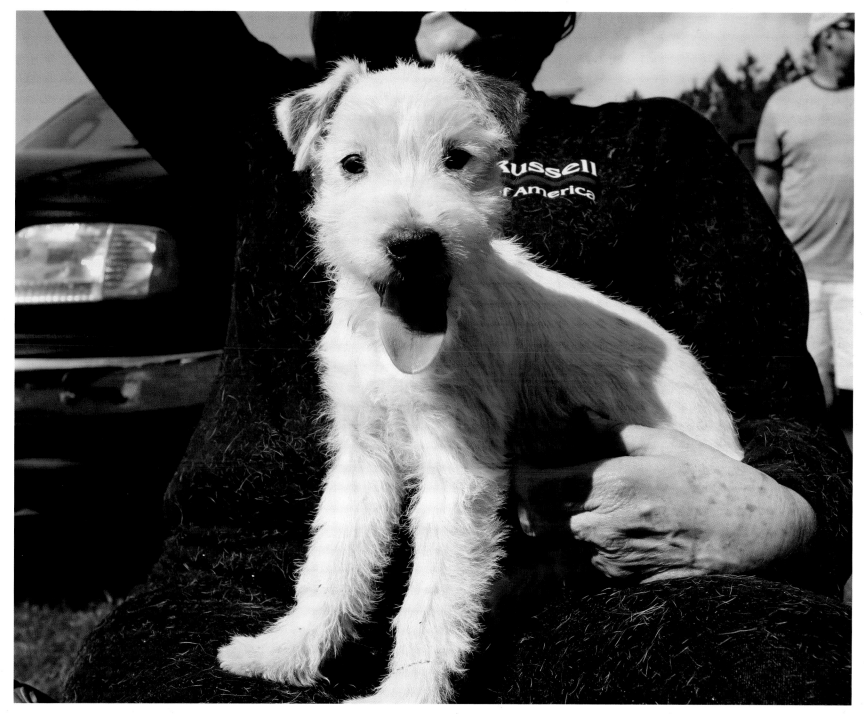

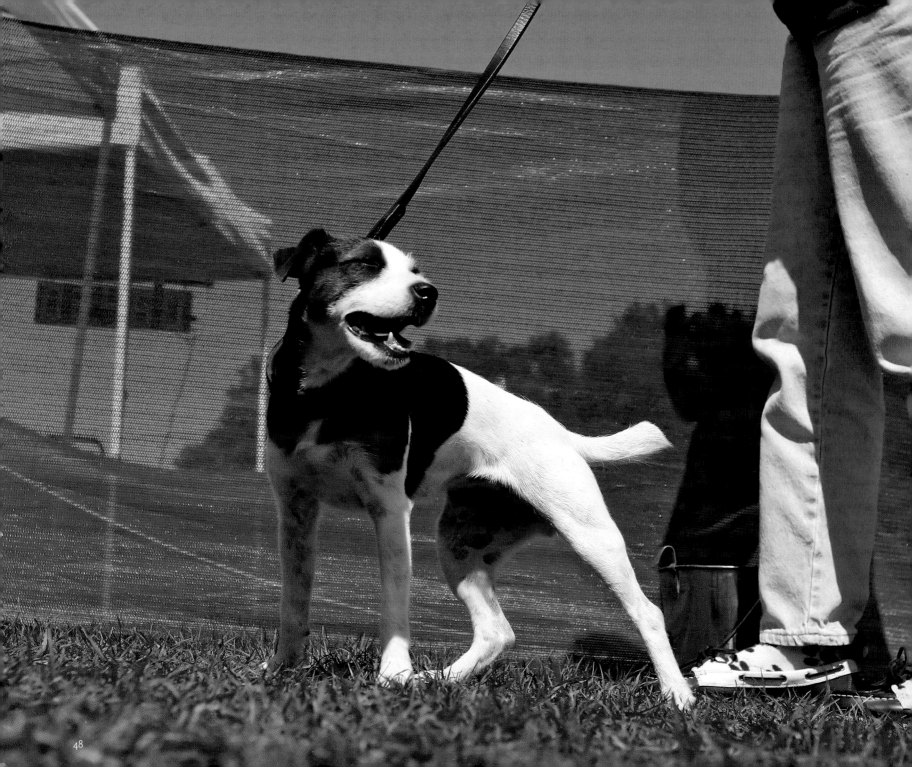

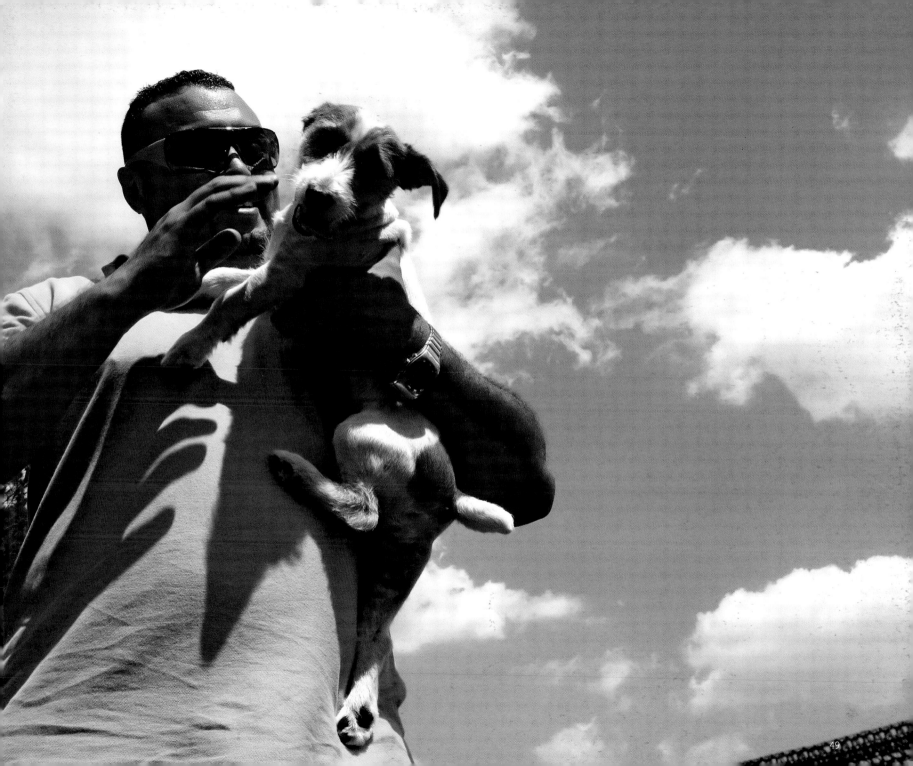

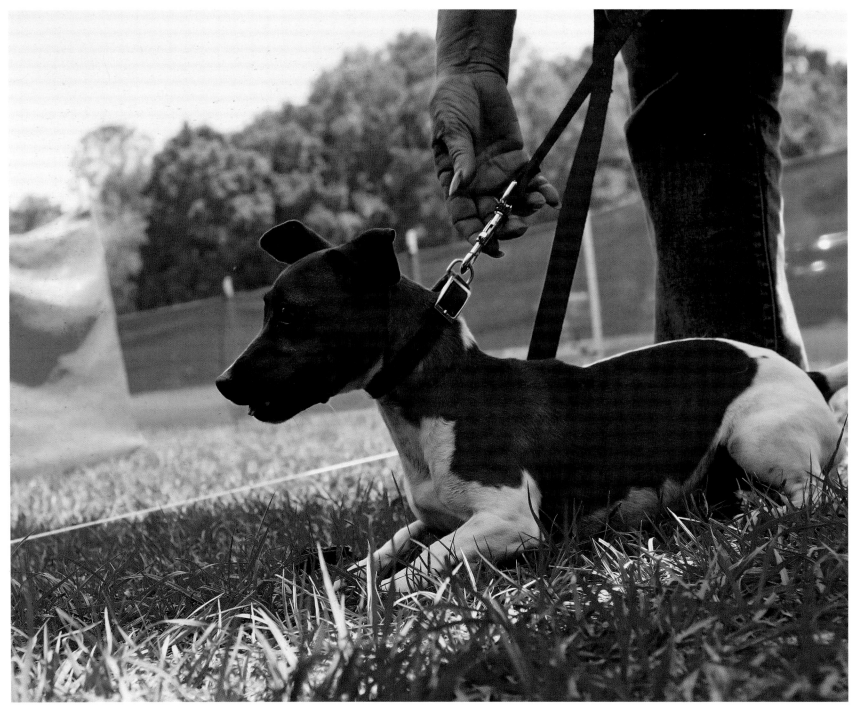

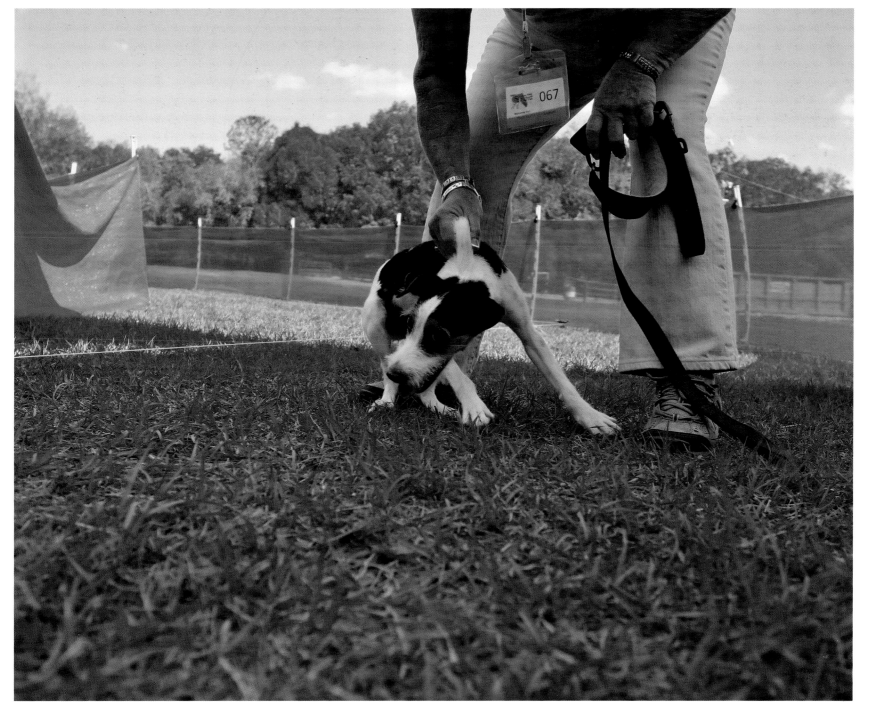

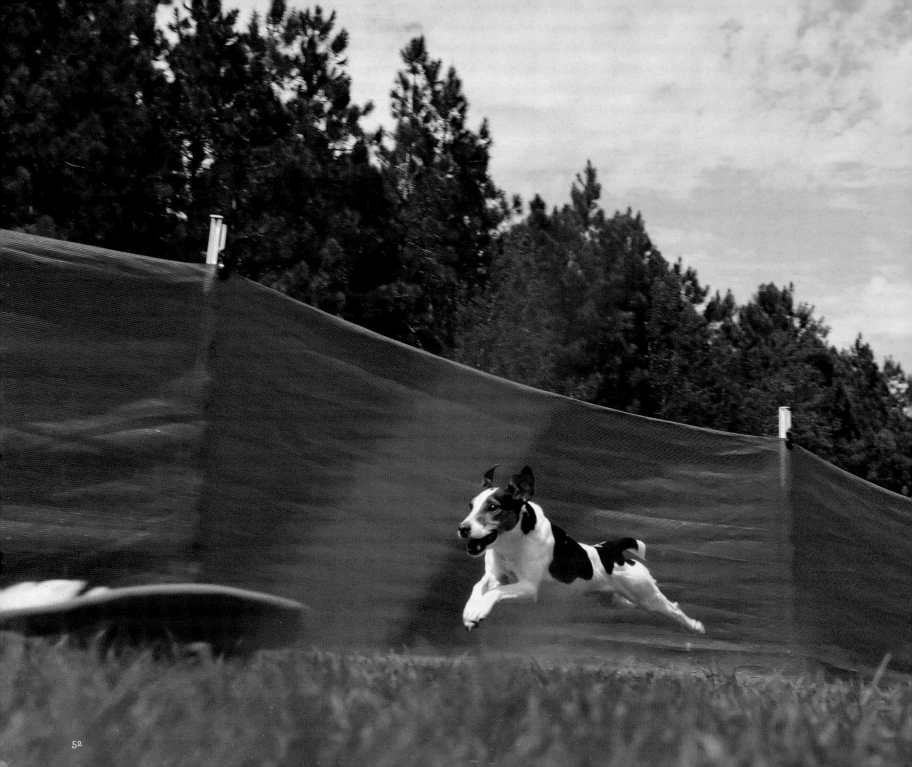

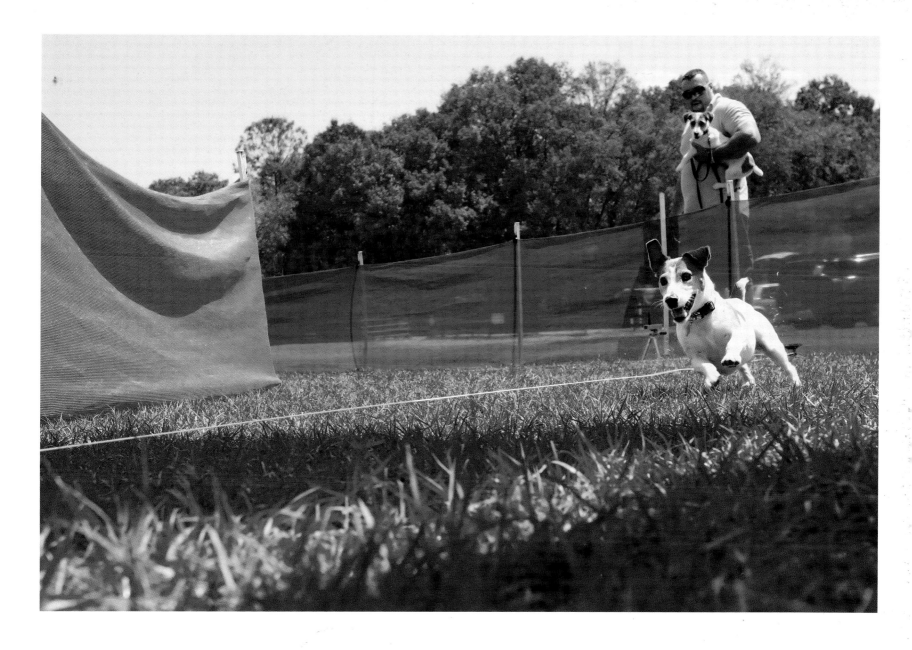

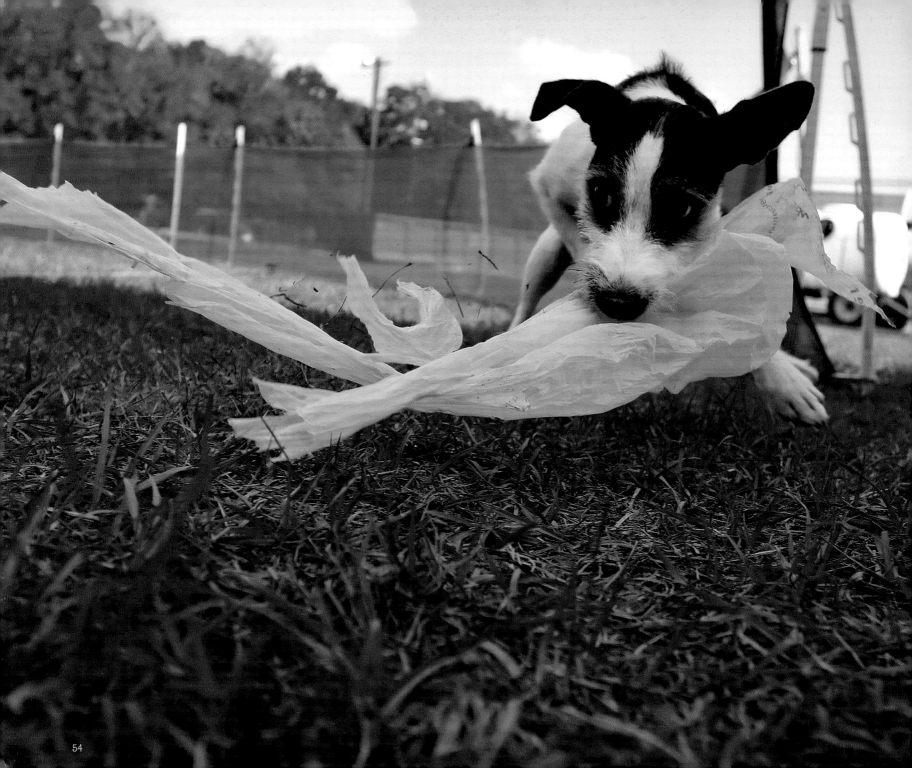

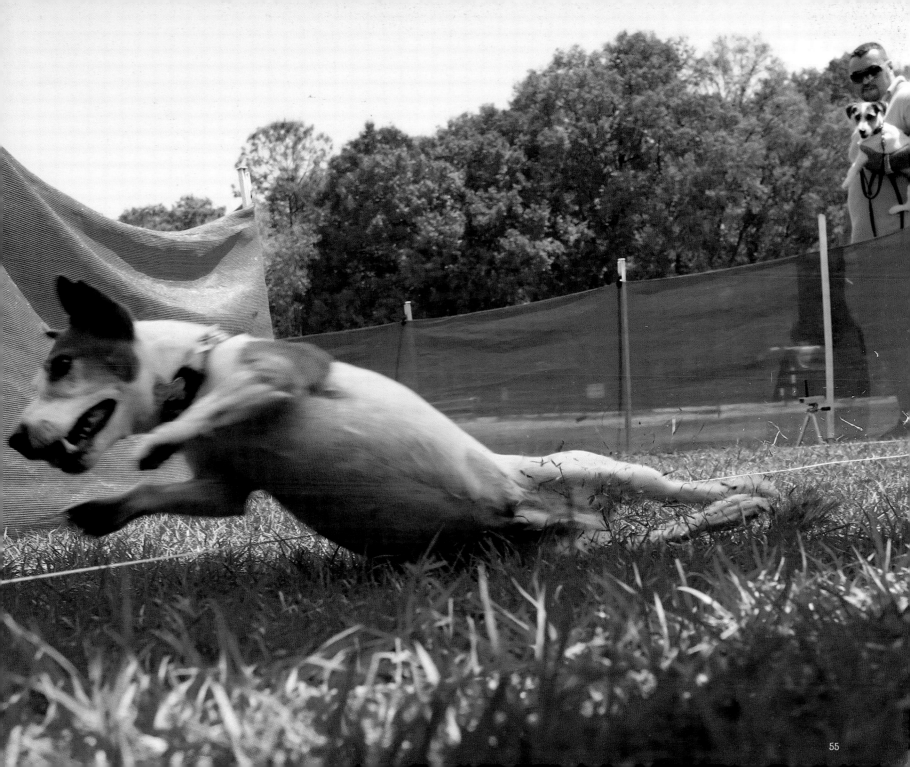

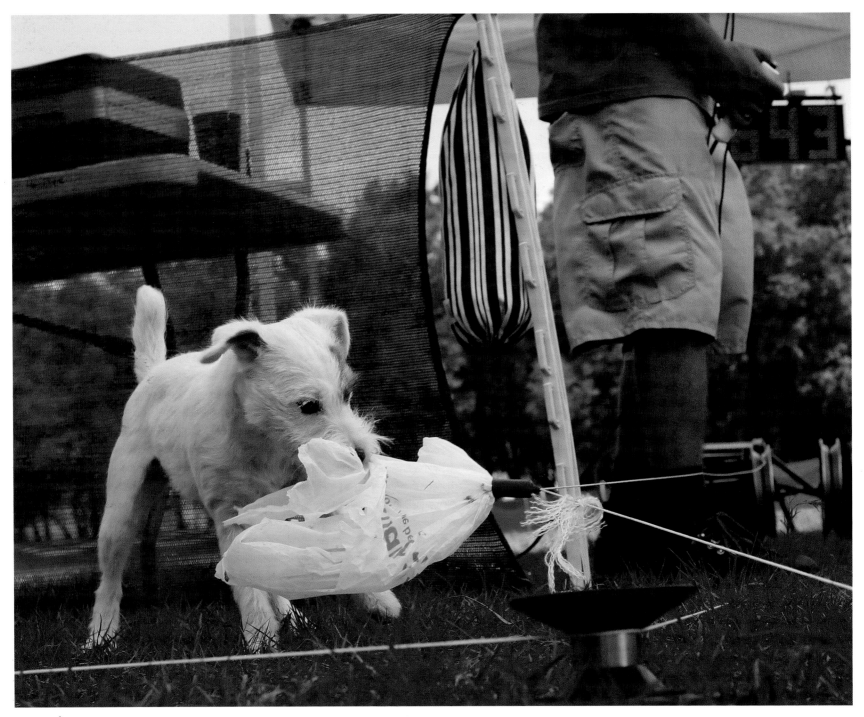

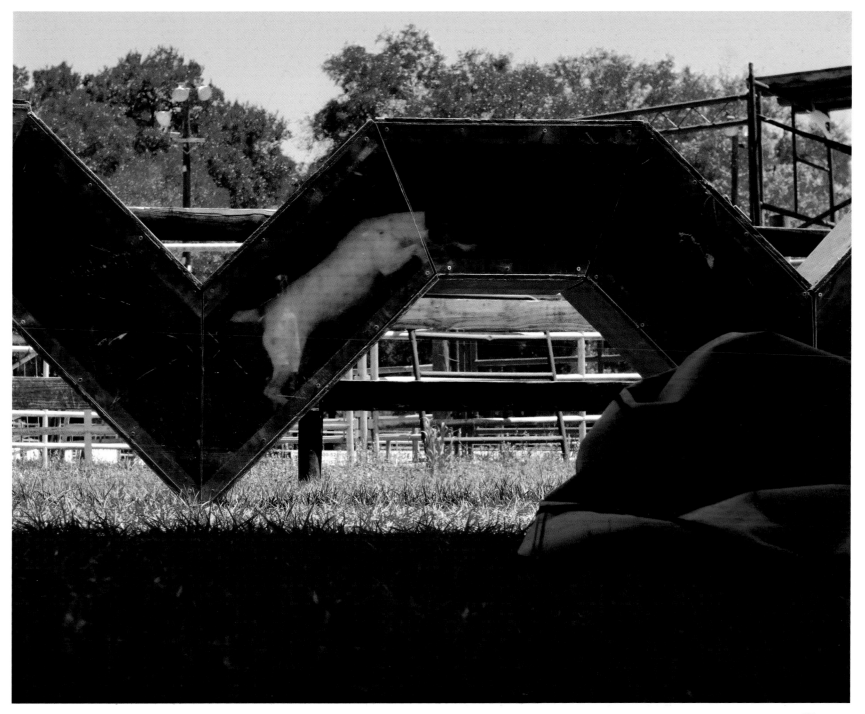

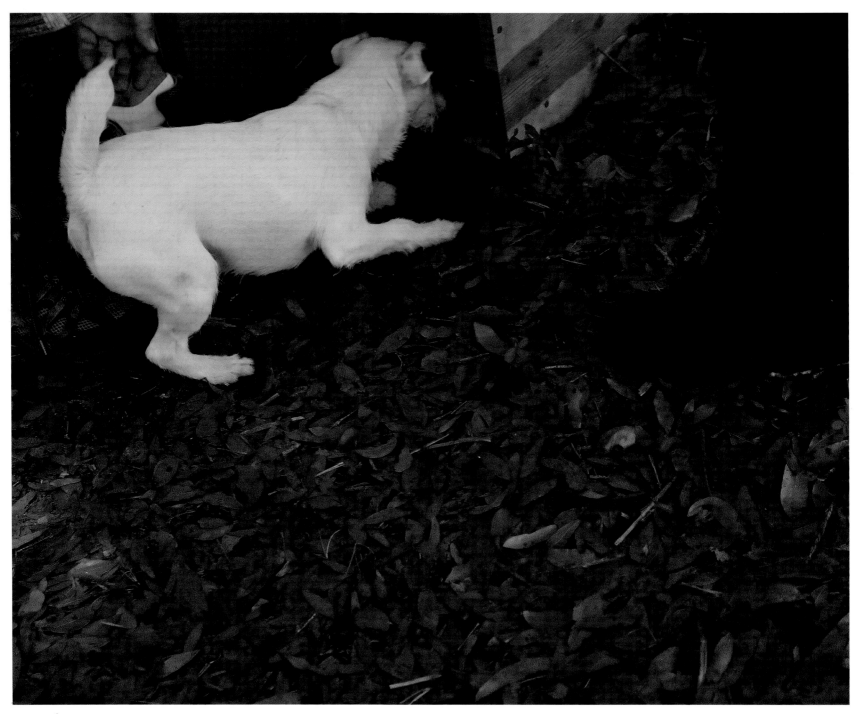

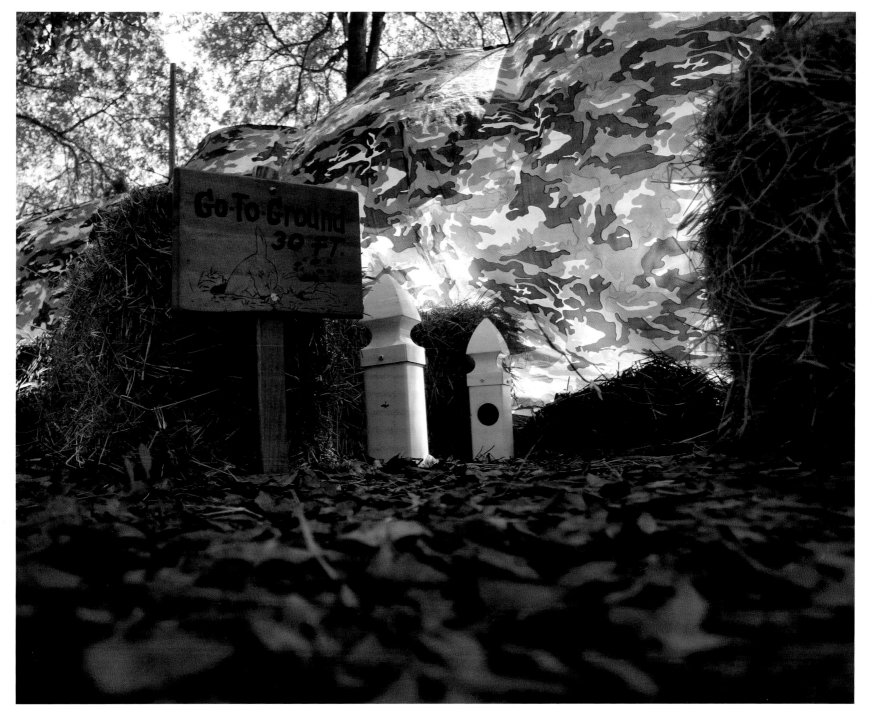

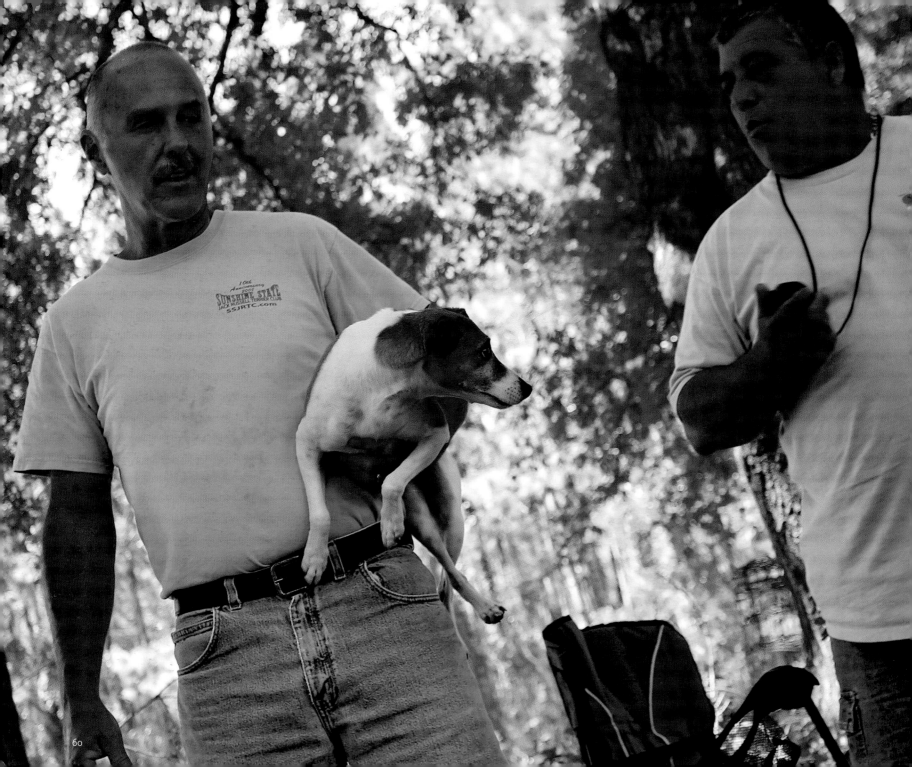

UA	D.C.Flash	13211	13.094	13271	13610	Freckles
OA	Riley	12791	13370	20284	18276	Rex
UA	Wensome	12676	12871	12602	12319	Hannah Ann
S	Gunni	11497	11351	NT	NT	Corin
M	Lucy	15544		15478	15424	Kaidie Kaydie
UA	Buddy	15203		12342	12191	Zack
UP	Troublette	12611	13643	14182	14009	Cooper
S	Tootsie	14798	15137	11679		Will
UA	Risque	12495	12561	12913	12129	Frenchie
UA	Mitch Miller	13210	14158	12397	12710	Miss Cy
S	Spot	17.520	15341	11773	11797	Vicious
OA	Beasley	12200	12619	12504	12838	
OA	Rexx	12625	12347	12854	1316	
S	Lucy	25789	17683	14089	13	
UA	Harris	13060	12940	13123	12688	Cookie

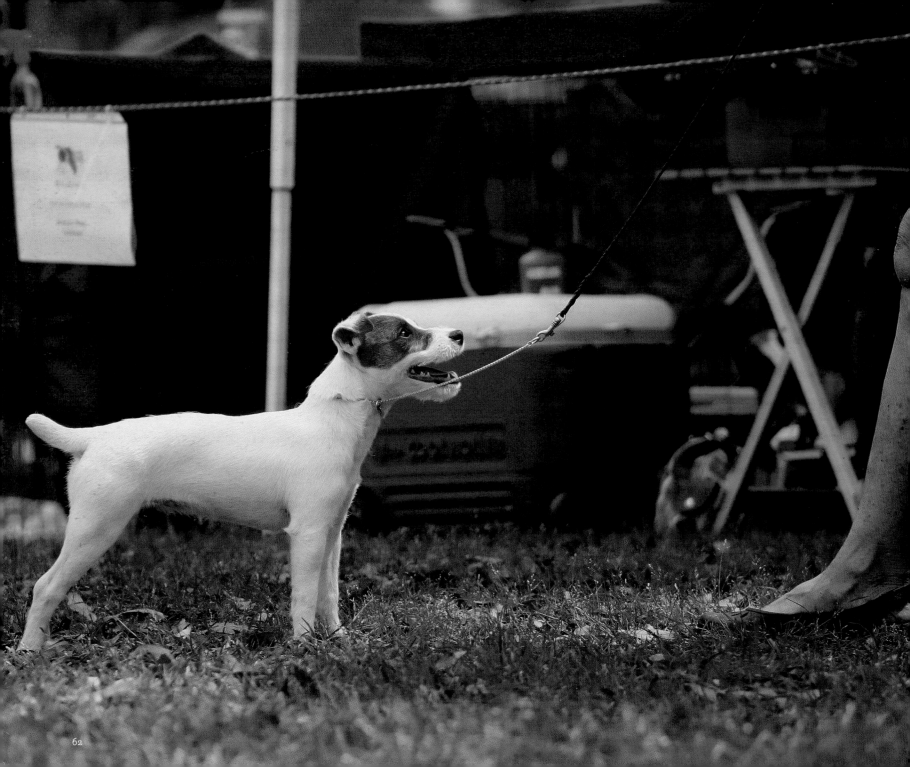

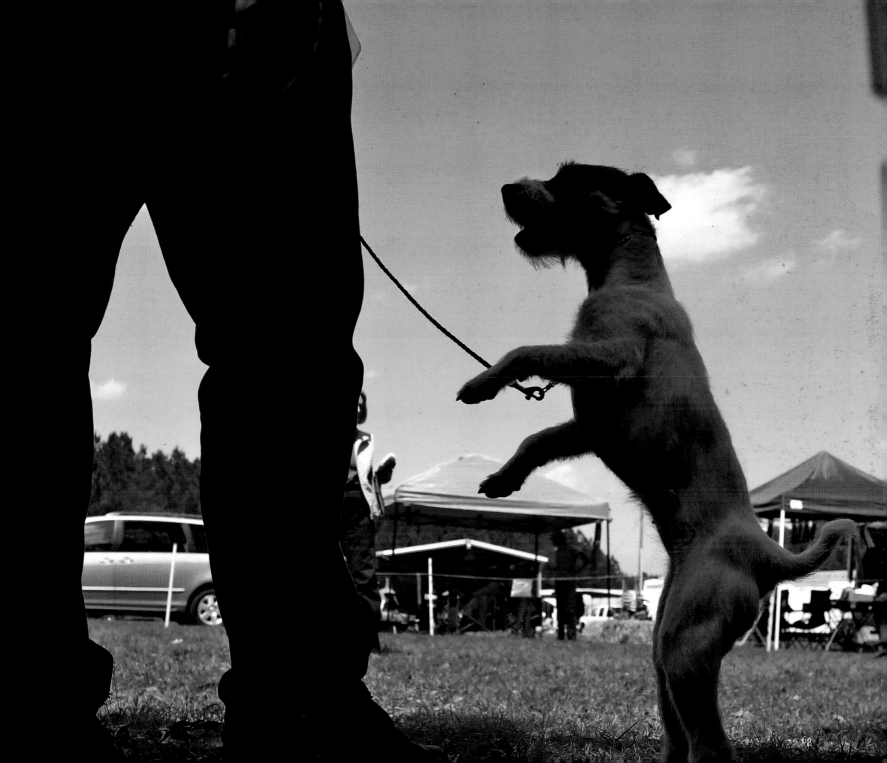

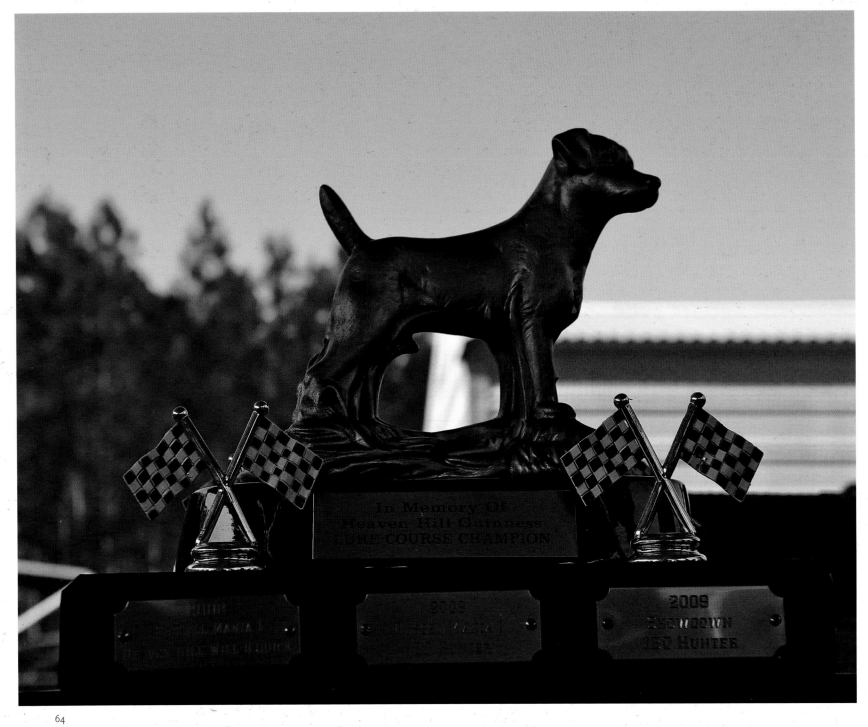

In Memory Of
Heaven Hill Guinness
LURE COURSE CHAMPION

2009

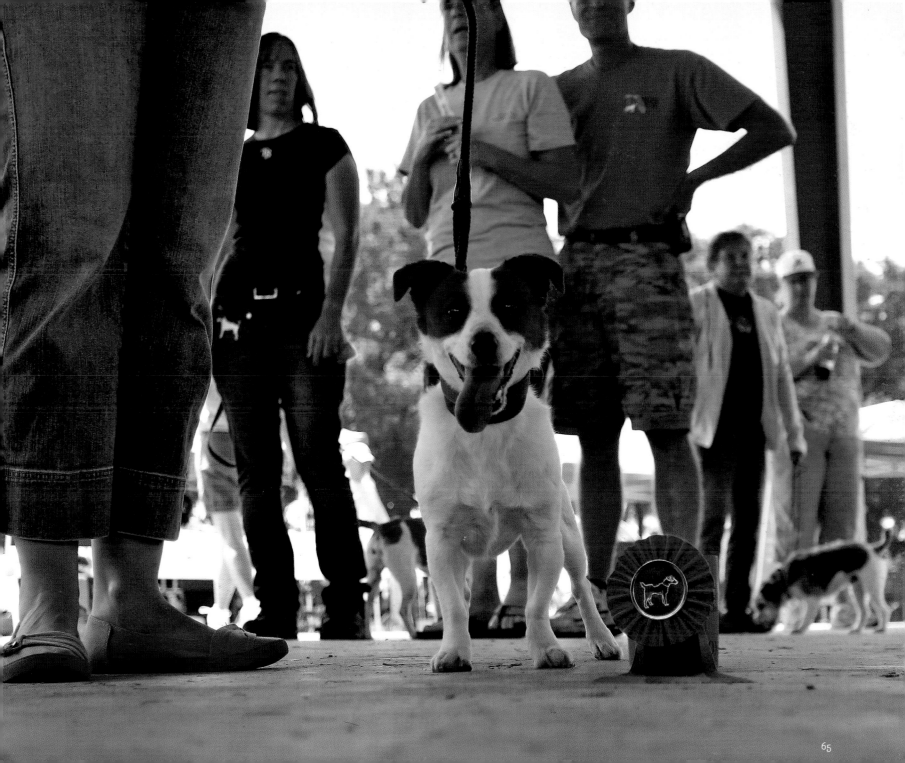

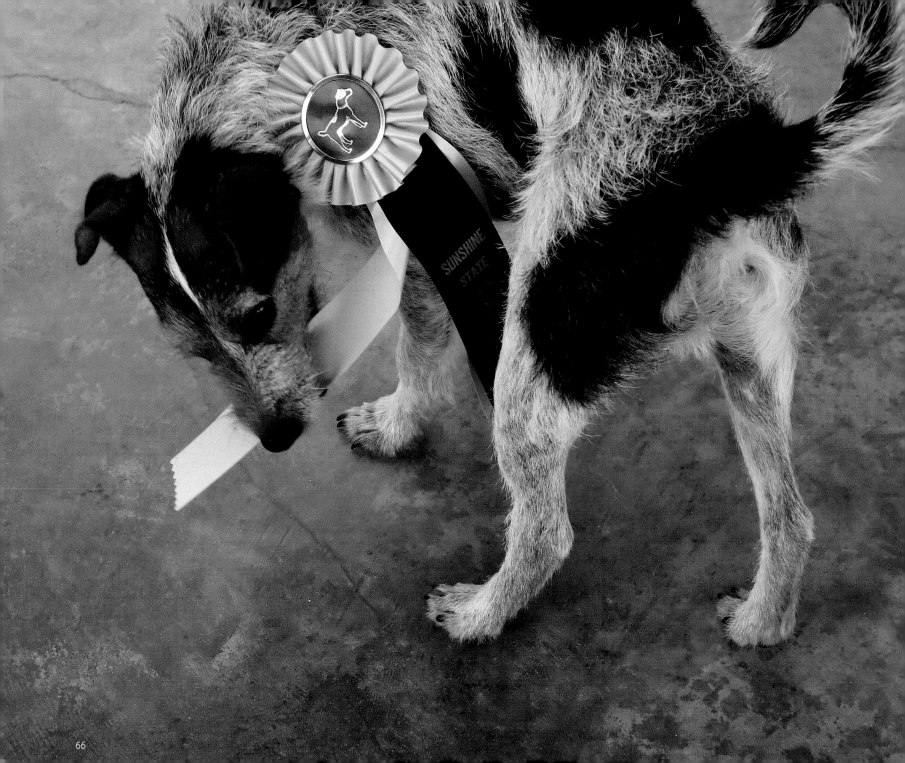

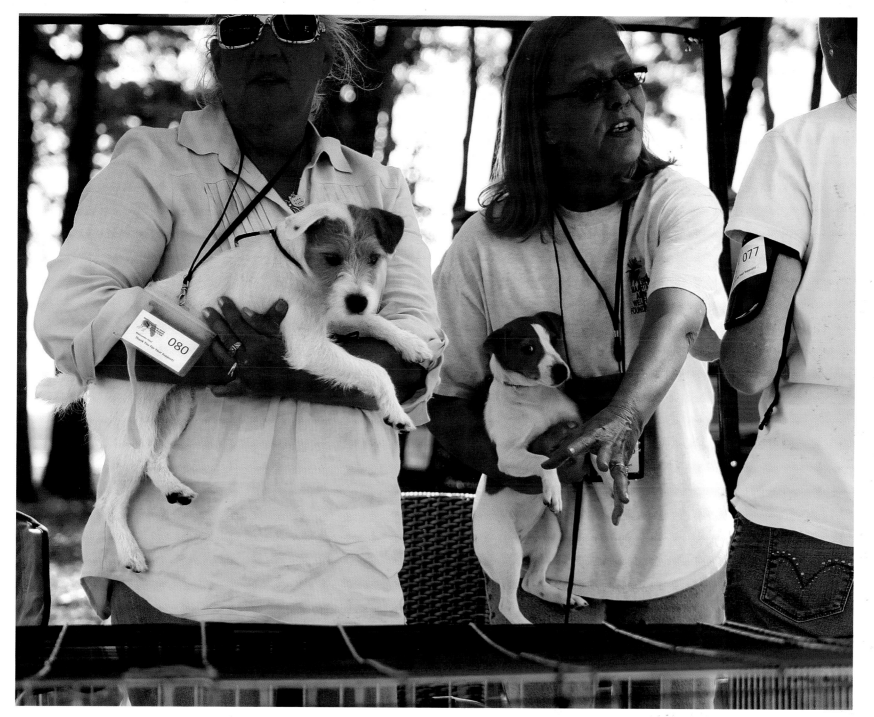

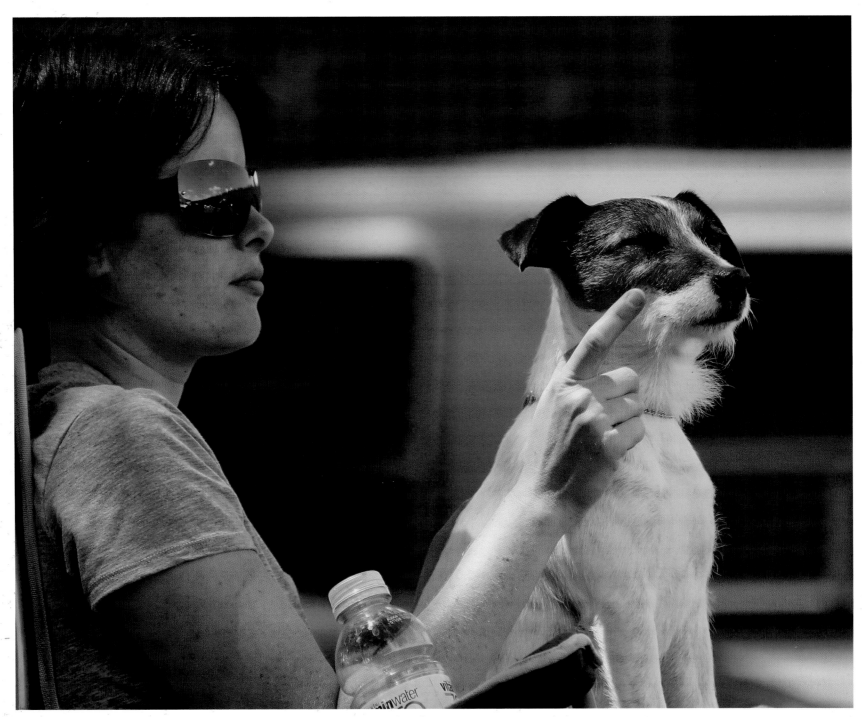

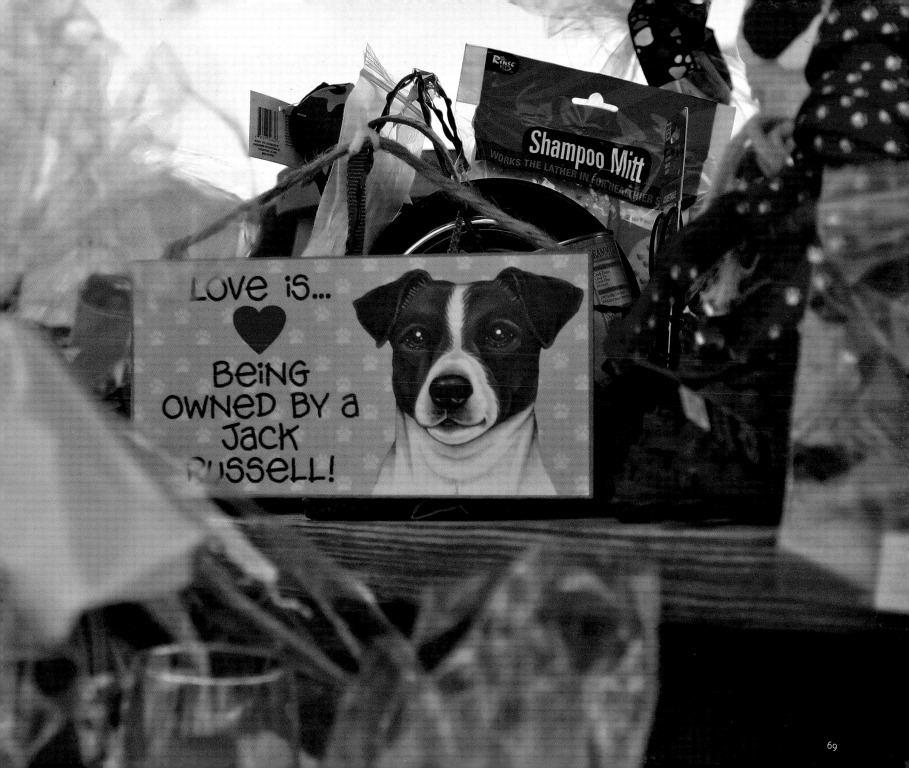

Love is...
♥
BEING
OWNED BY a
Jack
RUSSELL!

Shampoo Mitt
WORKS THE LATHER IN FOR HEALTHIER S

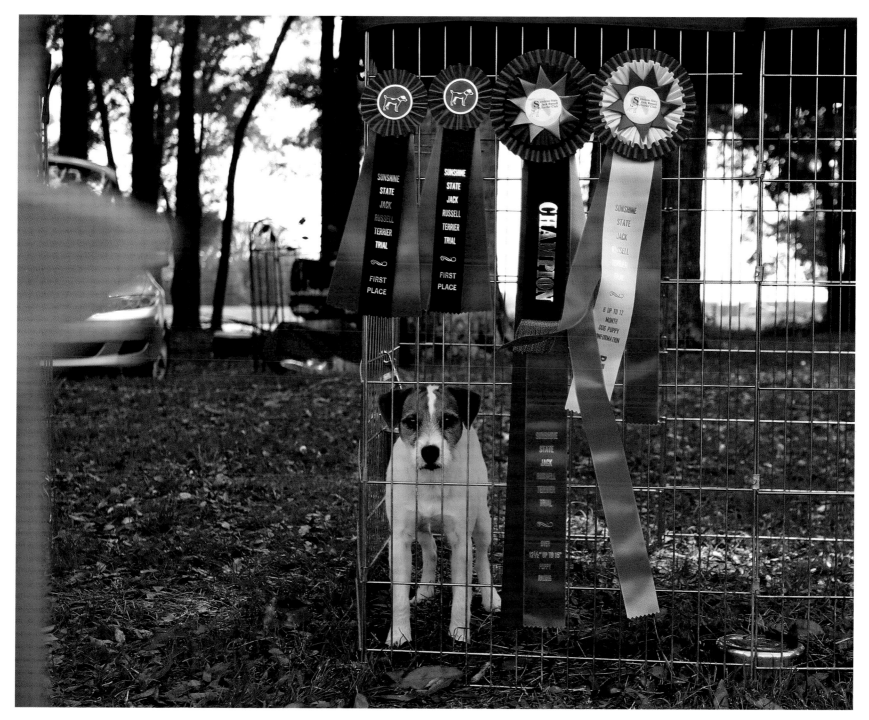

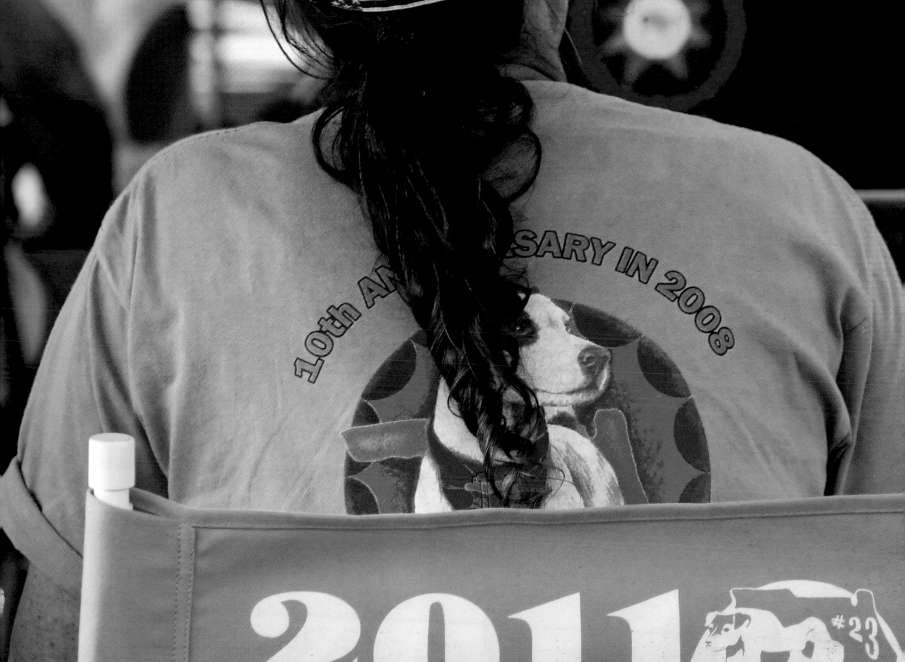

10th ANNIVERSARY IN 2008

2011
GOLD COAST TERRIER TRIAL
#23

73

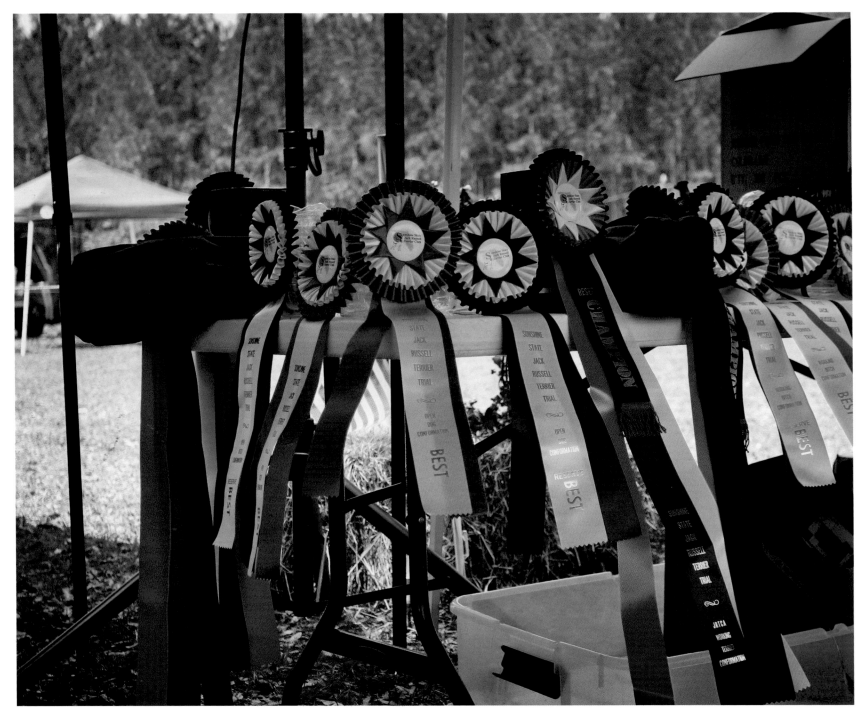

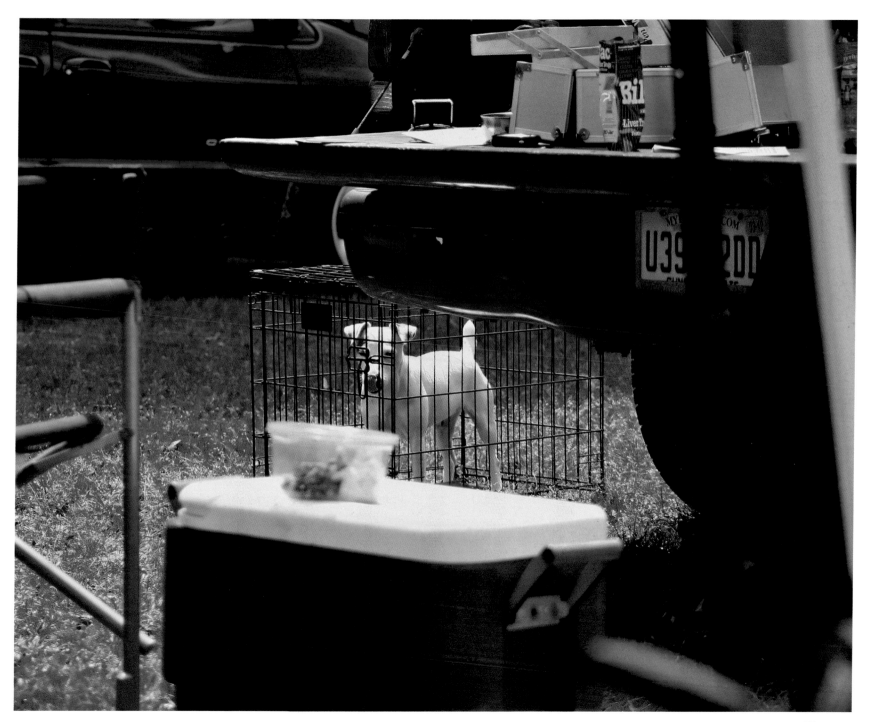

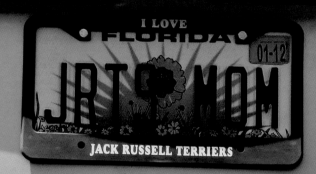

I LOVE FLORIDA

01-12

JRT♥MOM

JACK RUSSELL TERRIERS

TALLY HILLS TERRIERS
Monticello, Florida 850-997-6006

Jack Russell

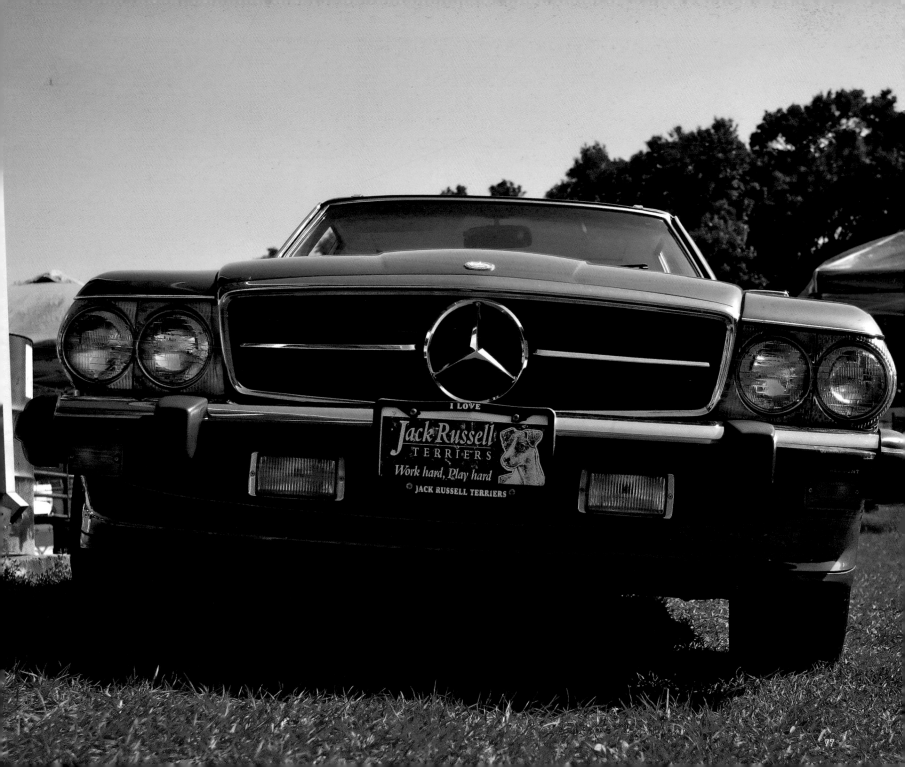

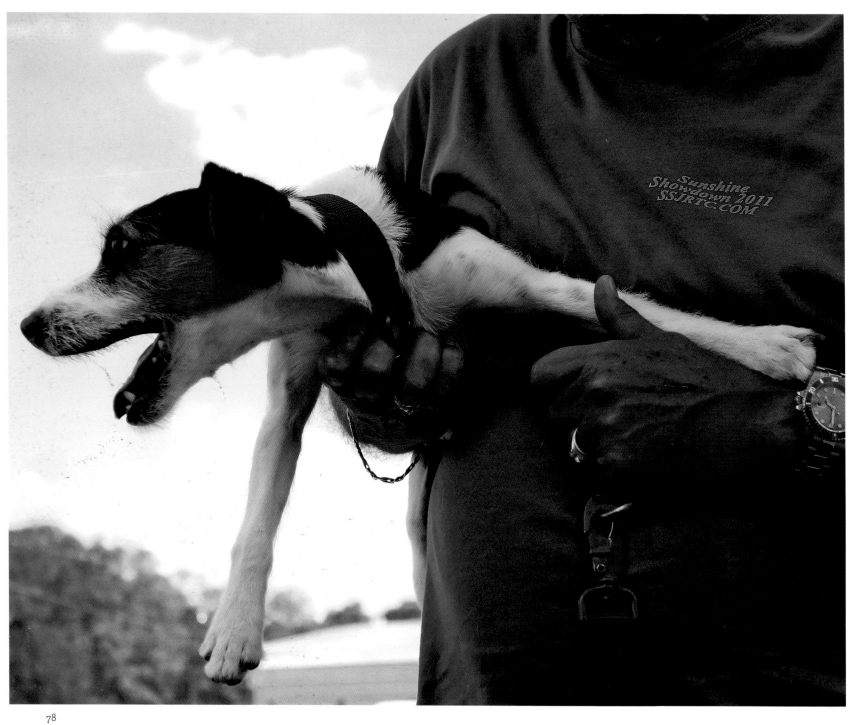

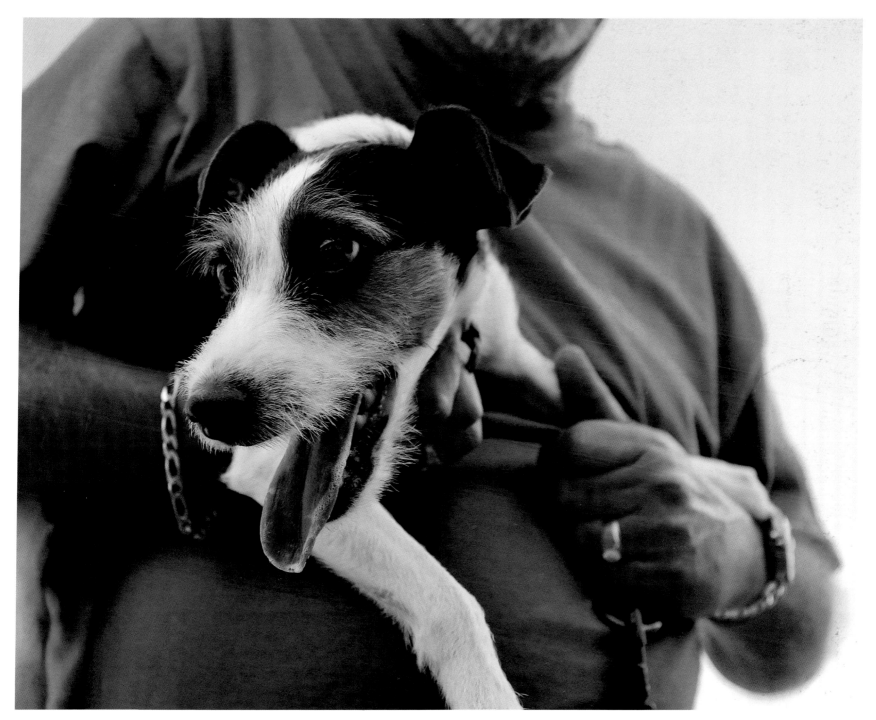

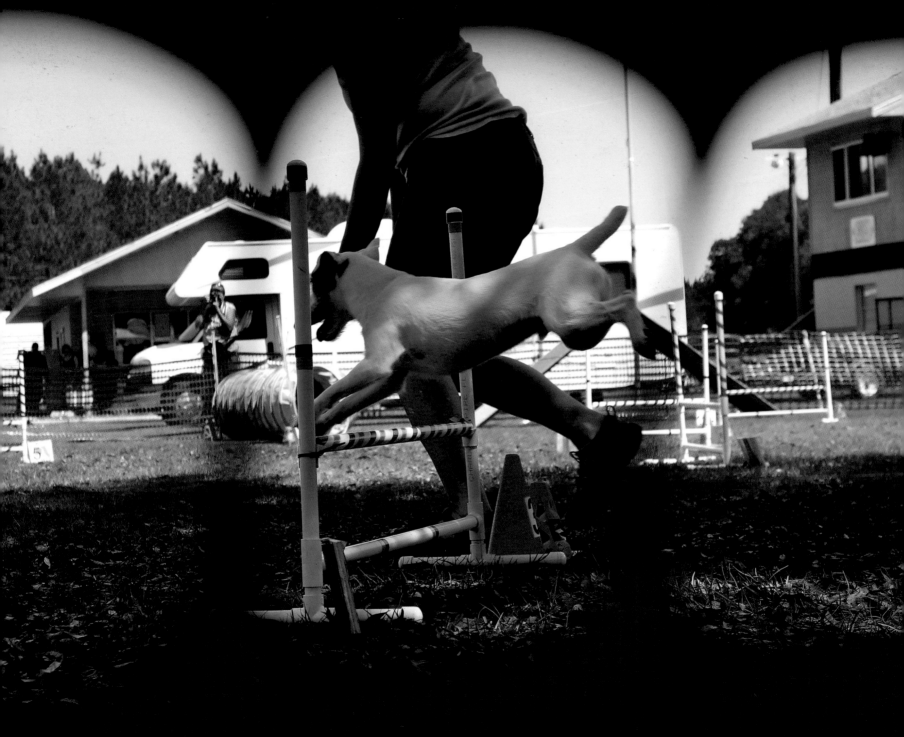

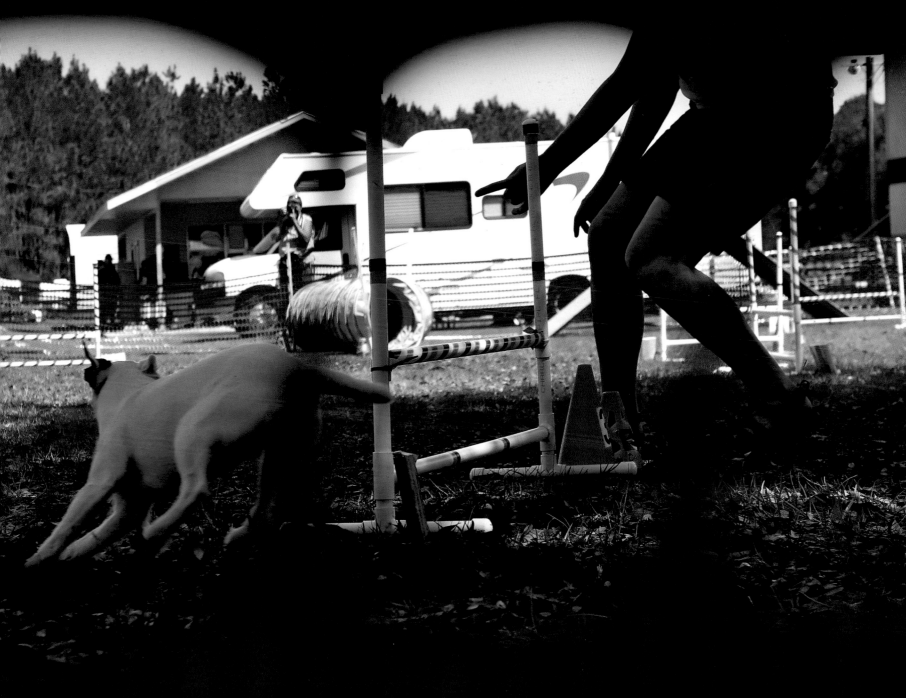

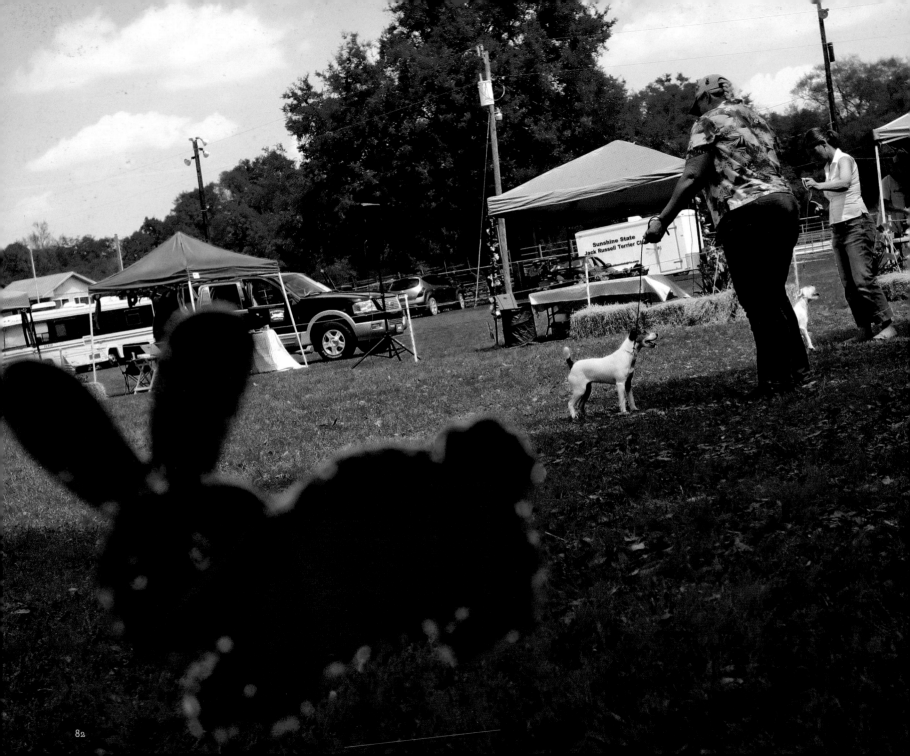

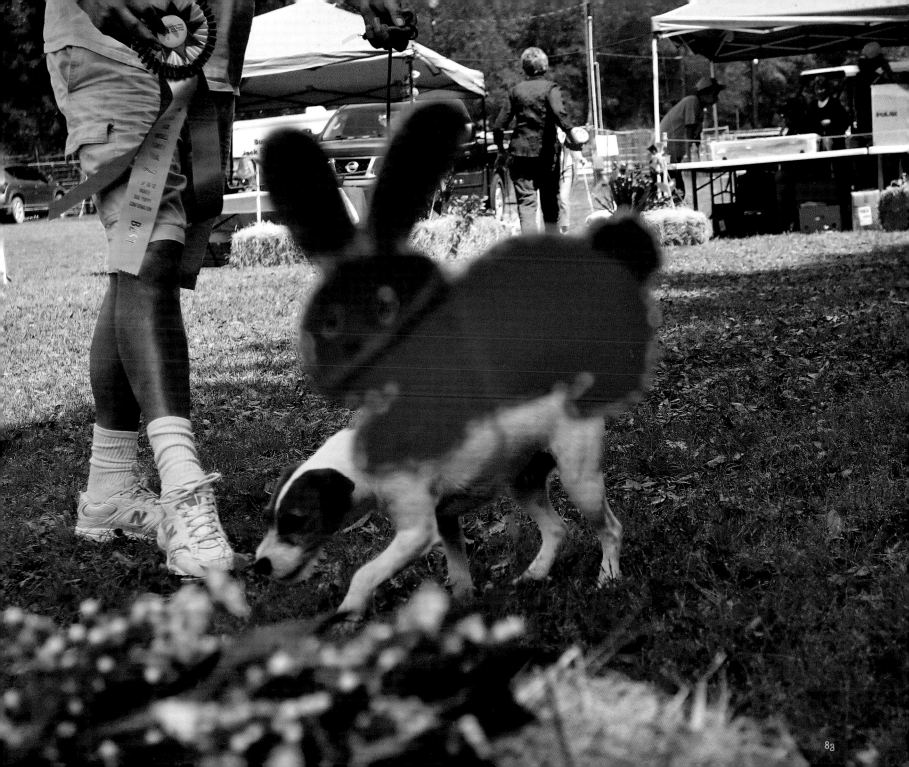

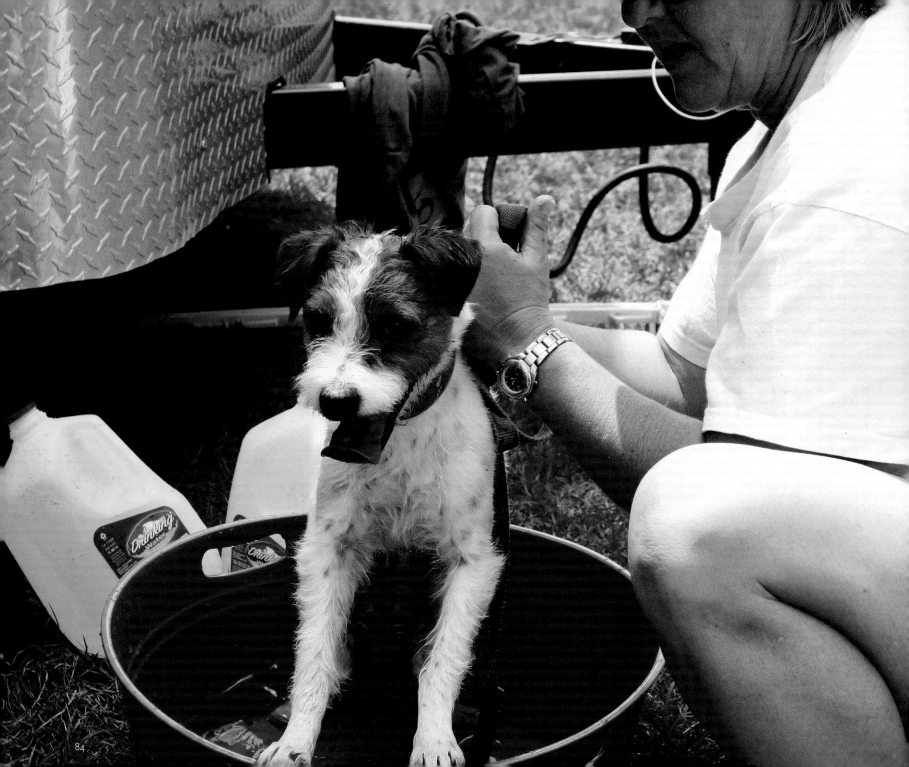

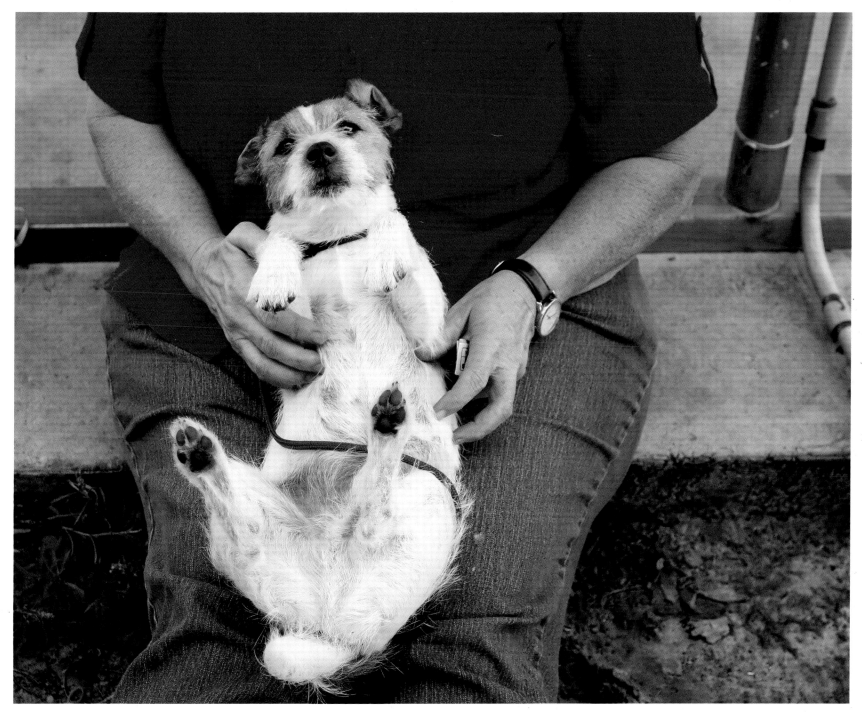

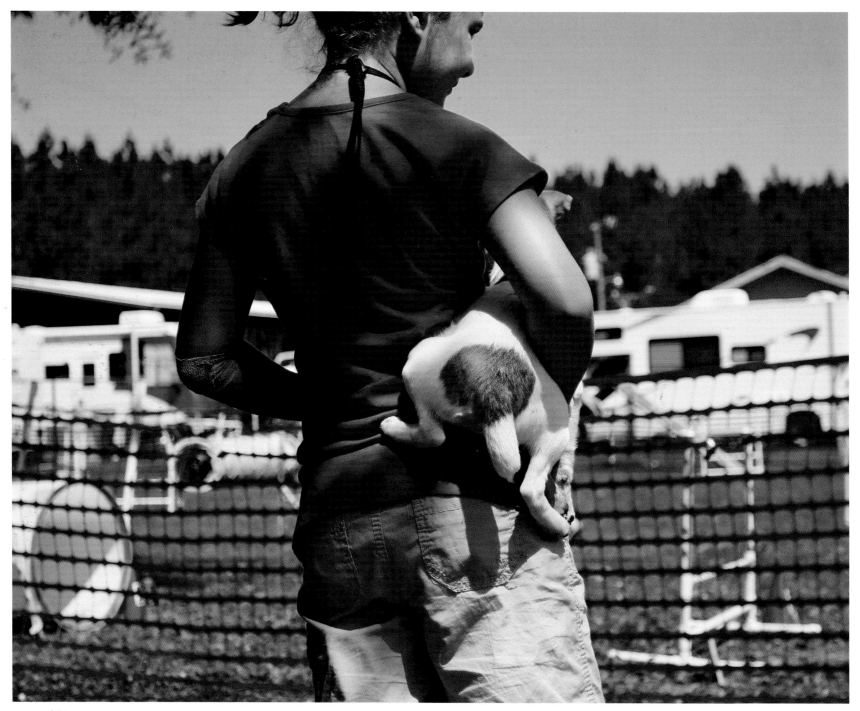

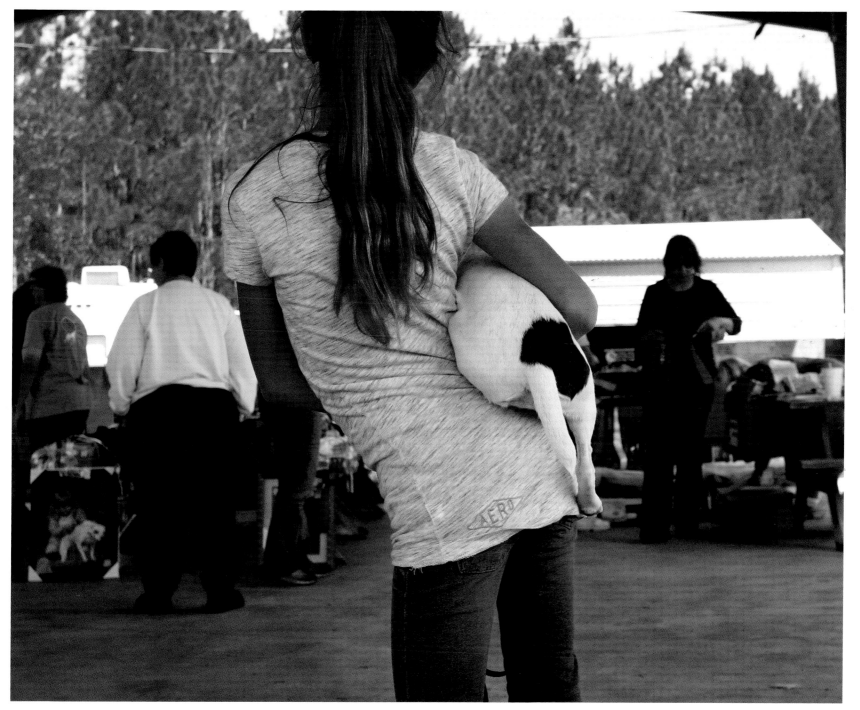

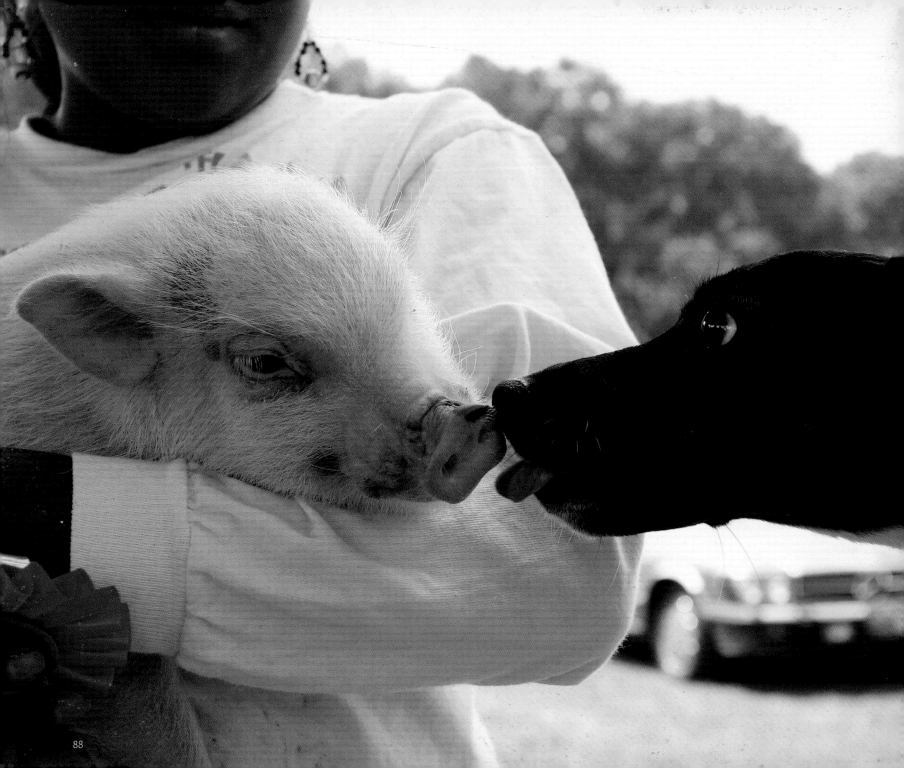

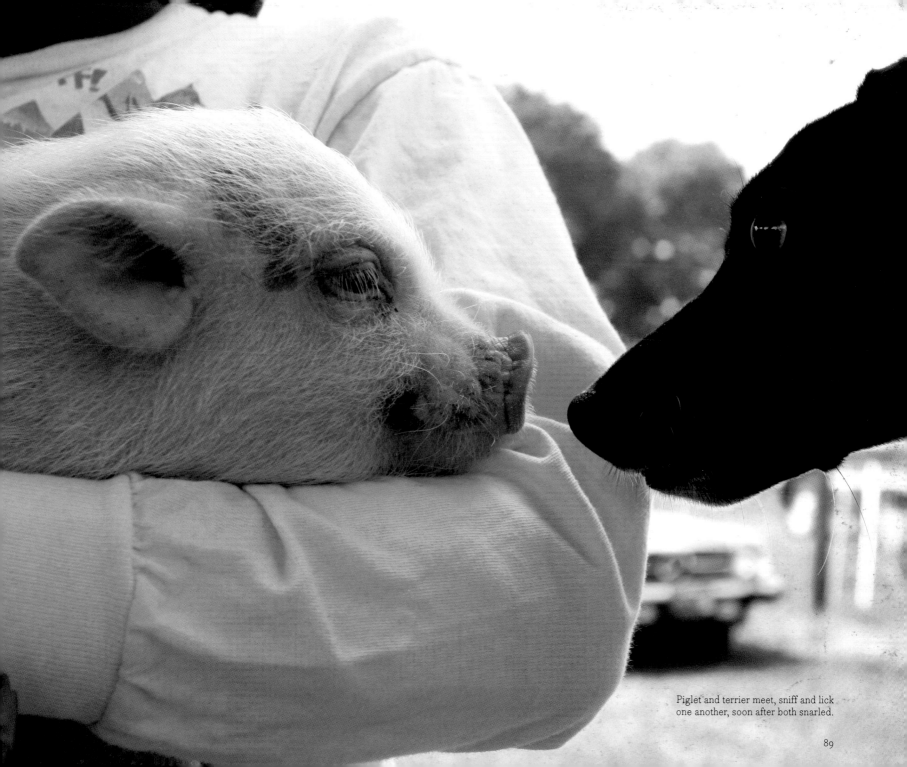

Piglet and terrier meet, sniff and lick
one another, soon after both snarled.

89

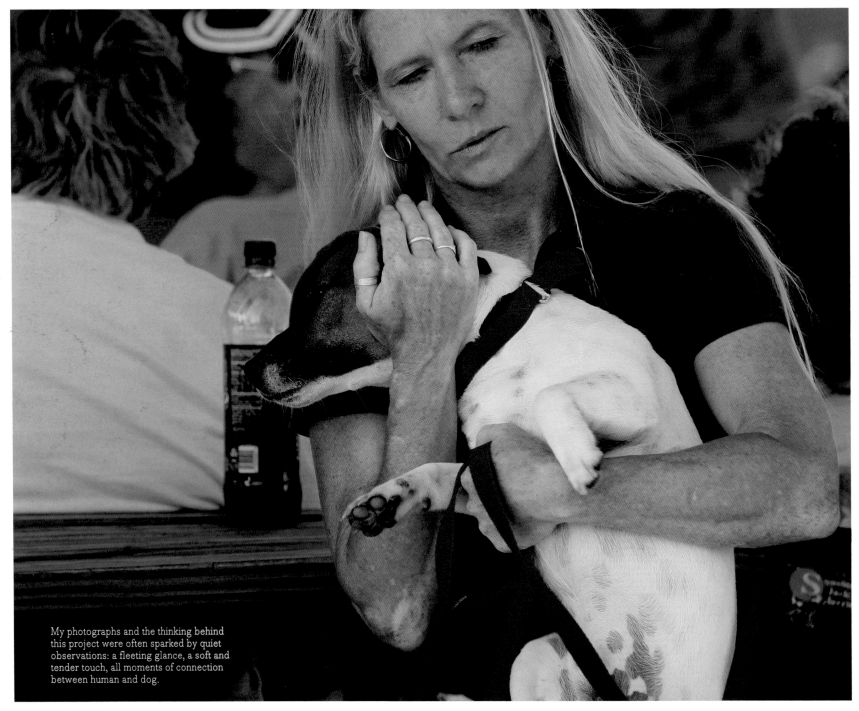

My photographs and the thinking behind this project were often sparked by quiet observations: a fleeting glance, a soft and tender touch, all moments of connection between human and dog.

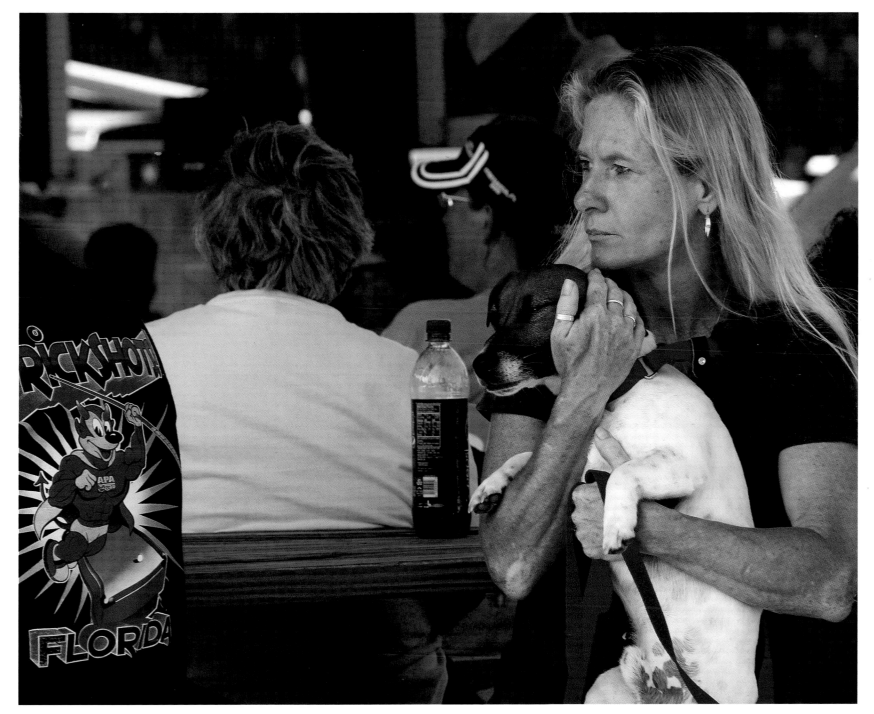

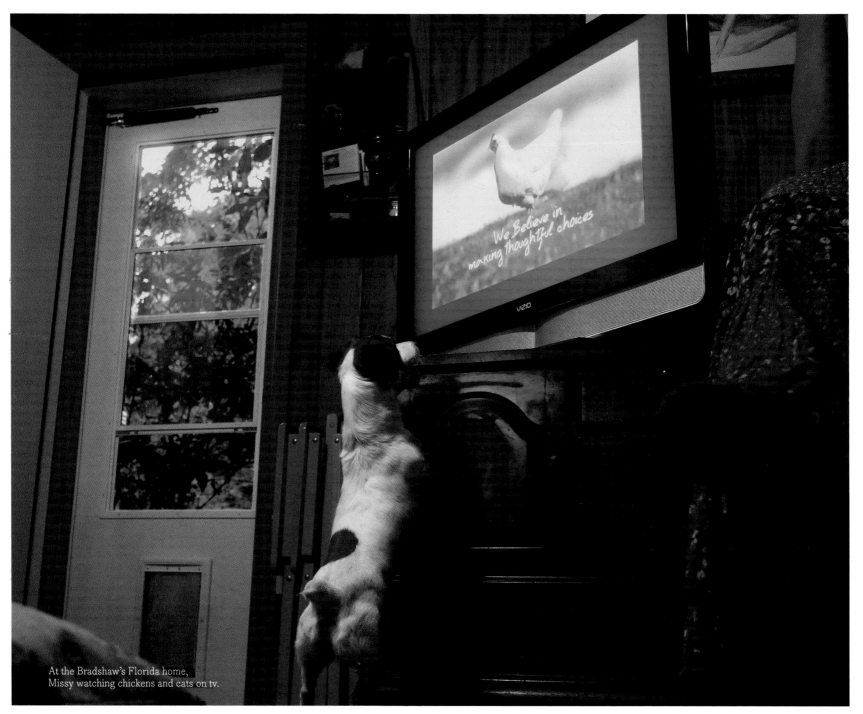

On the TV screen: *We Believe in making thoughtful choices*

At the Bradshaw's Florida home,
Missy watching chickens and cats on tv.

Missy at her Florida home

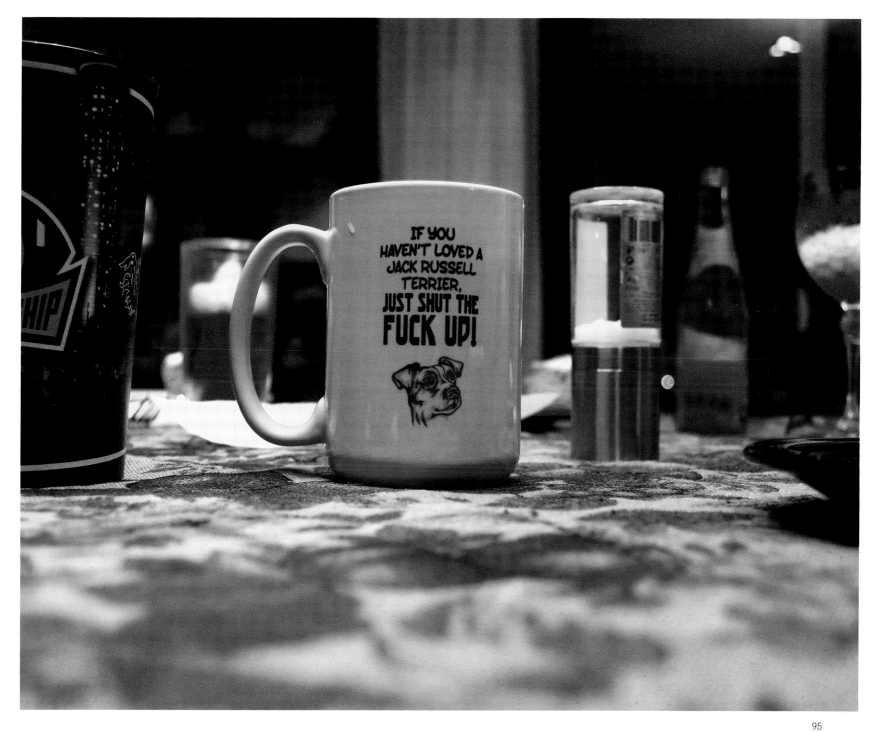

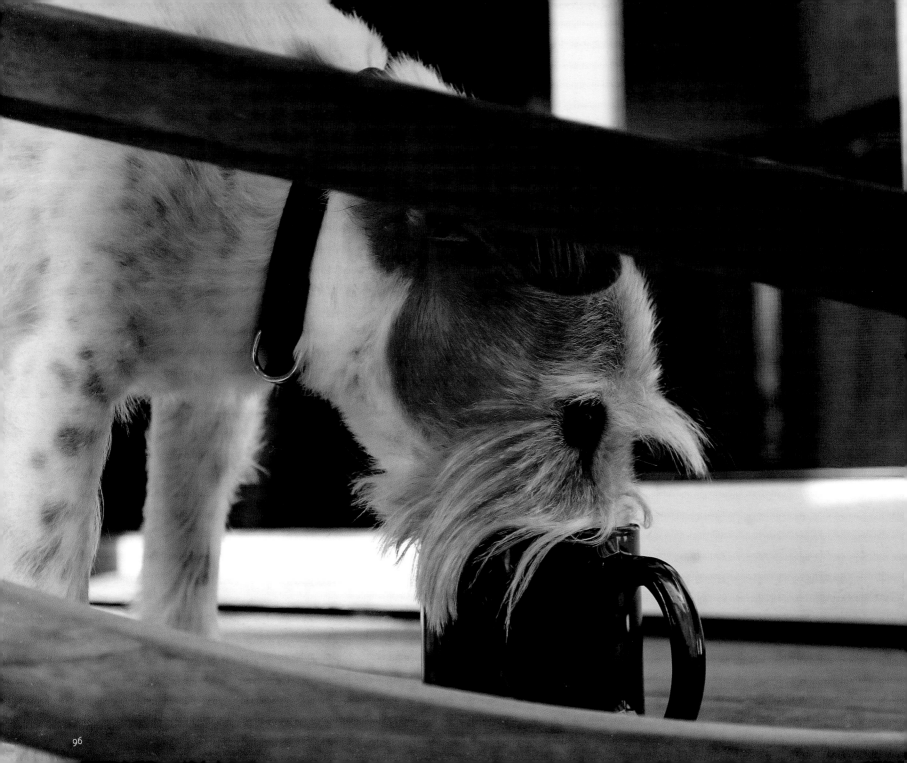

My American Jack Russell experience over, I returned to Cornwall, the beach, surfing and my own two dogs, Lily and Maui. Time to enjoy the sand and surf.

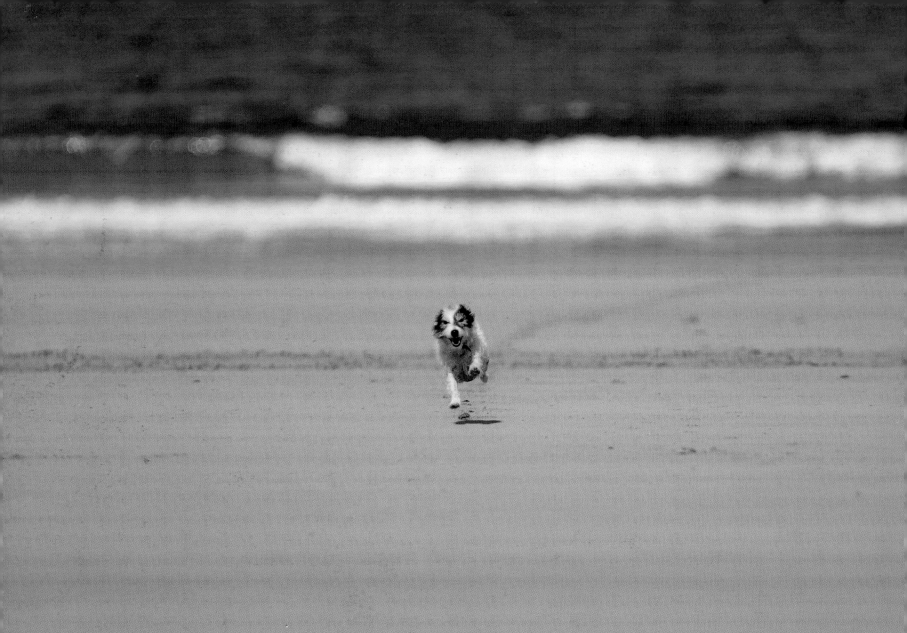

Maui on the beach

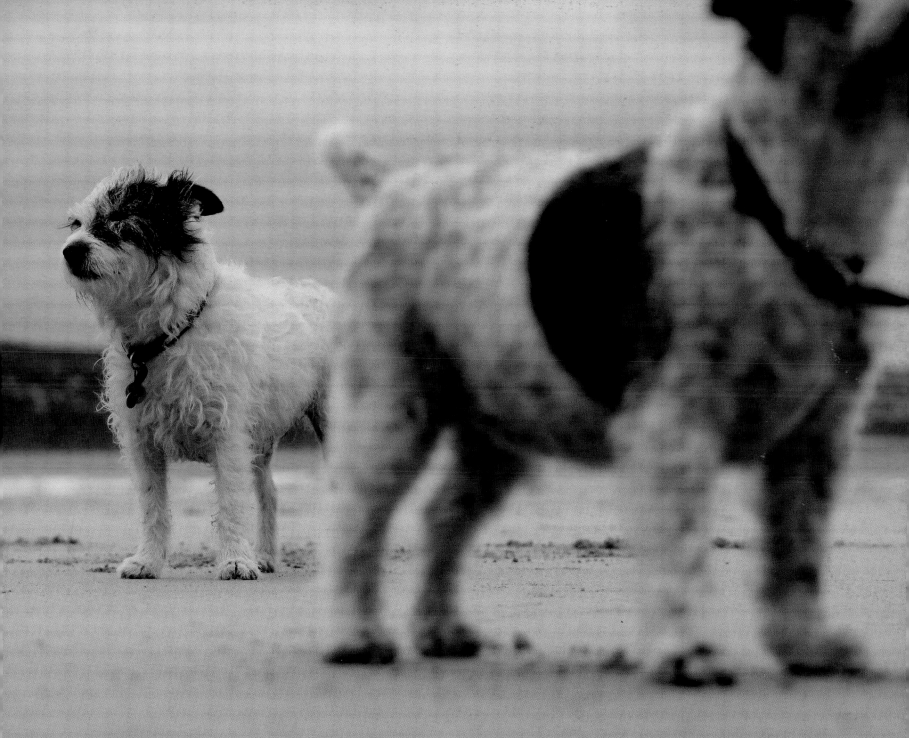

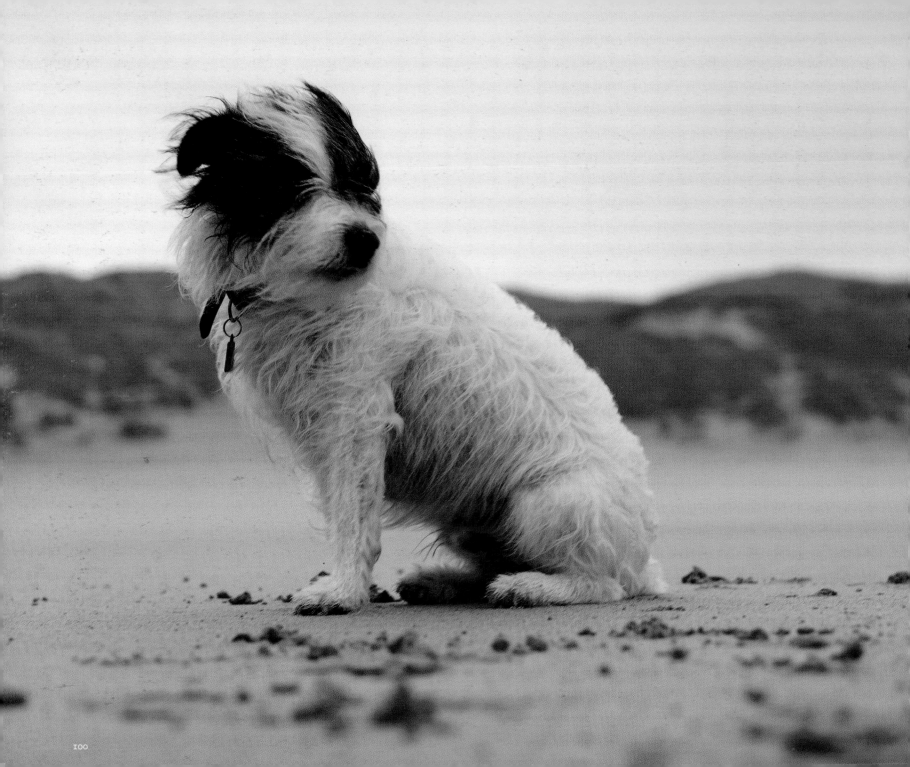

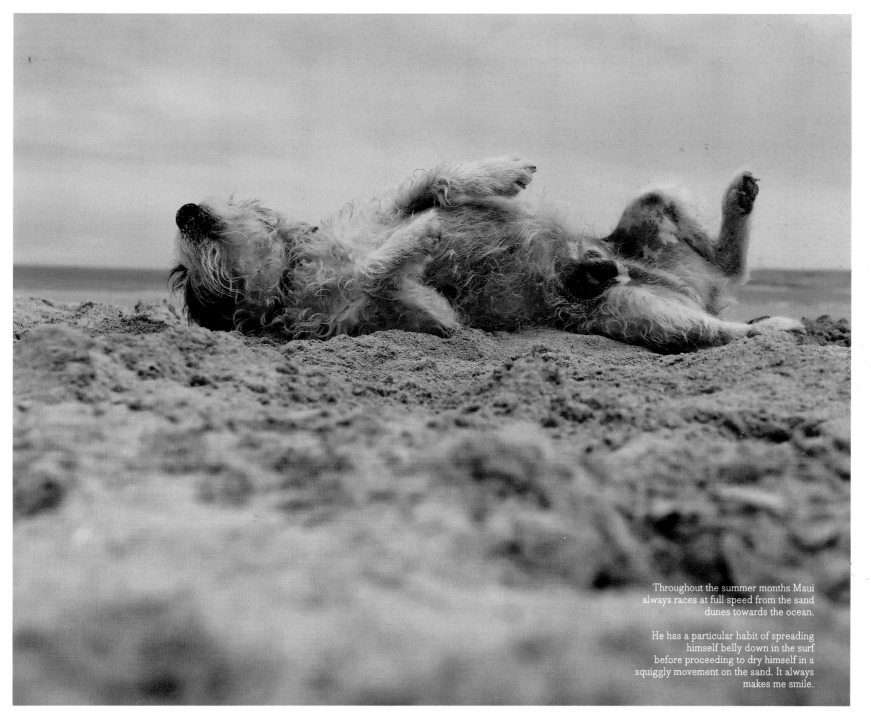

Throughout the summer months Maui always races at full speed from the sand dunes towards the ocean.

He has a particular habit of spreading himself belly down in the surf before proceeding to dry himself in a squiggly movement on the sand. It always makes me smile.

One of the most conspicuous features of the dog is one of the most conspicuously overlooked when contemplating their view of the world: their height. If you think that there is little difference between the world at the height of an average human and that at the height of an average upright dog — one to two feet — you are in for a surprise.

A HOROWITZ

At Porthtowan in Cornwall, there's a small property right by the sea. For many years a small white Jack Russell sat on the roof of this bungalow and it always fascinated me how the dog got up there. Last time I called by the dog was sitting on the garden table. Her roof climbing days were over, she had suffered a stroke and now takes half an aspirin a day.

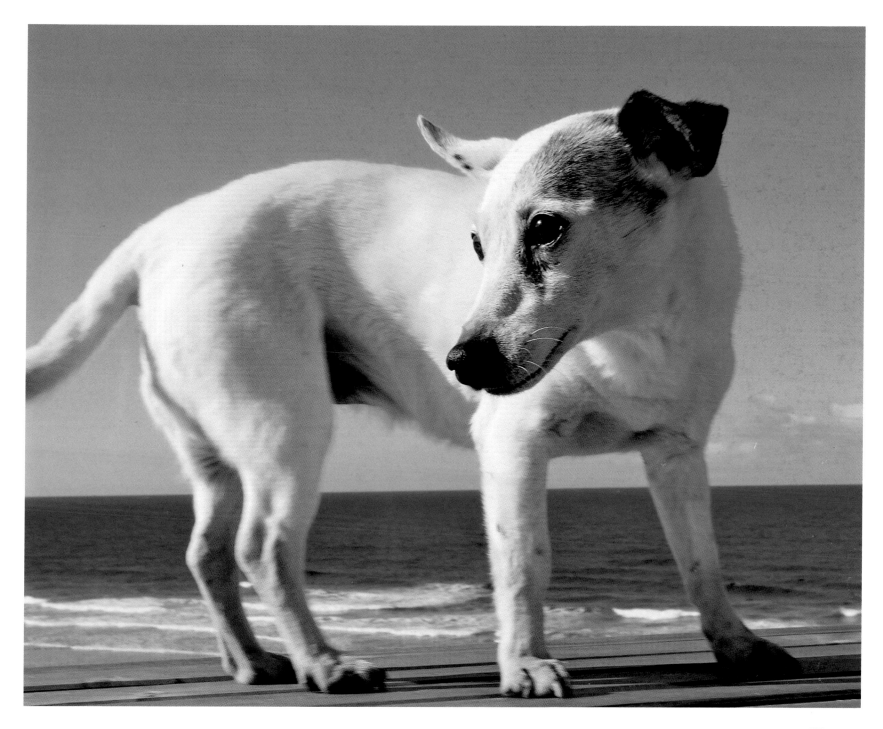

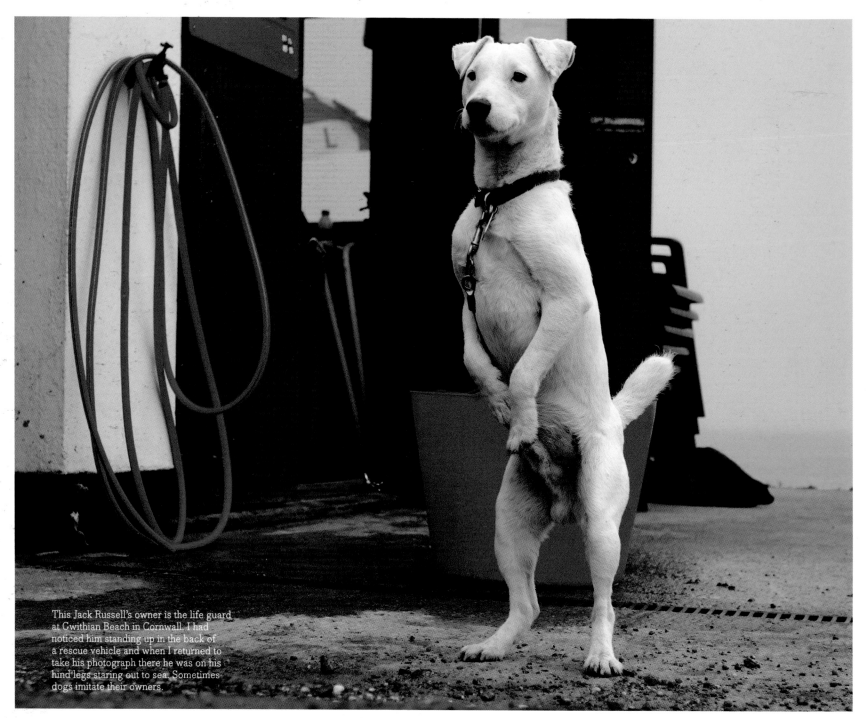

This Jack Russell's owner is the life guard at Gwithian Beach in Cornwall. I had noticed him standing up in the back of a rescue vehicle and when I returned to take his photograph there he was on his hind legs staring out to sea. Sometimes dogs imitate their owners.

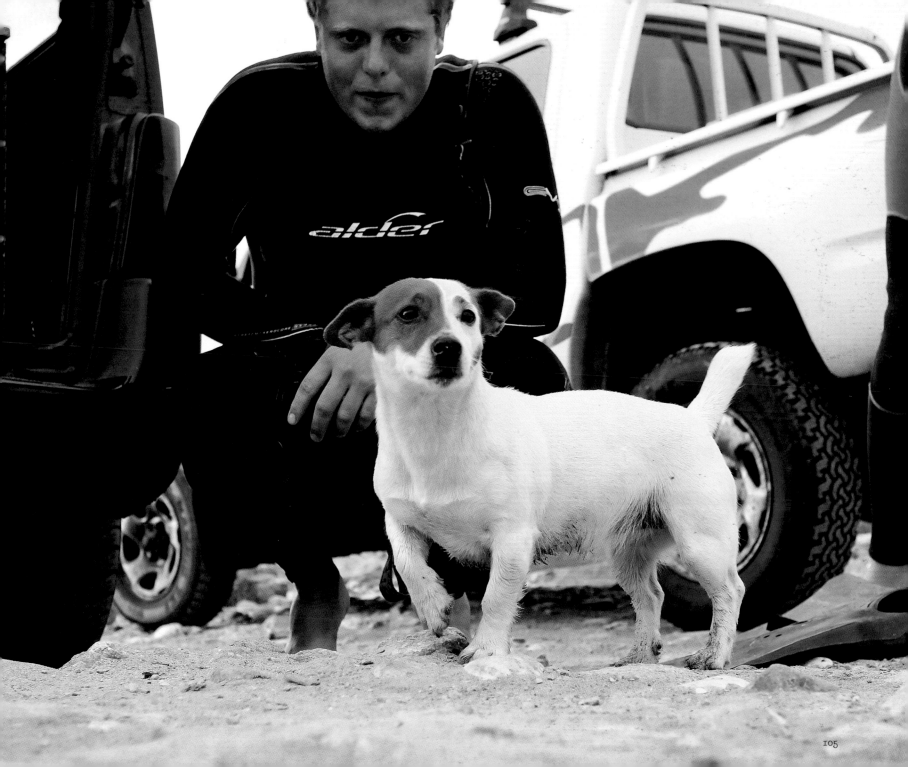

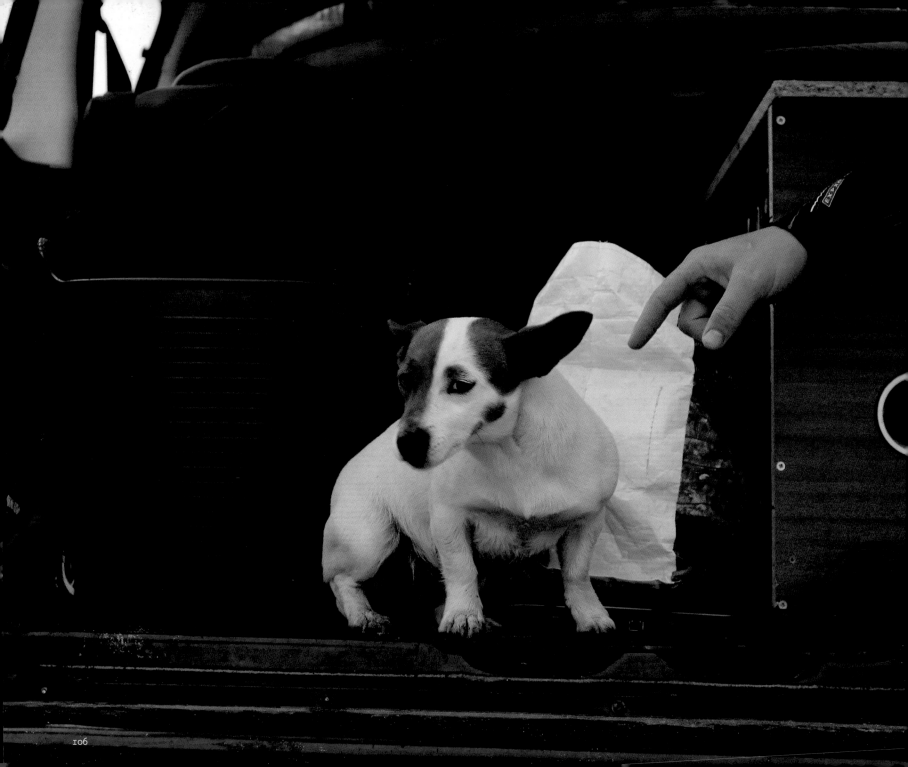

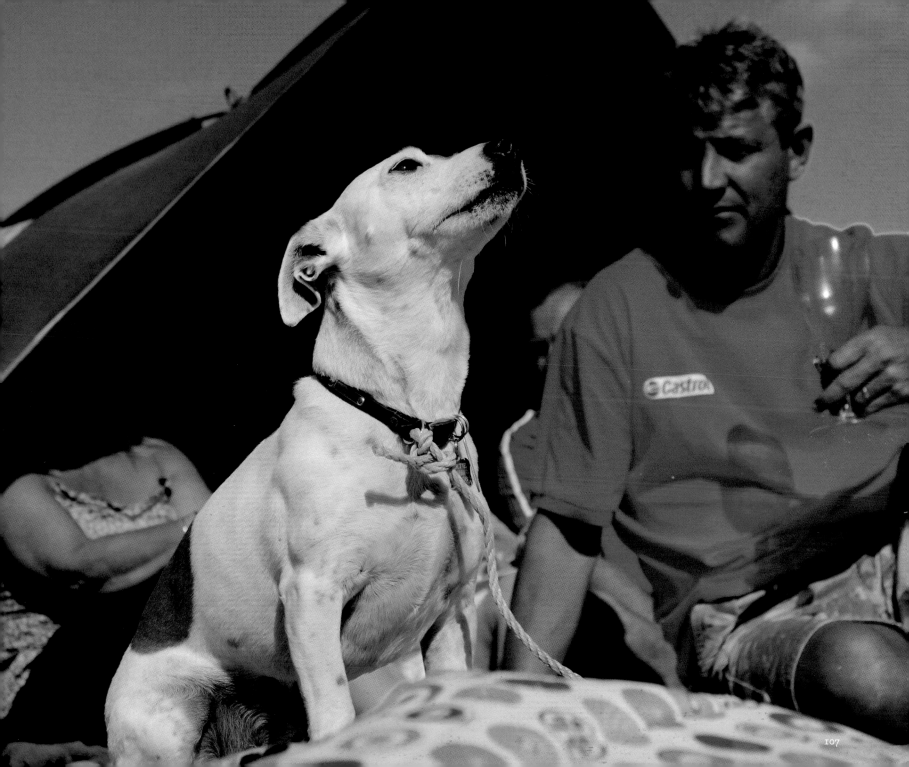

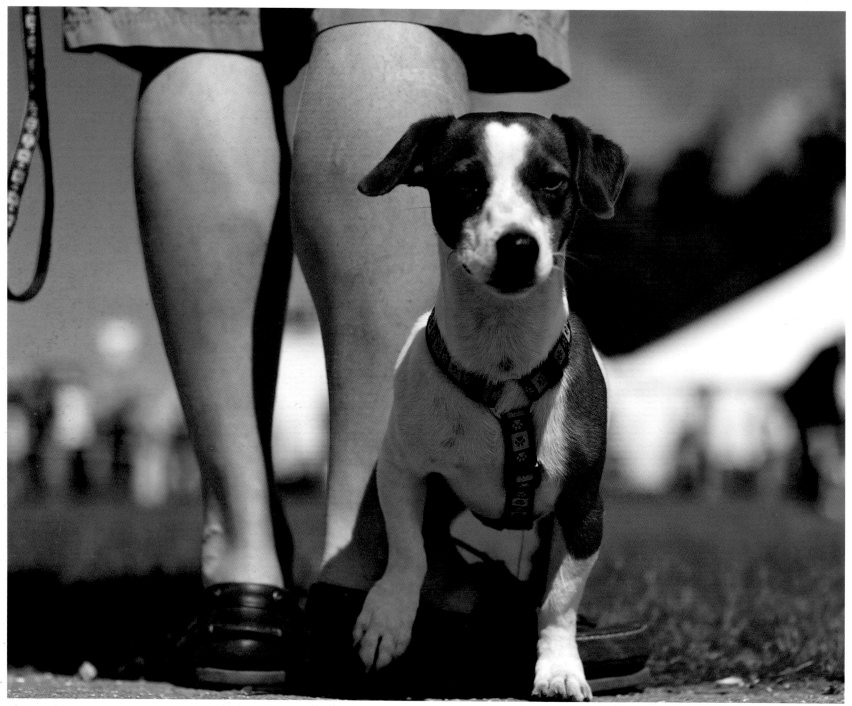

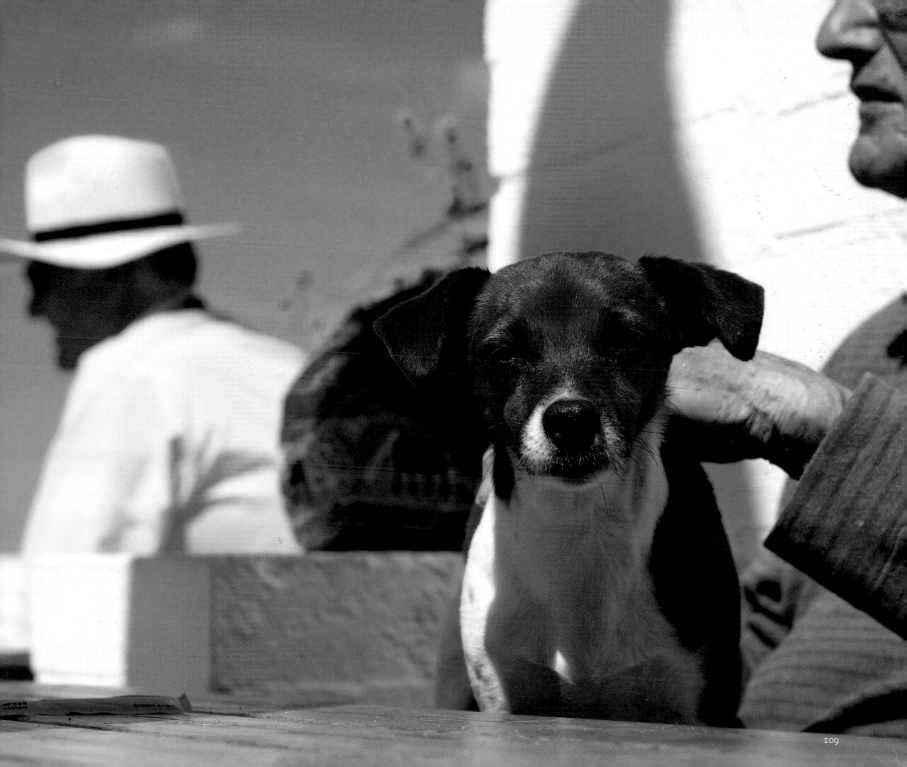

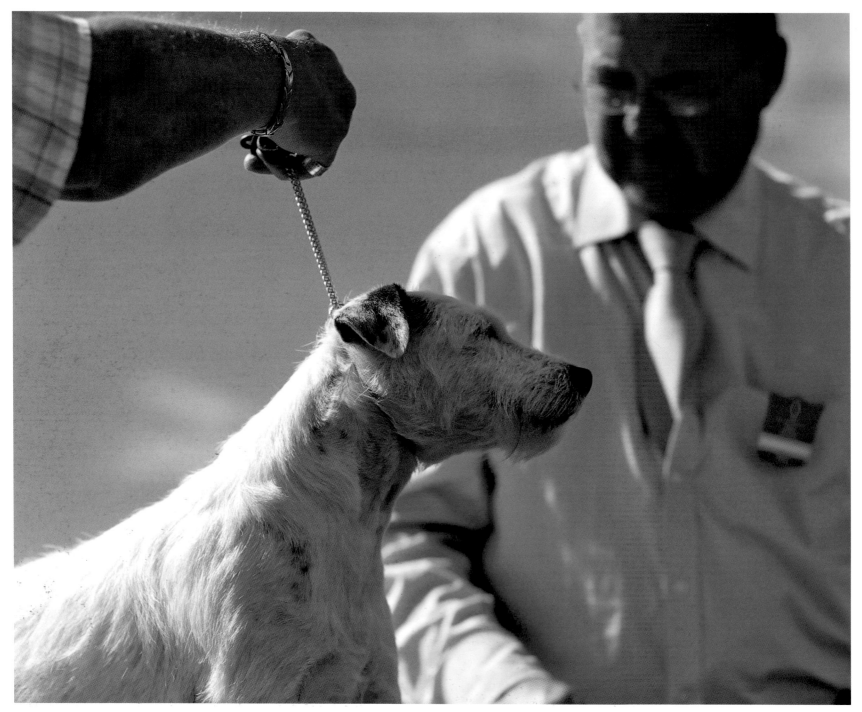

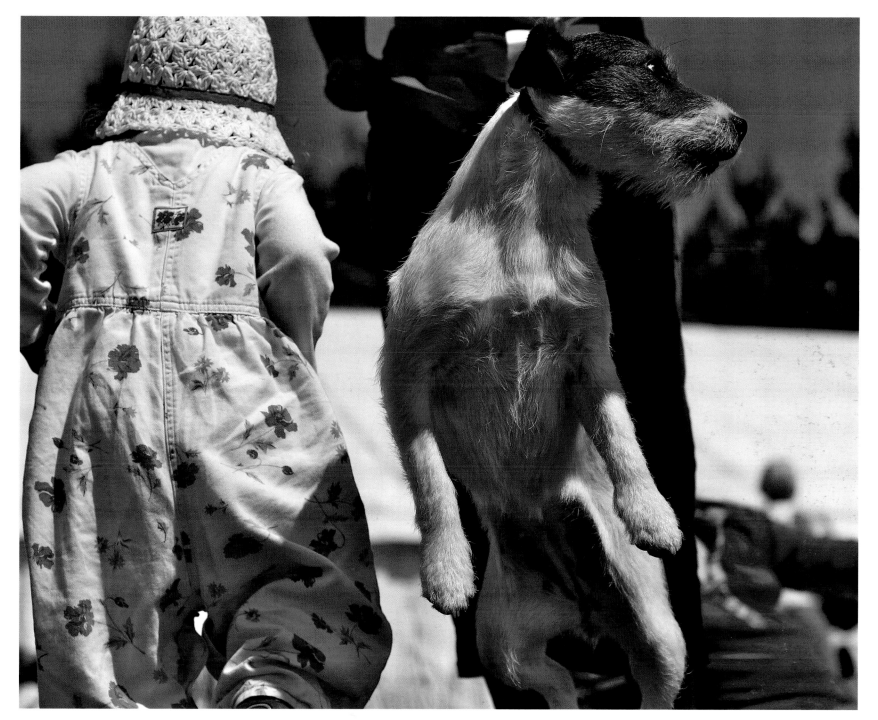

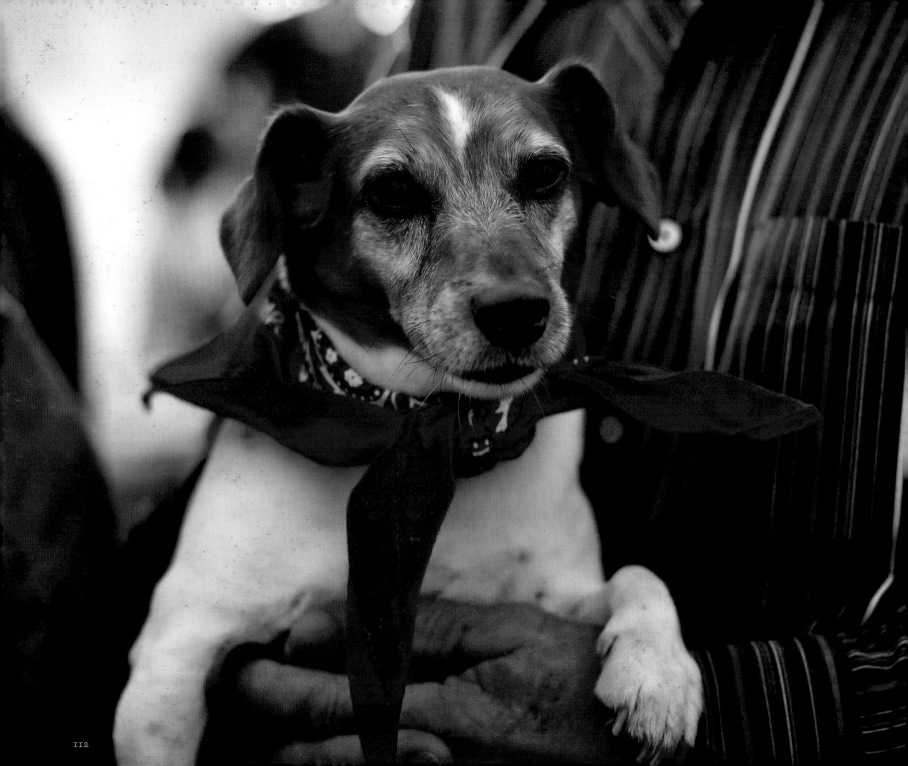

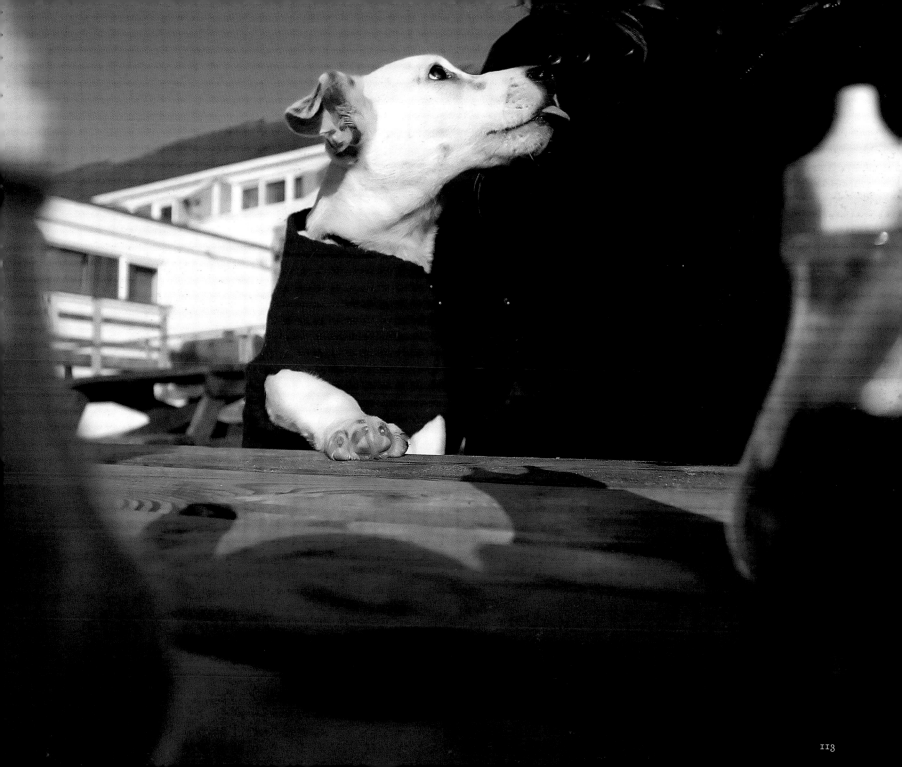

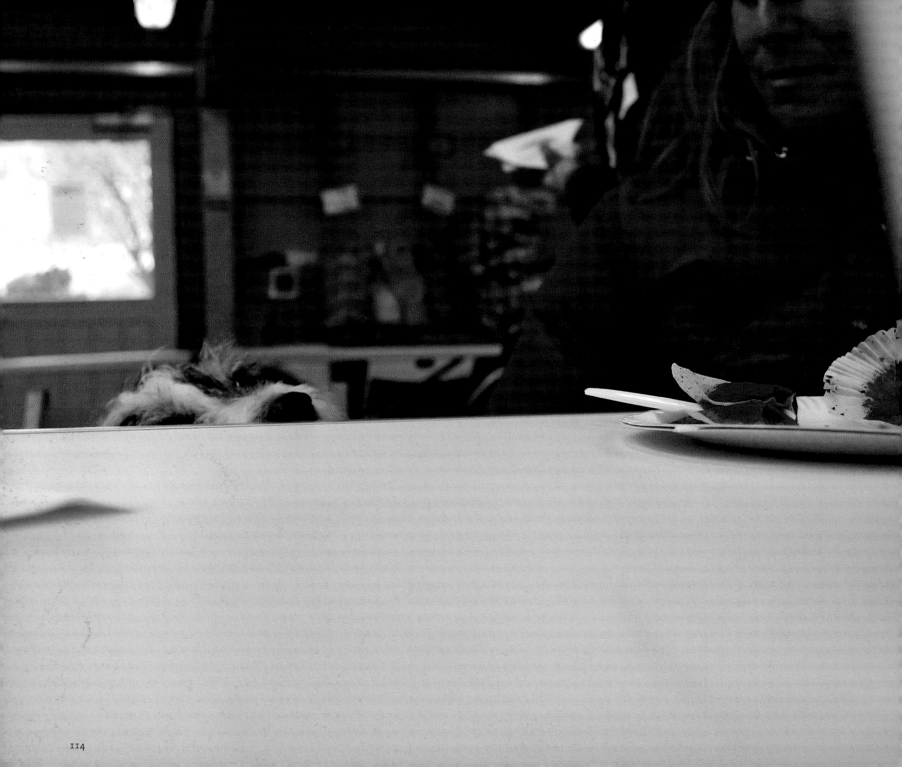

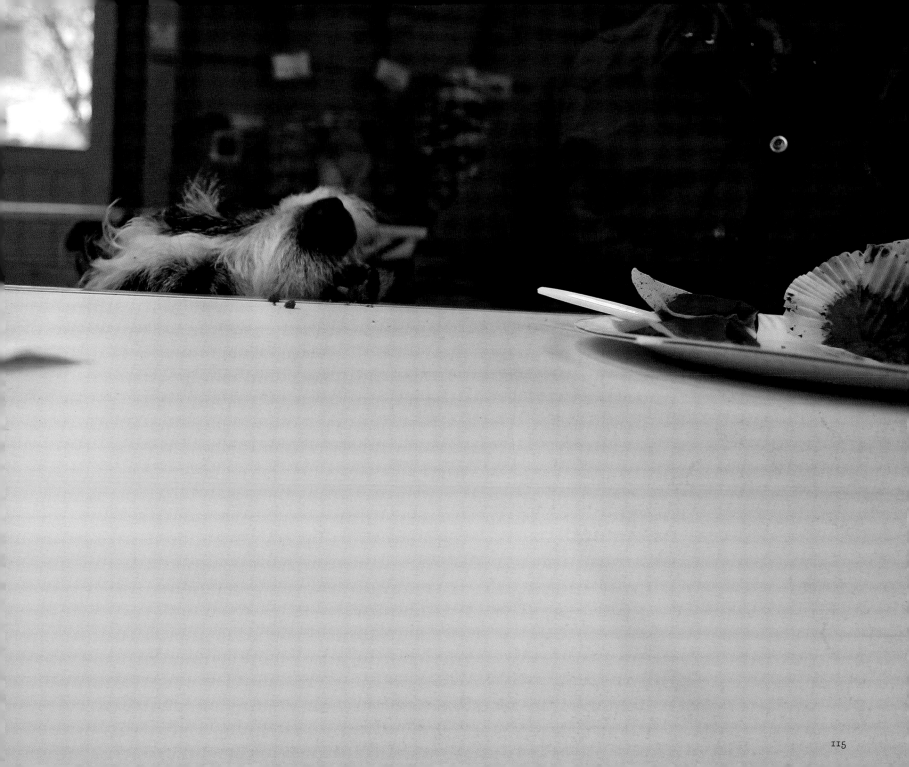

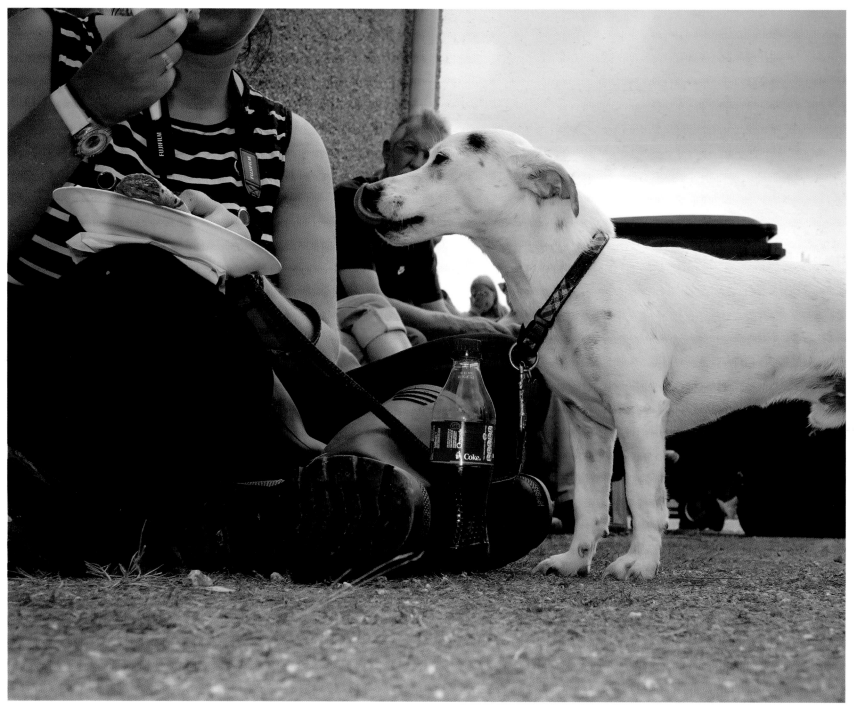

As we see the world, the dog smells it. The dog's universe is a stratum of complex odors. The world of scents is at least as rich as the world of sight.

A HOROWITZ

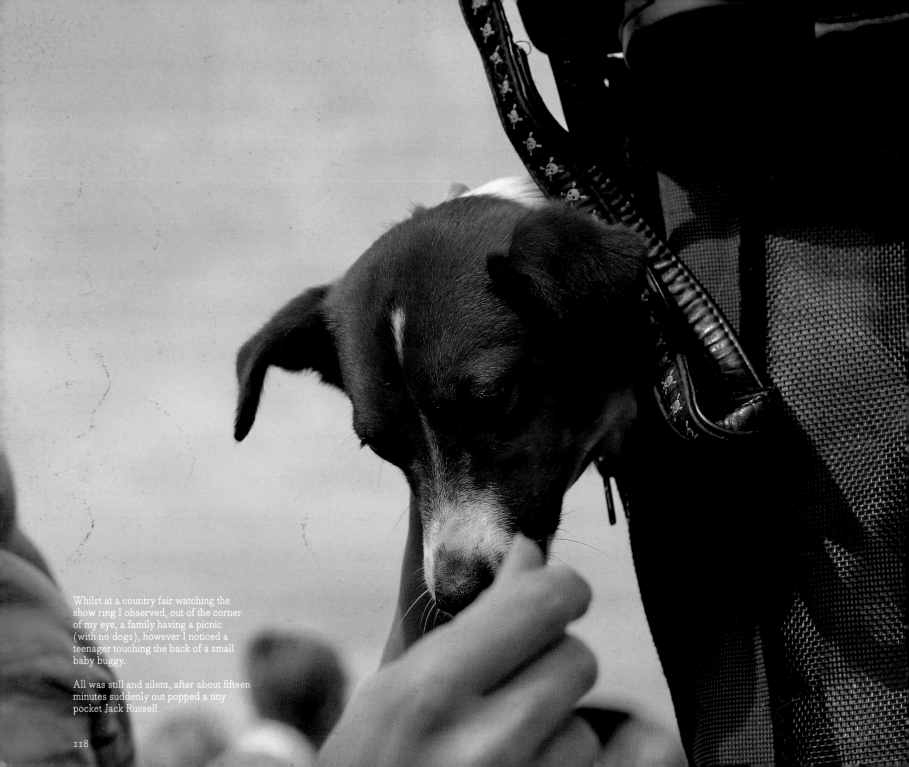

Whilst at a country fair watching the show ring I observed, out of the corner of my eye, a family having a picnic (with no dogs), however I noticed a teenager touching the back of a small baby buggy.

All was still and silent, after about fifteen minutes suddenly out popped a tiny pocket Jack Russell.

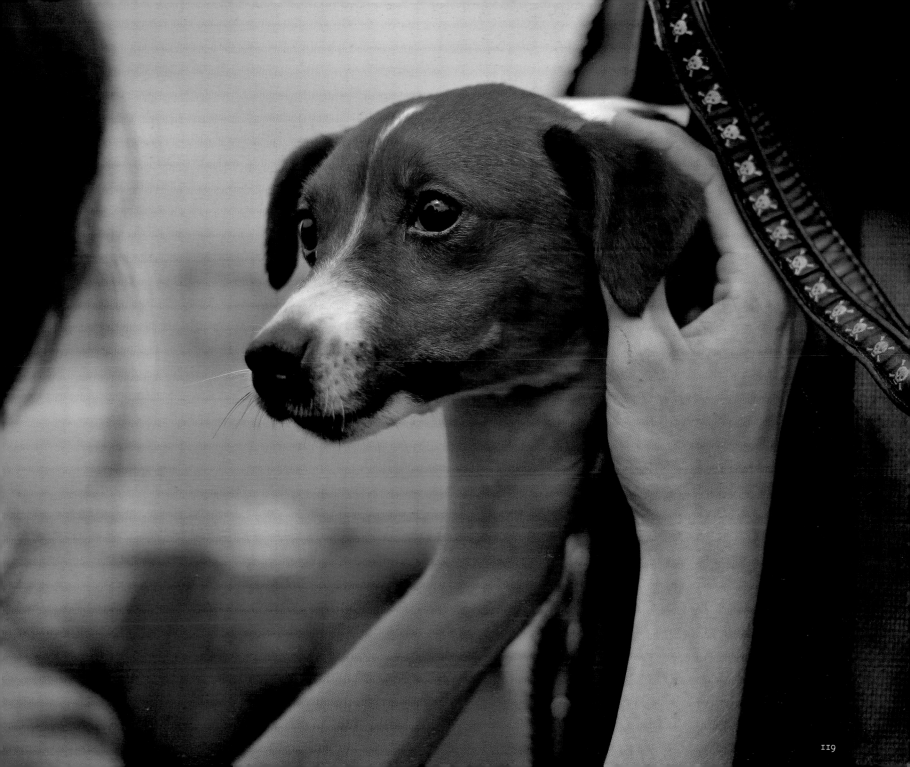

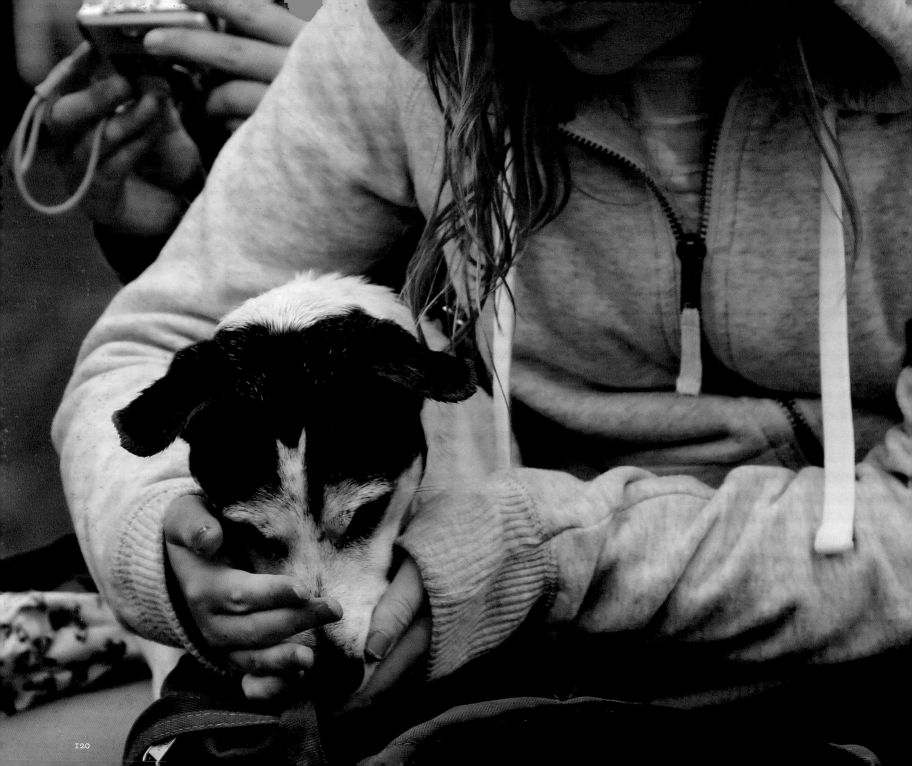

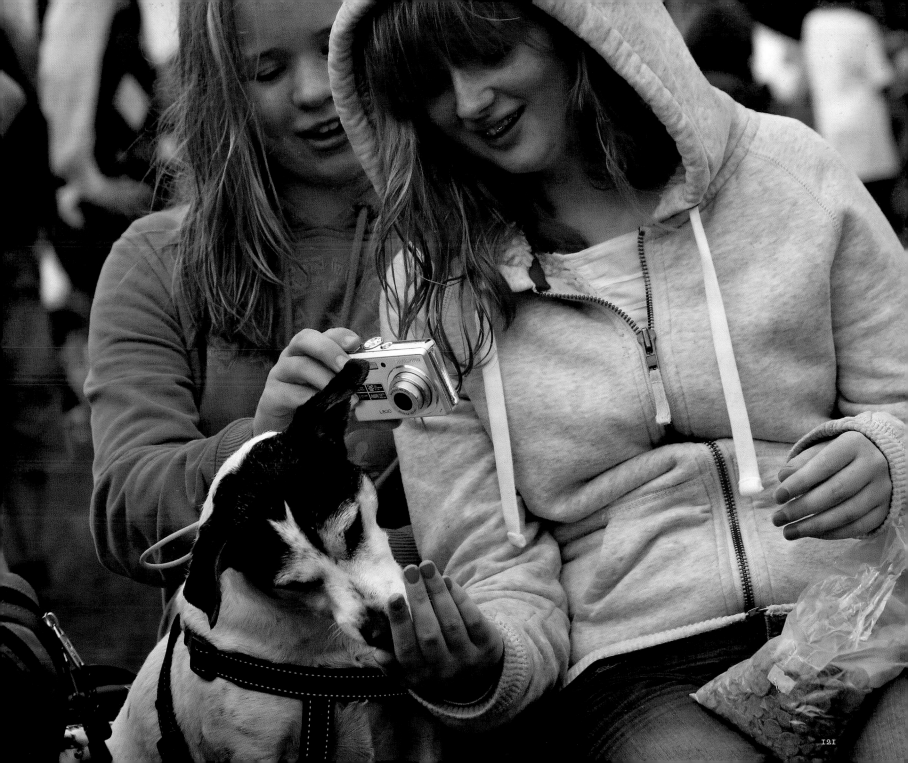

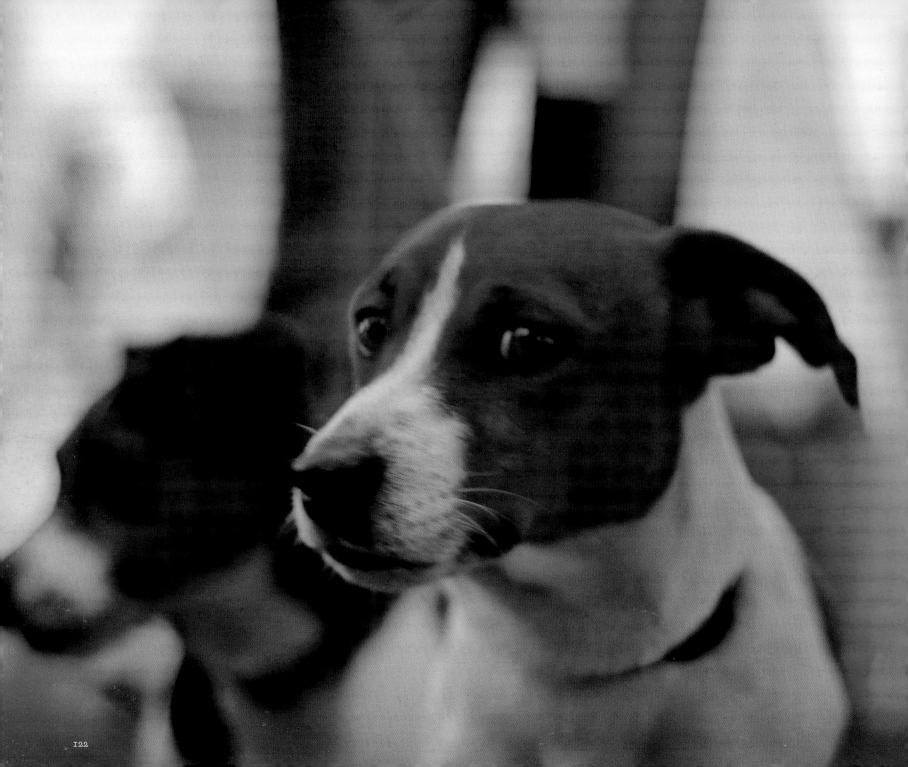

The natural history of the dog eye, seen in the story of their forebears, wolves, explains the context in which their vision evolved. It is a happy and transformative side effect that this has made them good watchers of human beings.

A HOROWITZ

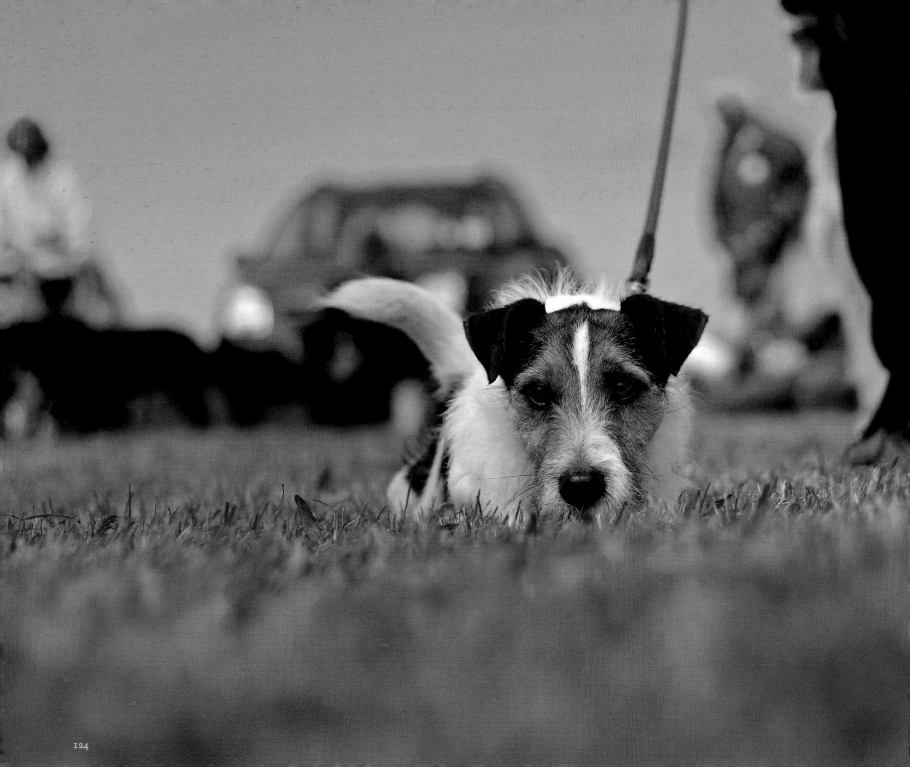

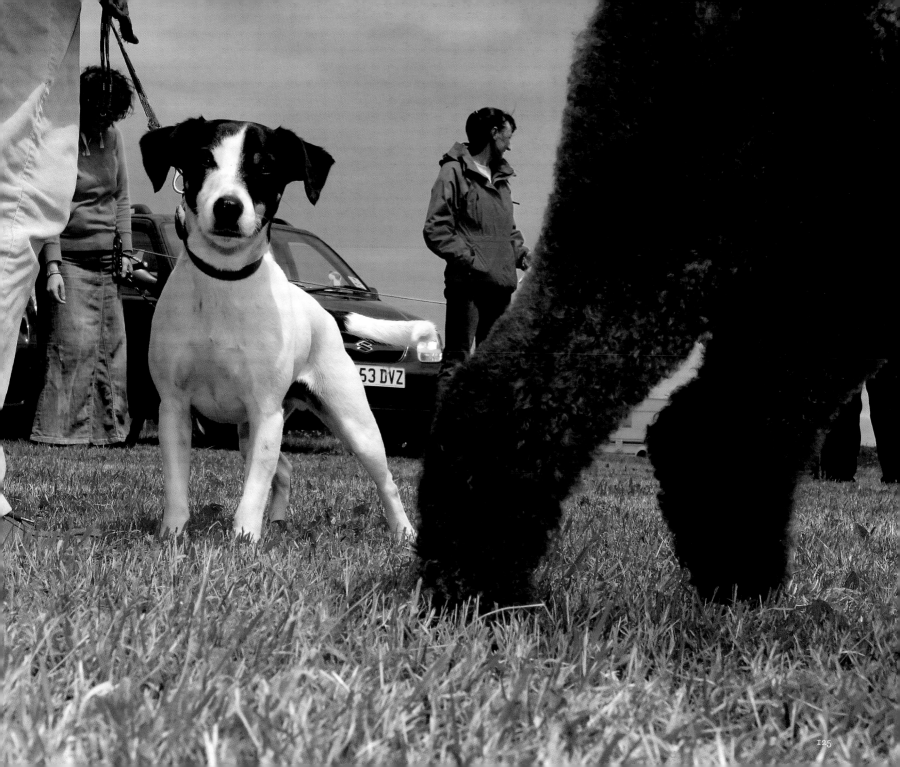

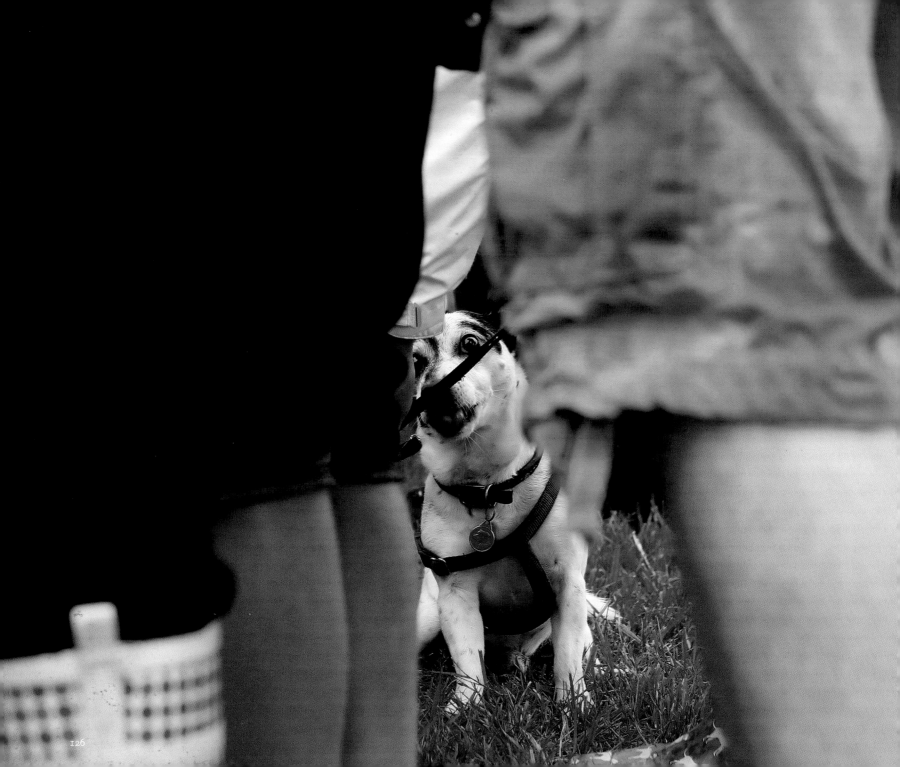

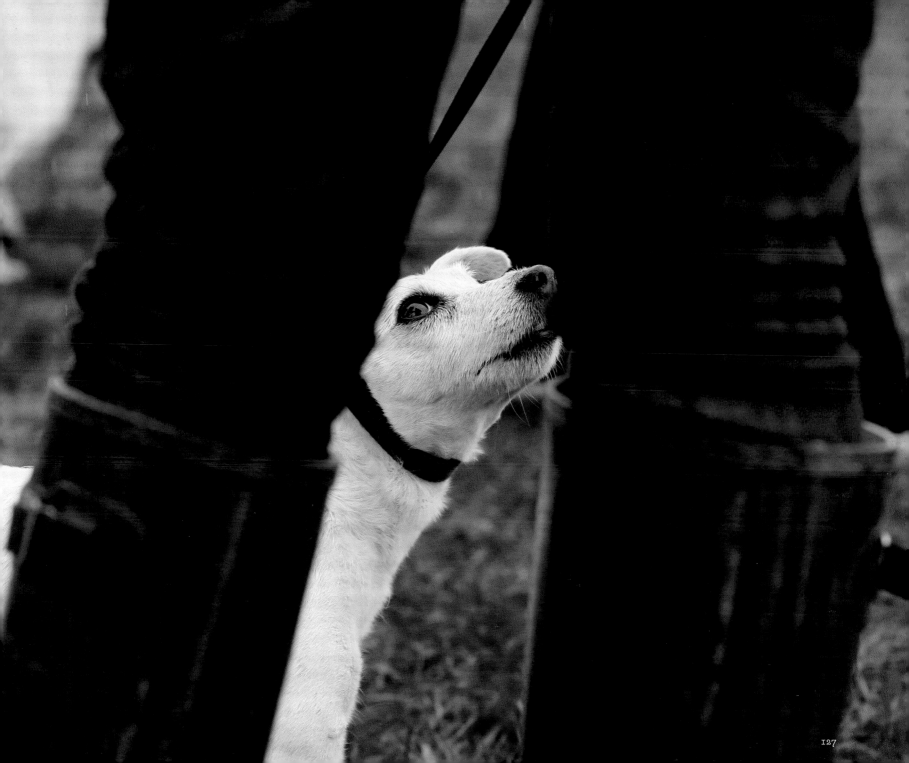

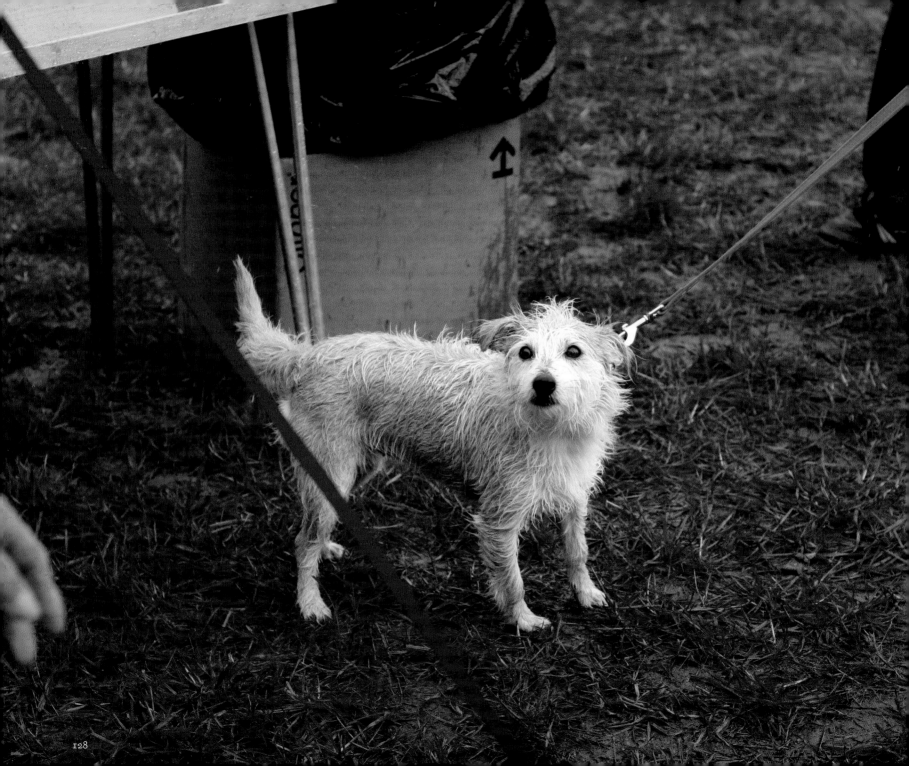

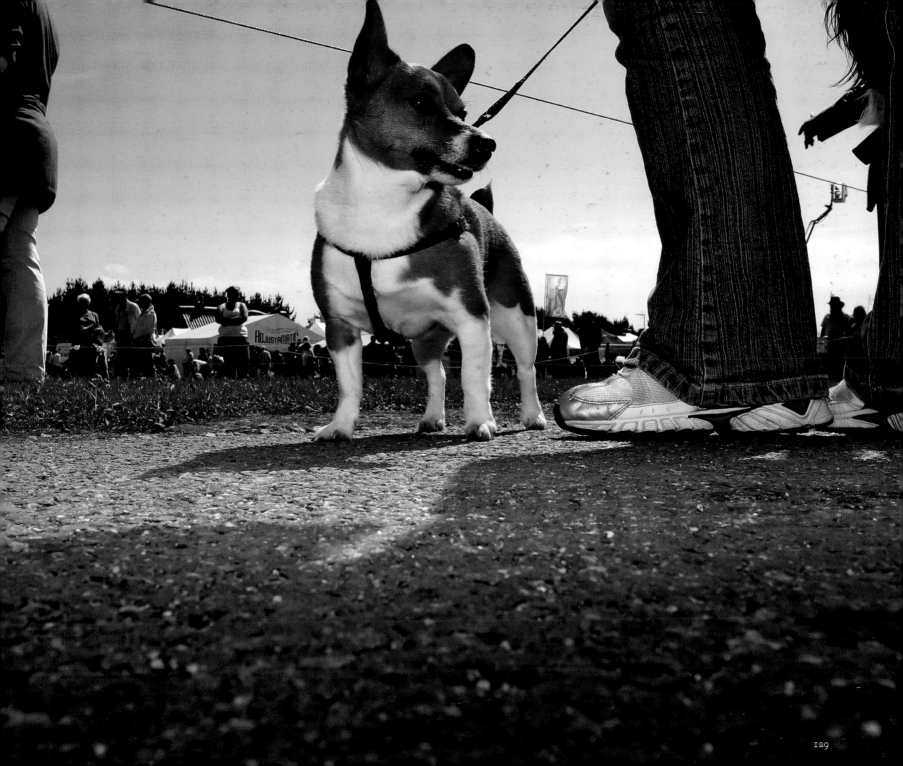

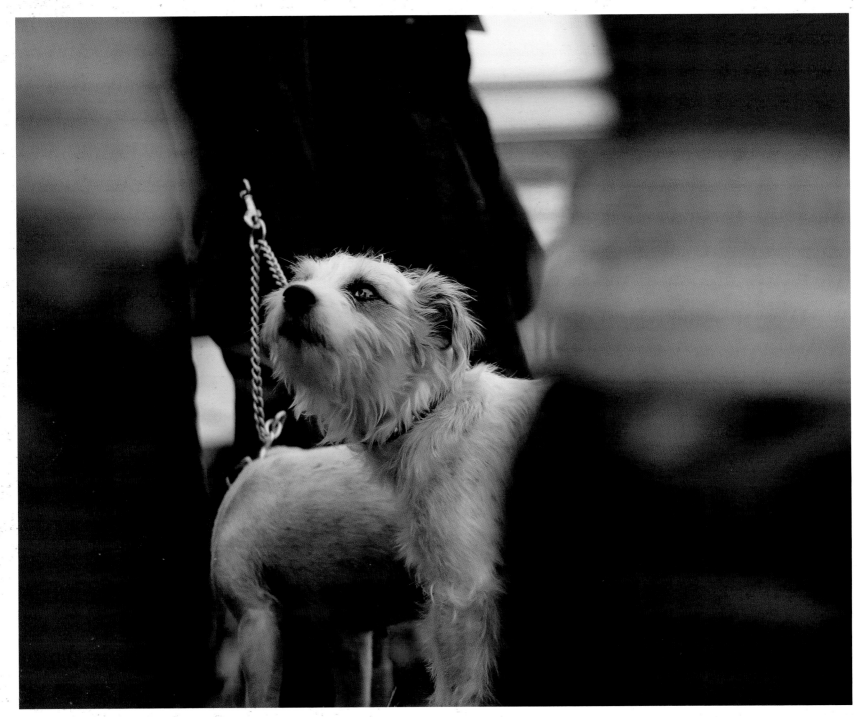

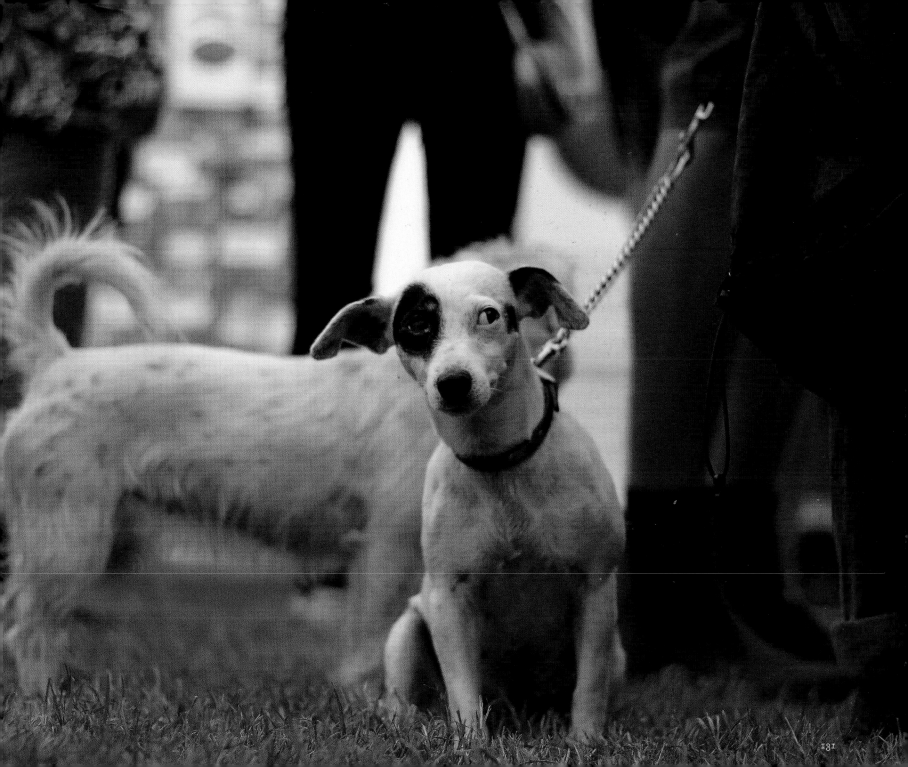

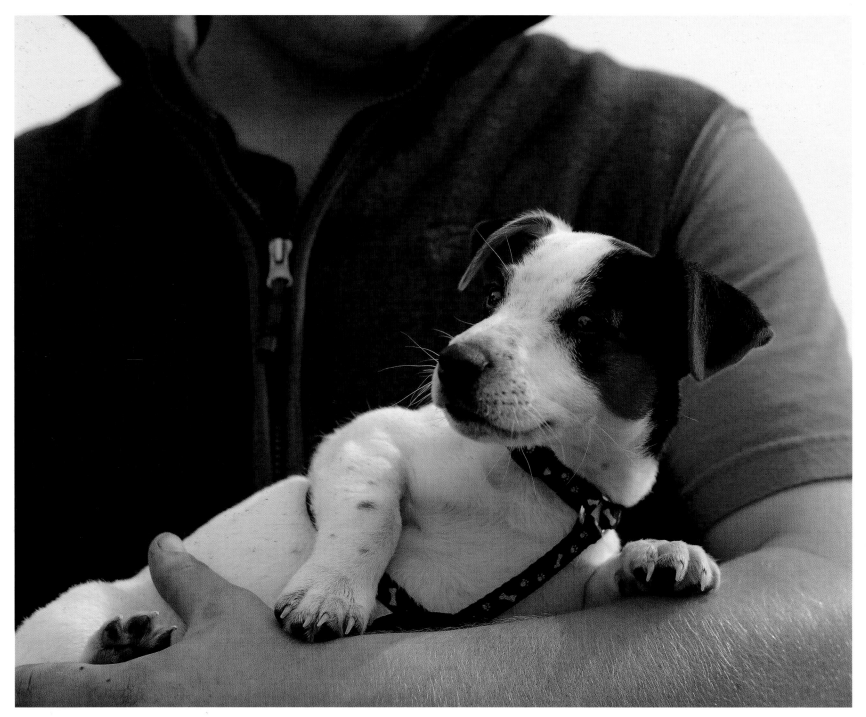

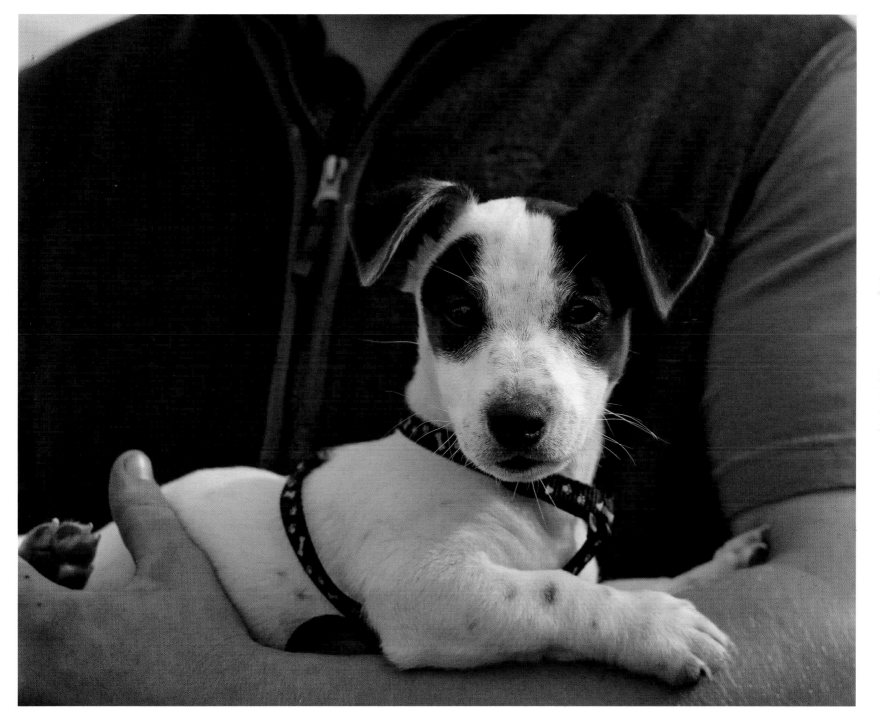

Often when I ask to photograph a dog
their owners lift them up, just like a proud
parent showing off their child.

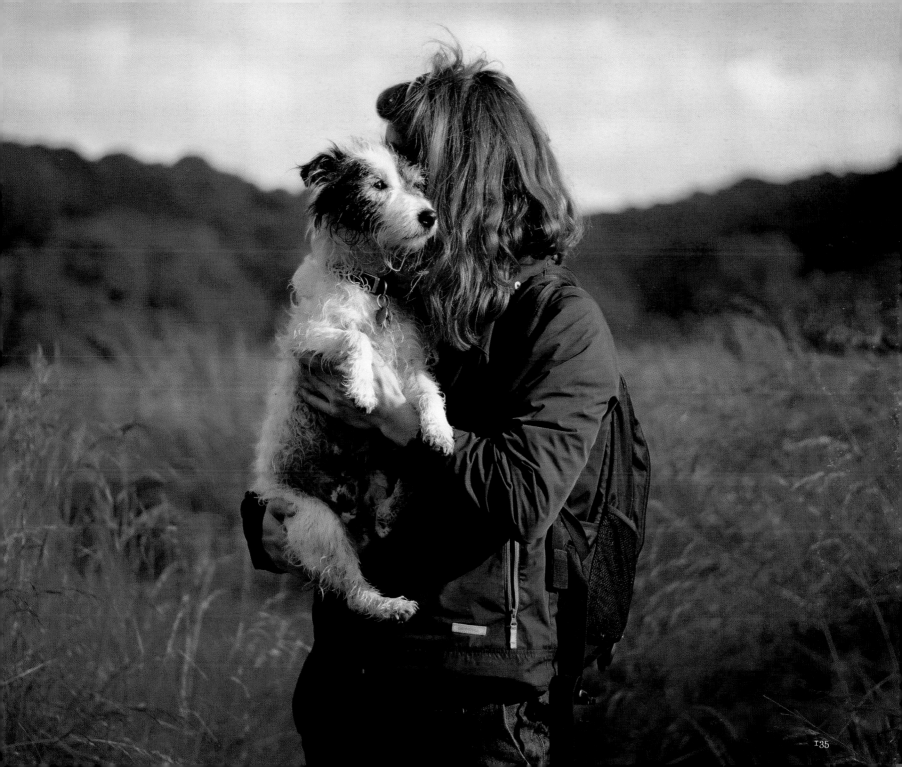

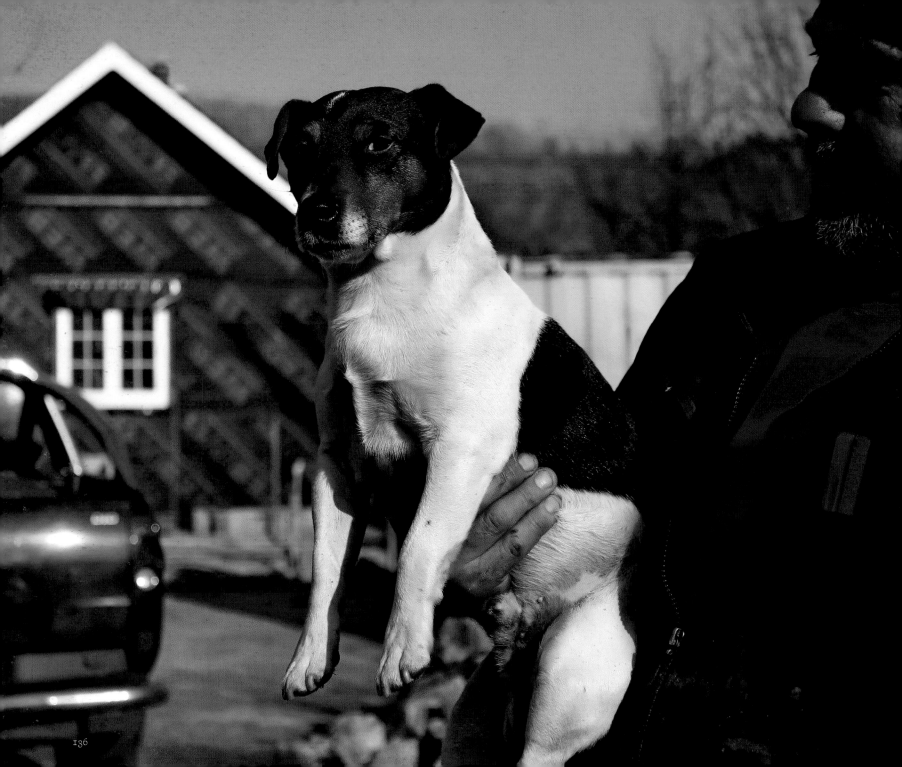

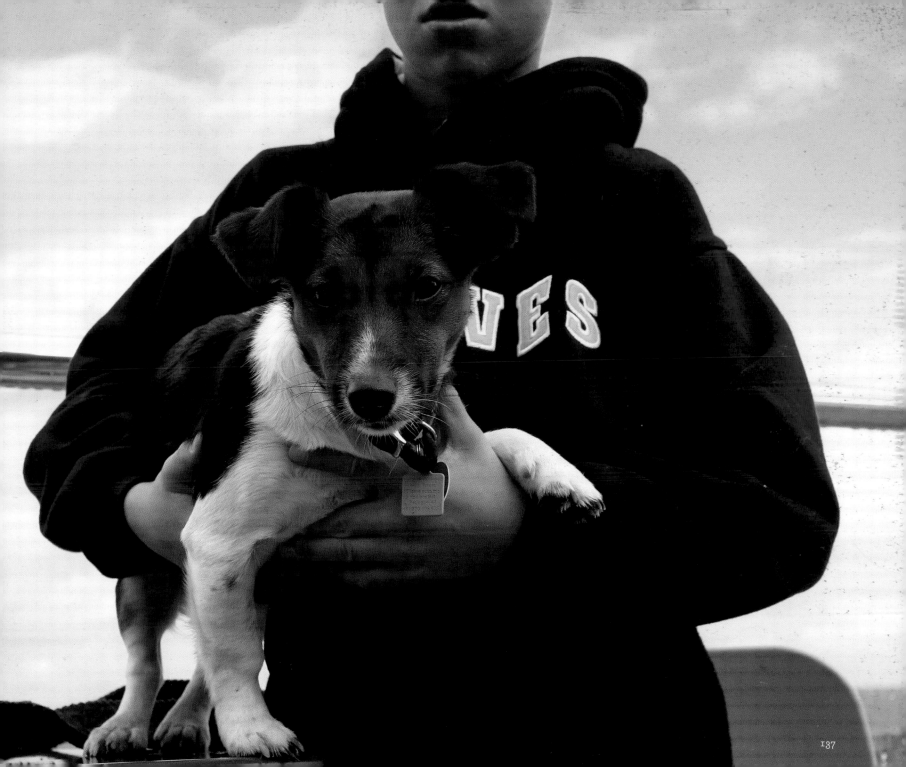

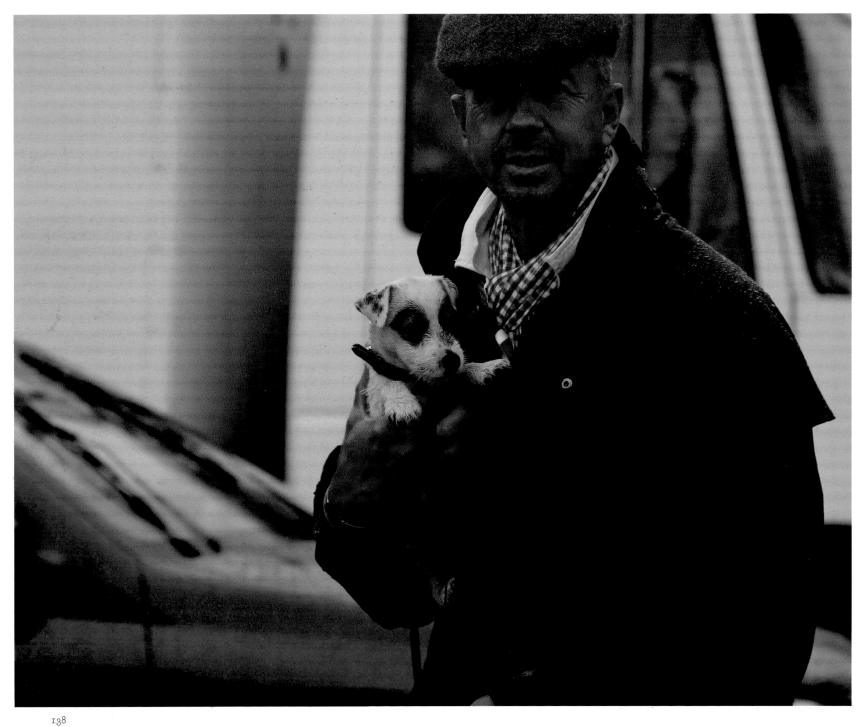

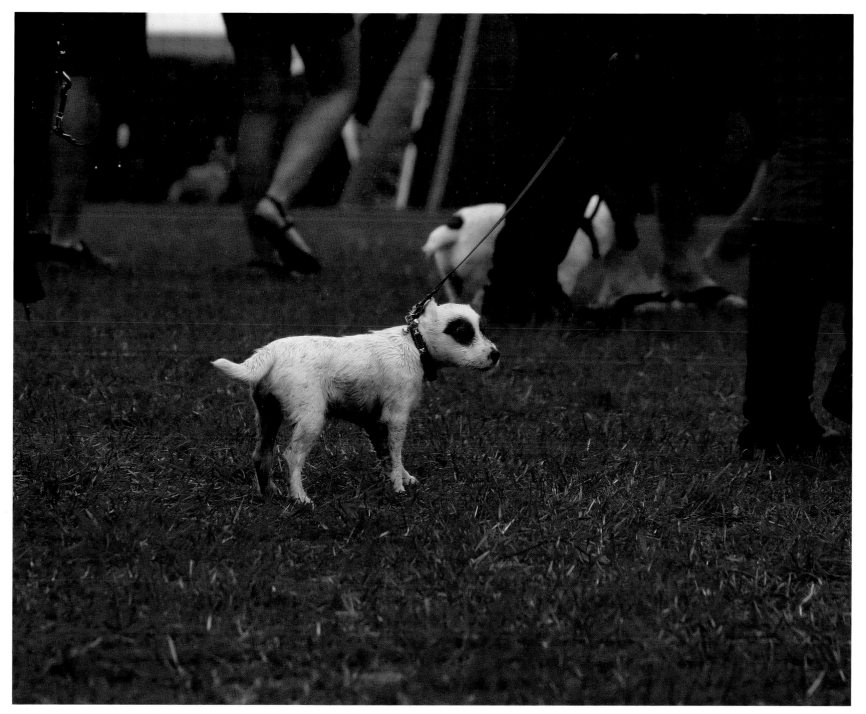

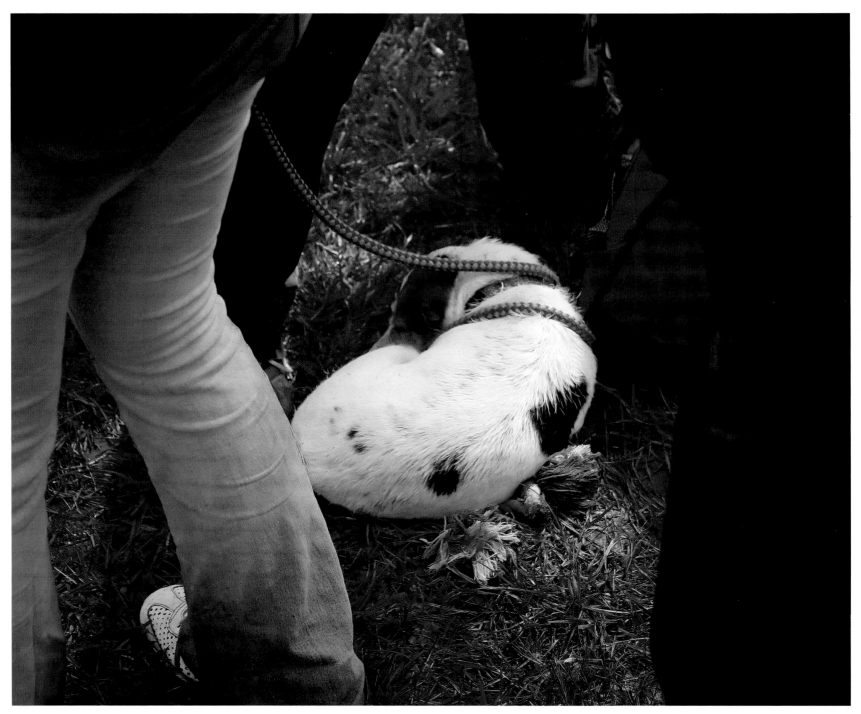

140

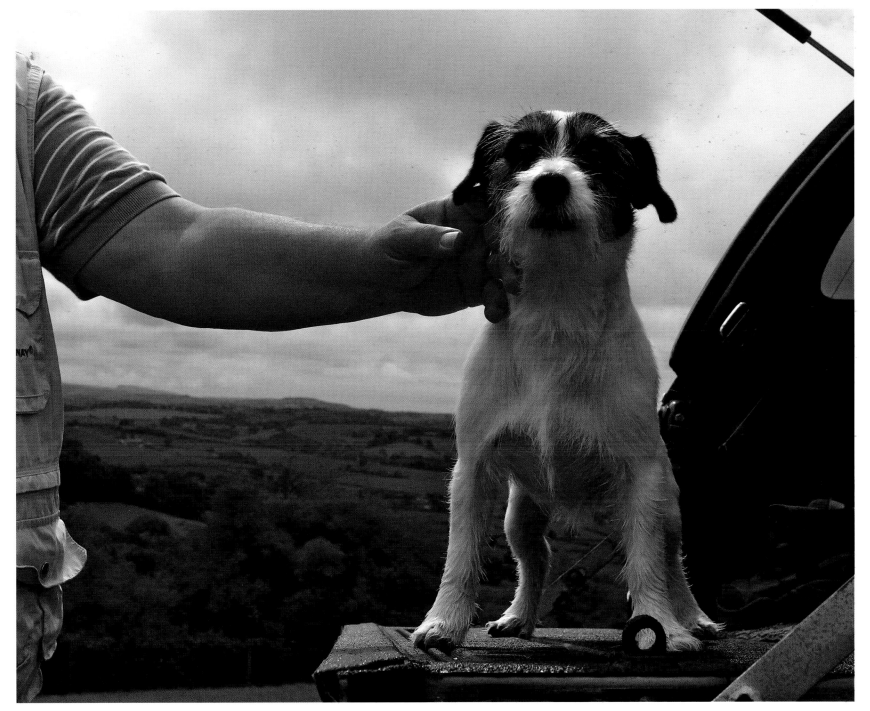

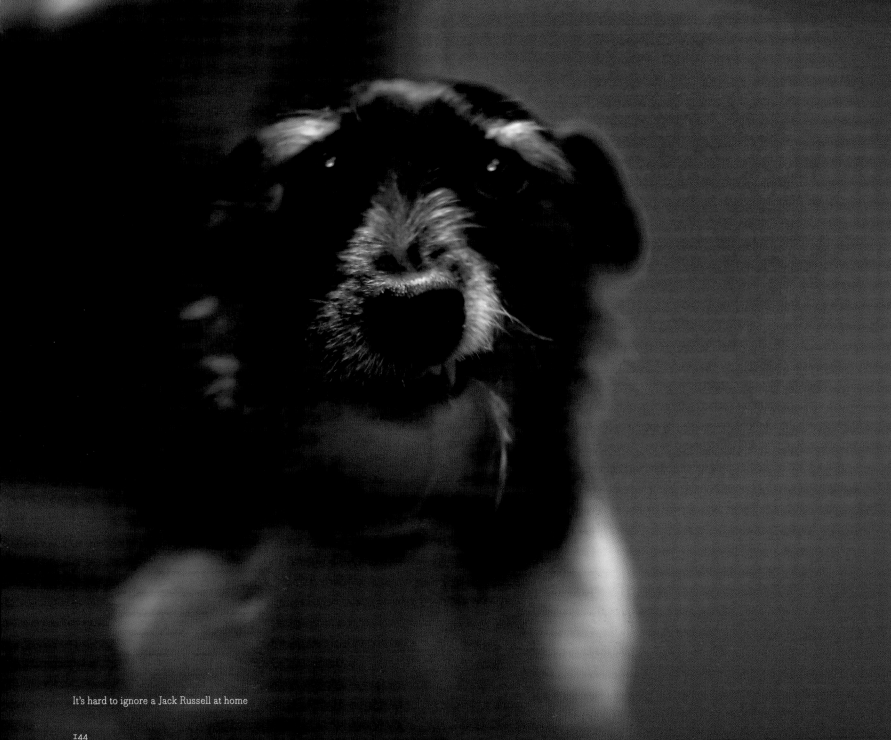

It's hard to ignore a Jack Russell at home

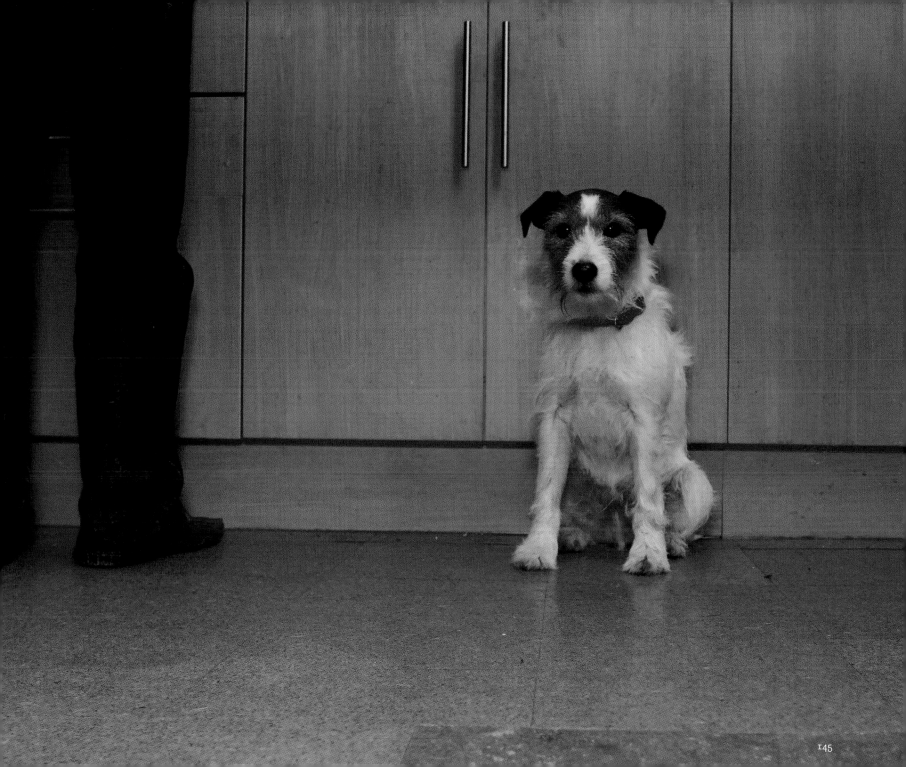

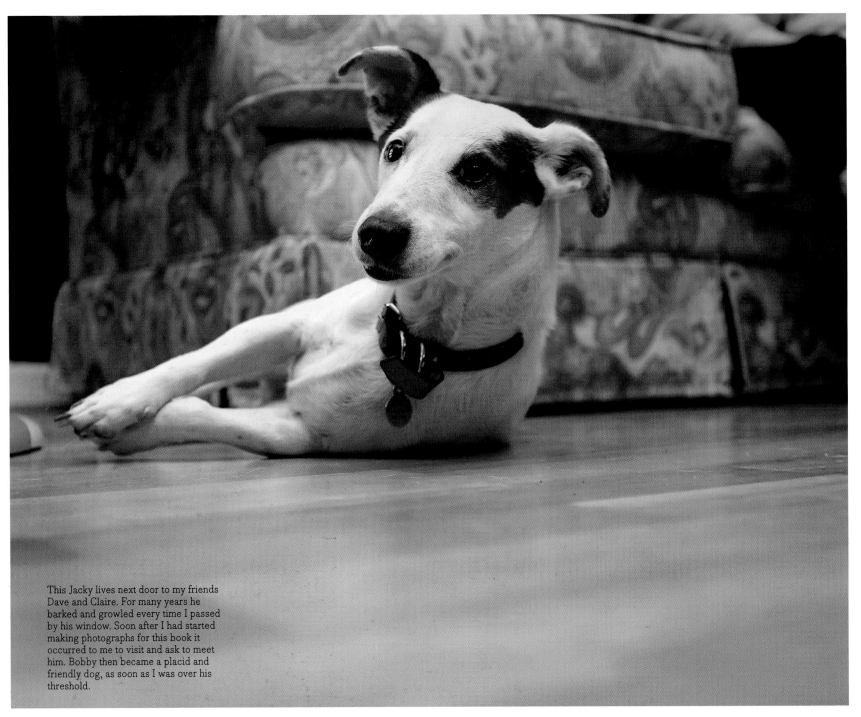

This Jacky lives next door to my friends Dave and Claire. For many years he barked and growled every time I passed by his window. Soon after I had started making photographs for this book it occurred to me to visit and ask to meet him. Bobby then became a placid and friendly dog, as soon as I was over his threshold.

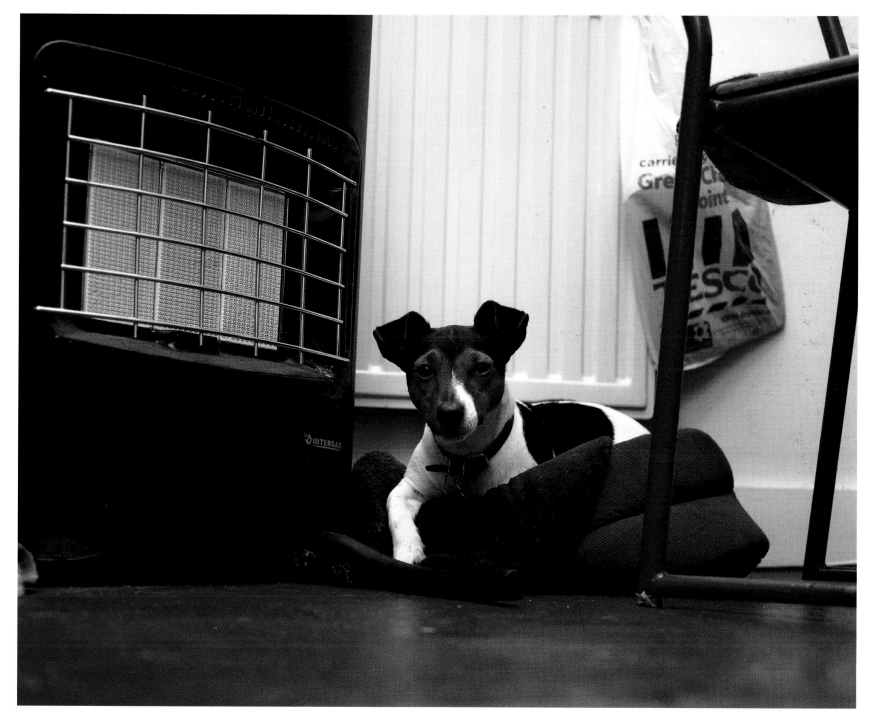

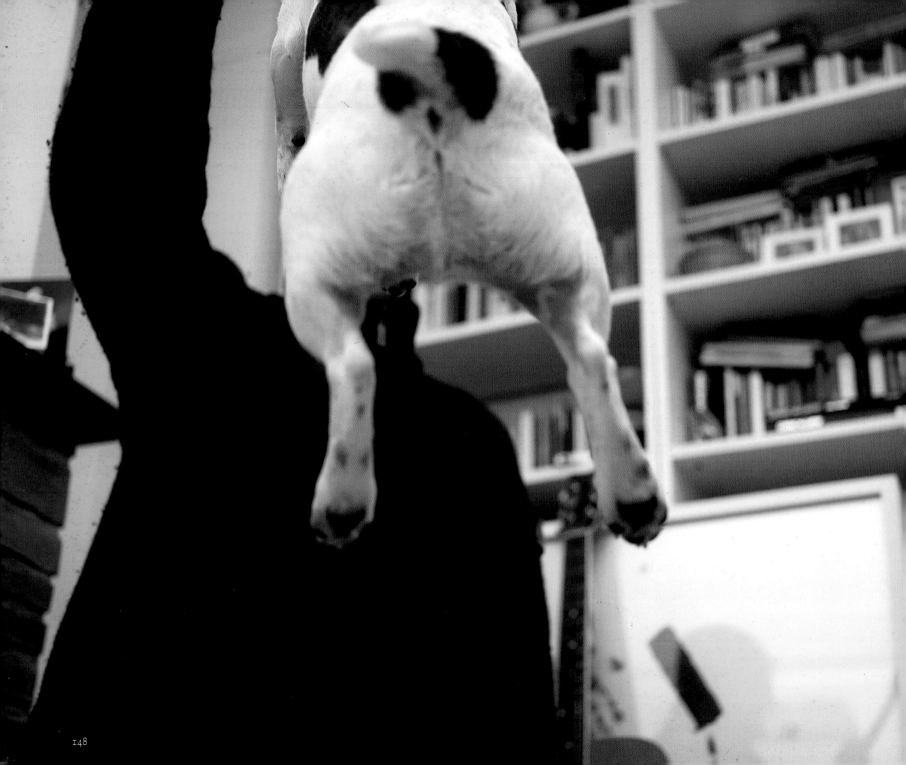

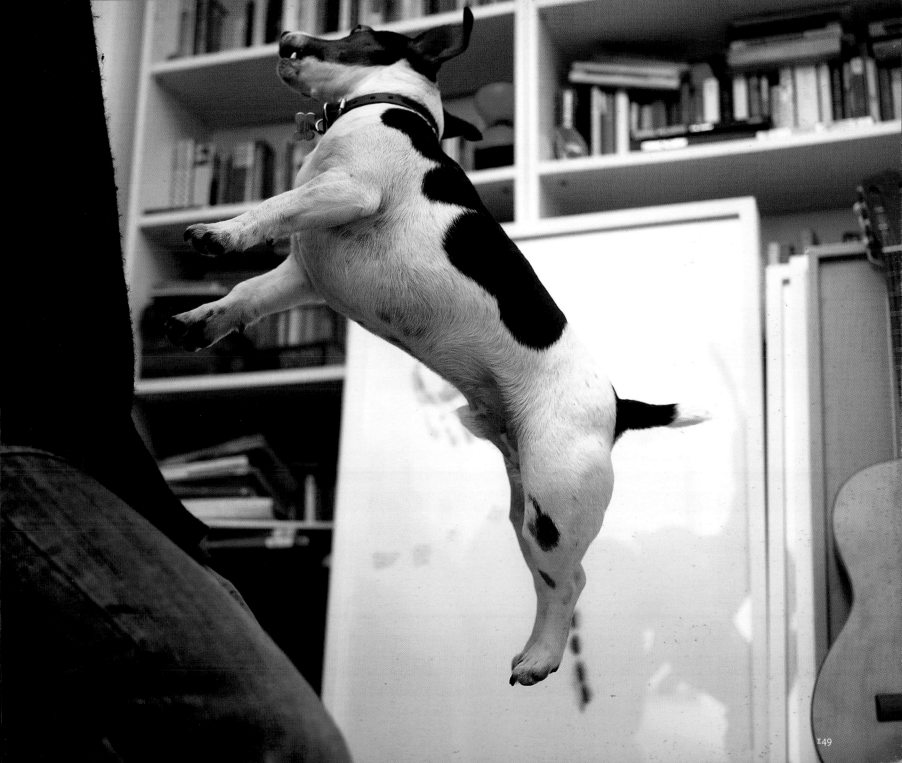

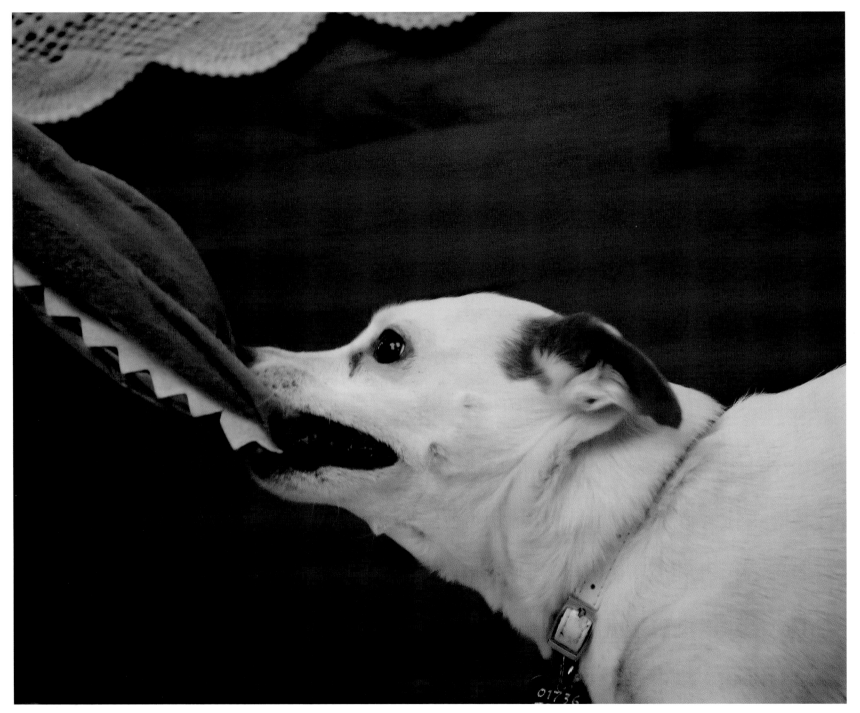

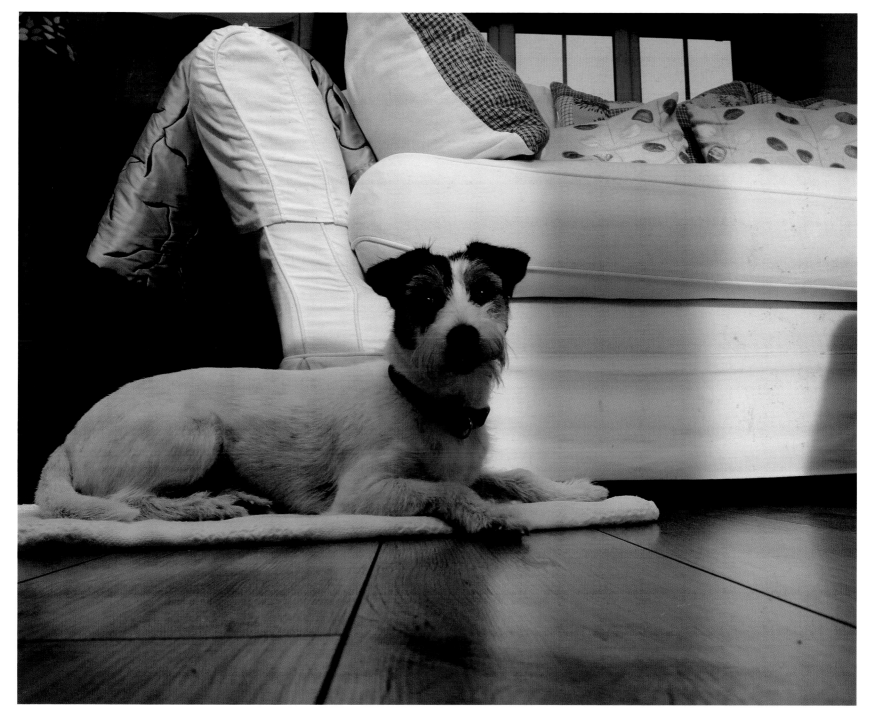

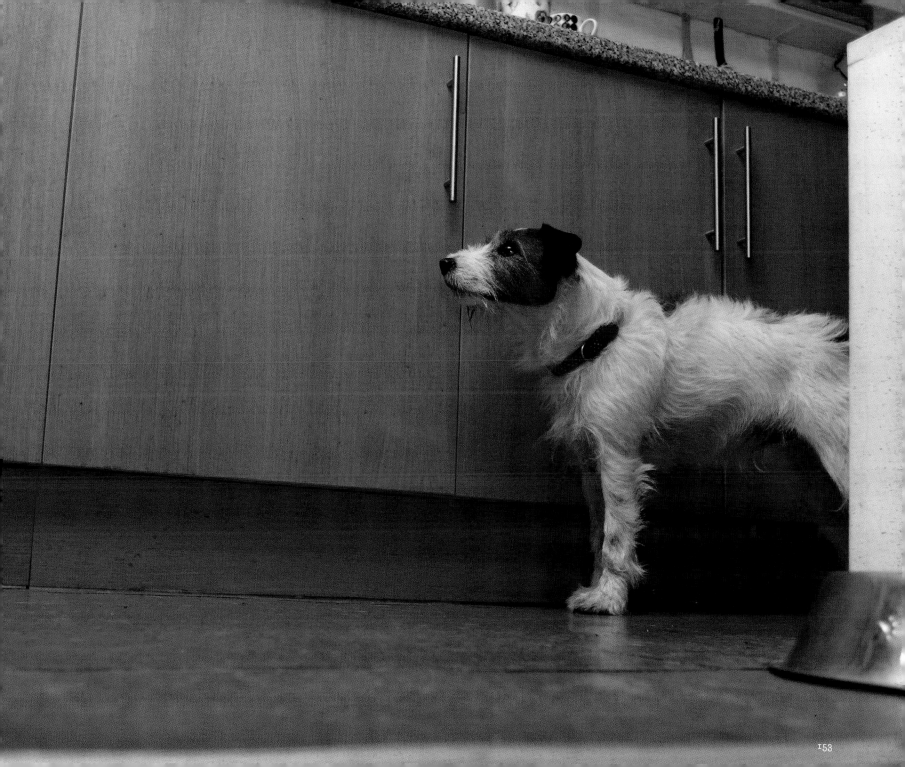

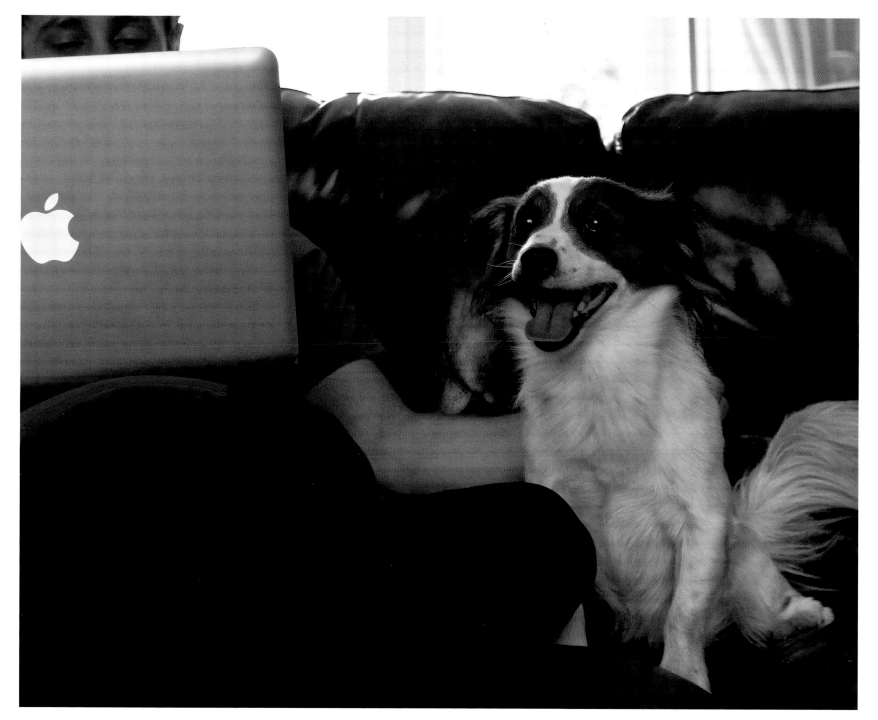

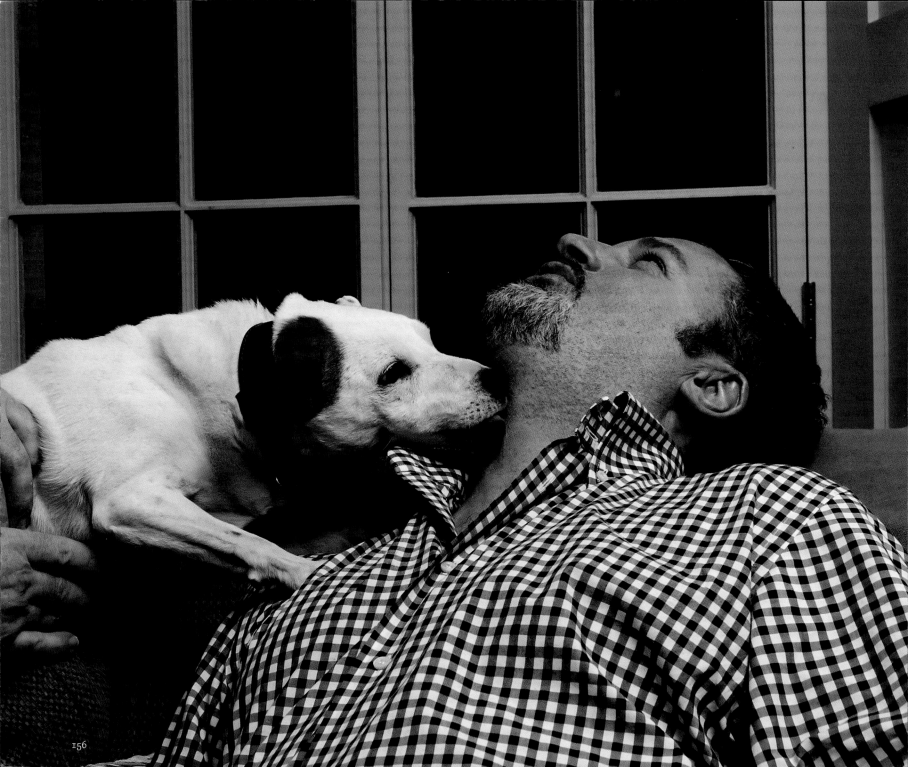

Furthermore, our mouths taste great to dogs. Like wolves and humans, dogs have taste receptors for salty, sweet, bitter, sour, and even umami, the earthy, mushroomy-seaweedy flavour captured in the flavour-heightening monosodium glutamate.

A HOROWITZ

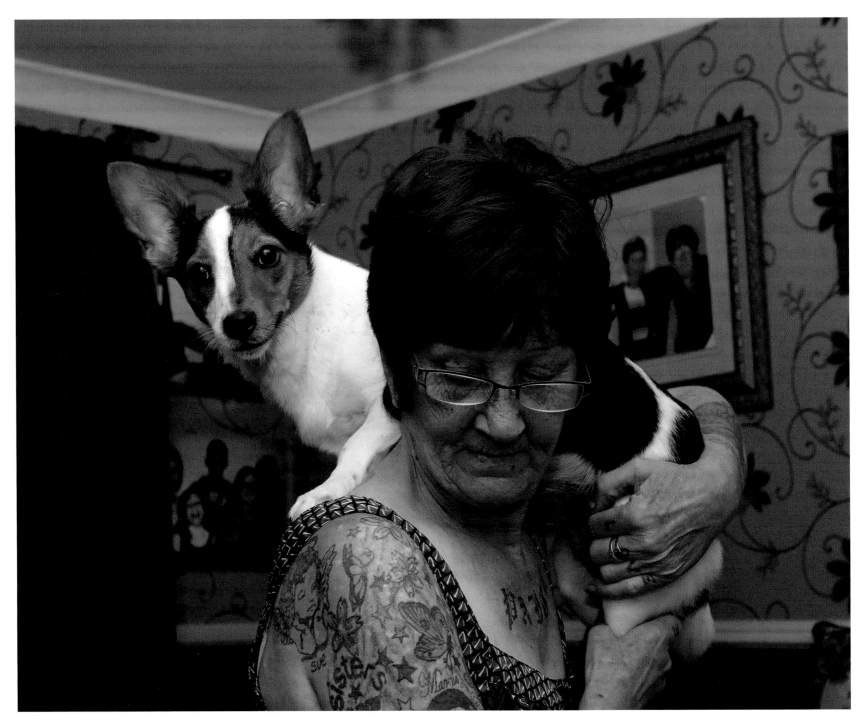

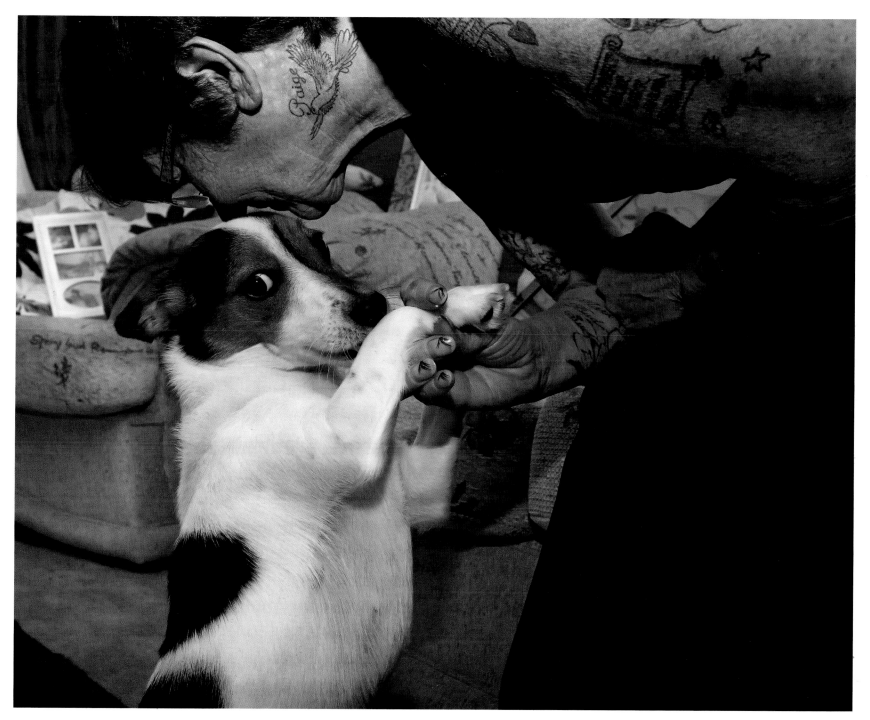

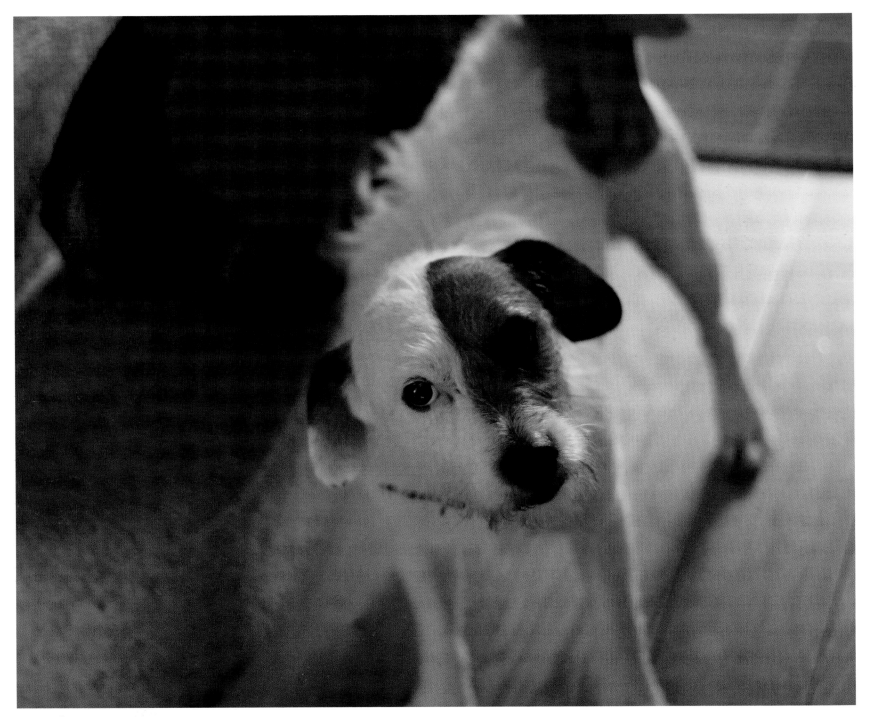

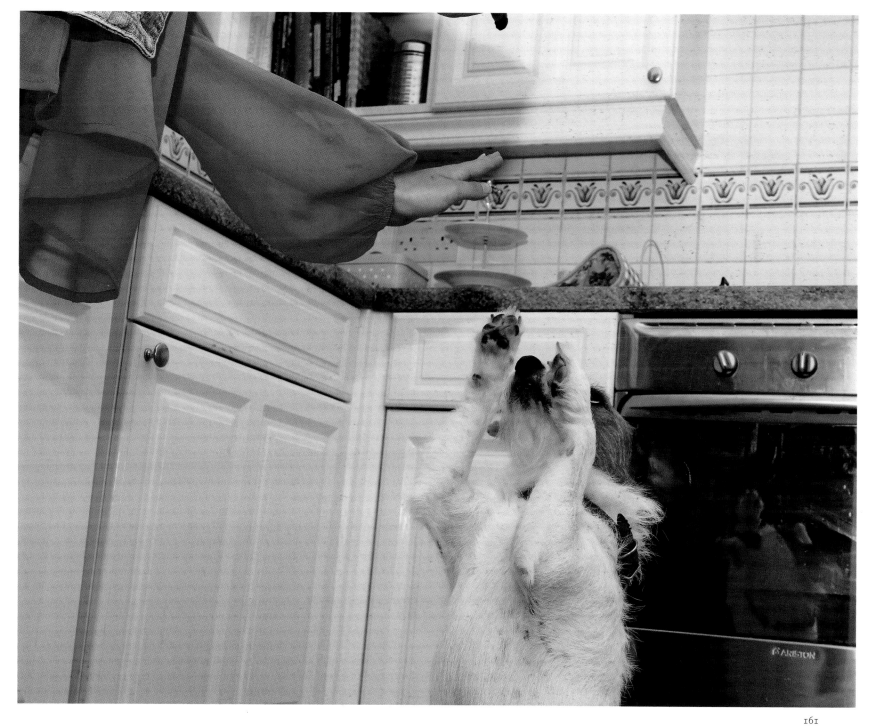

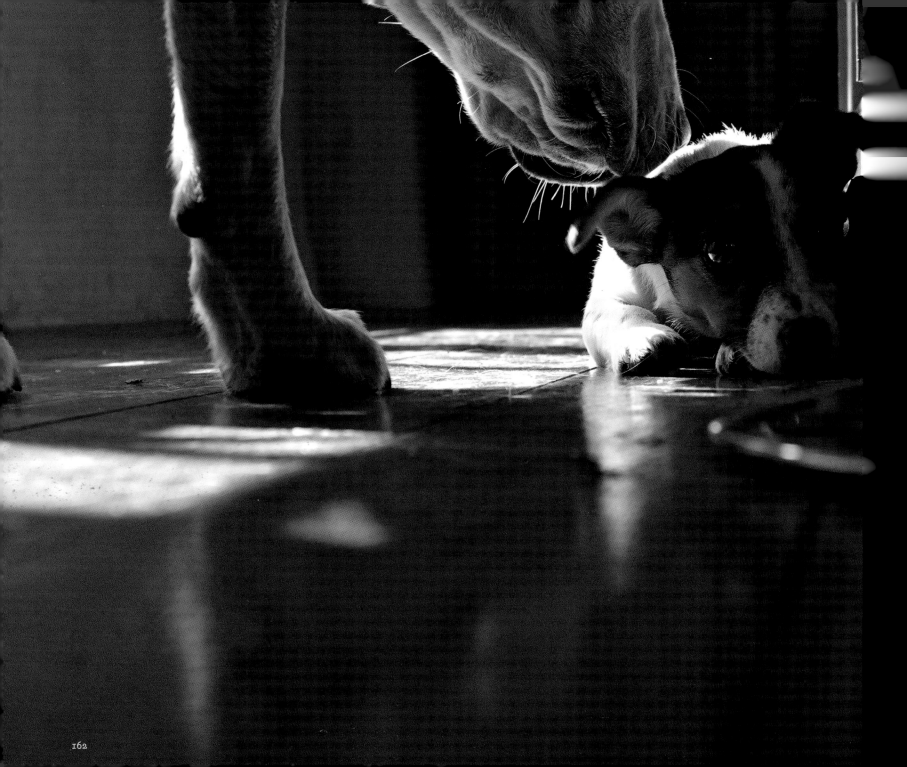

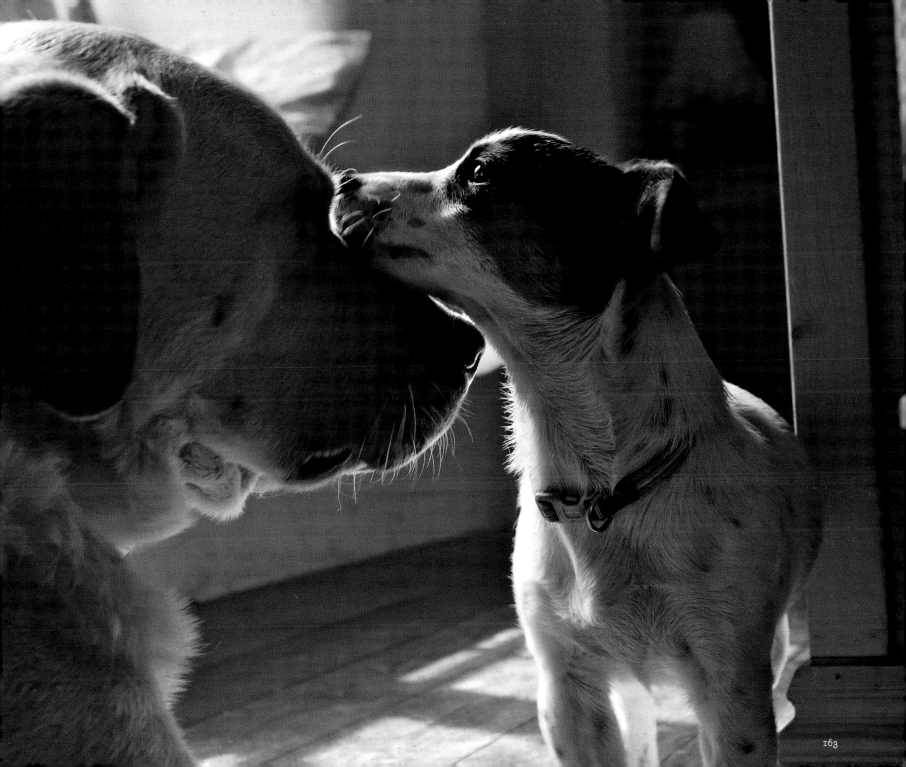

When a dog turns his head towards you, it
is not so much to look at you with his eyes;
rather, it is to get his nose to look at you.
The eyes just come along for the ride.

A HOROWITZ

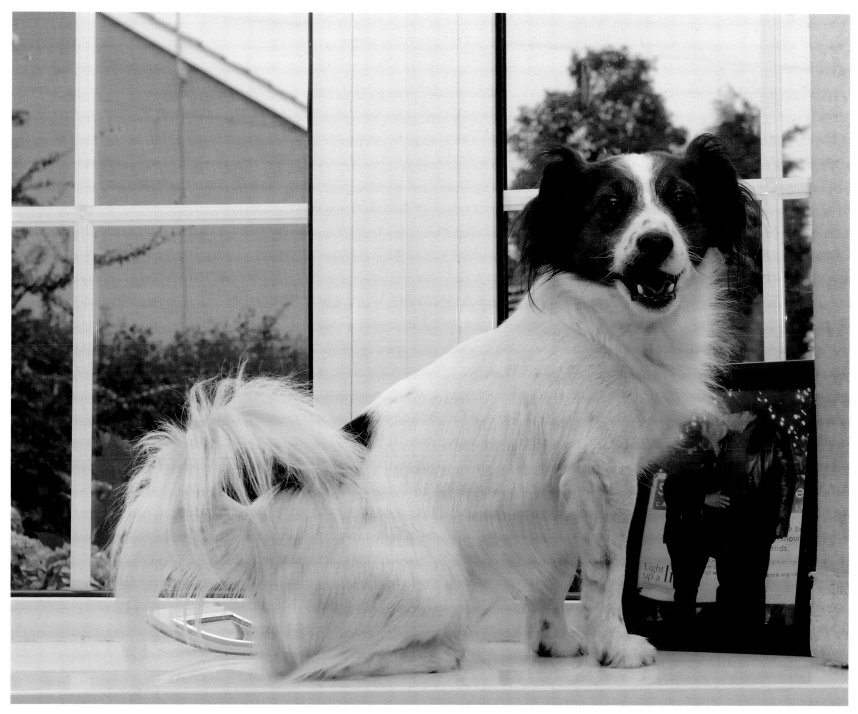

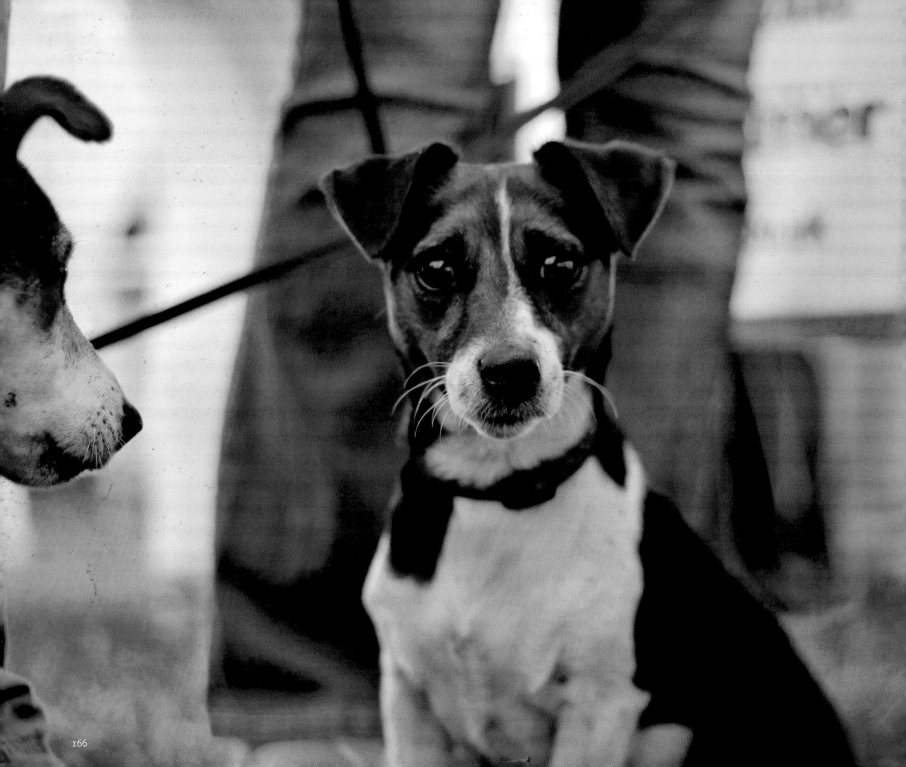

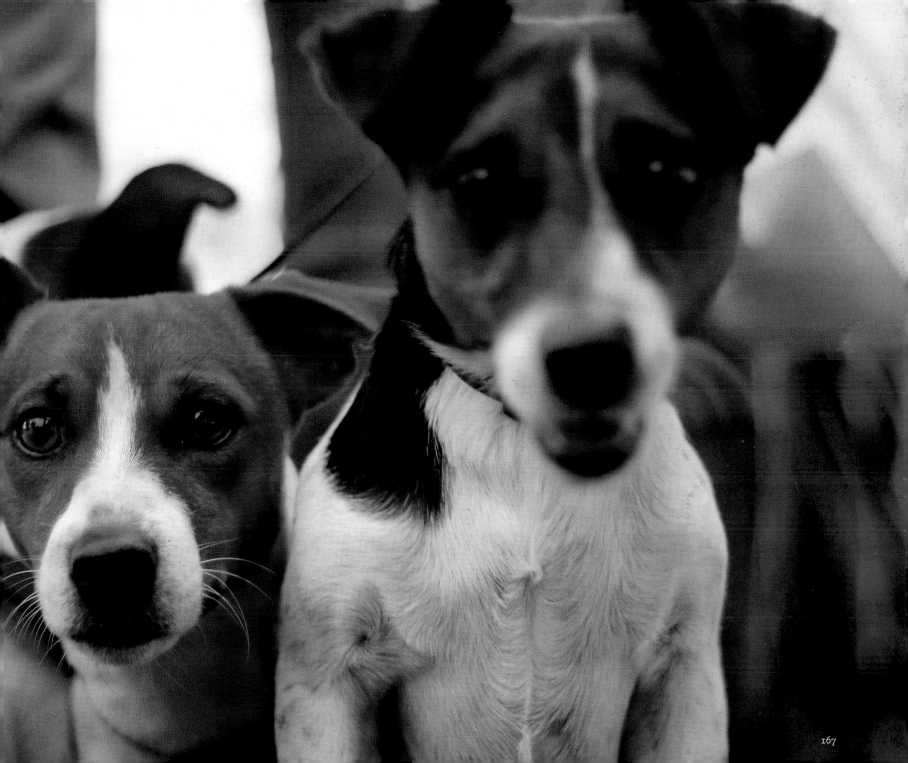

HAPPINESS IS OWNING A
JACK RUSSELL TERRIER

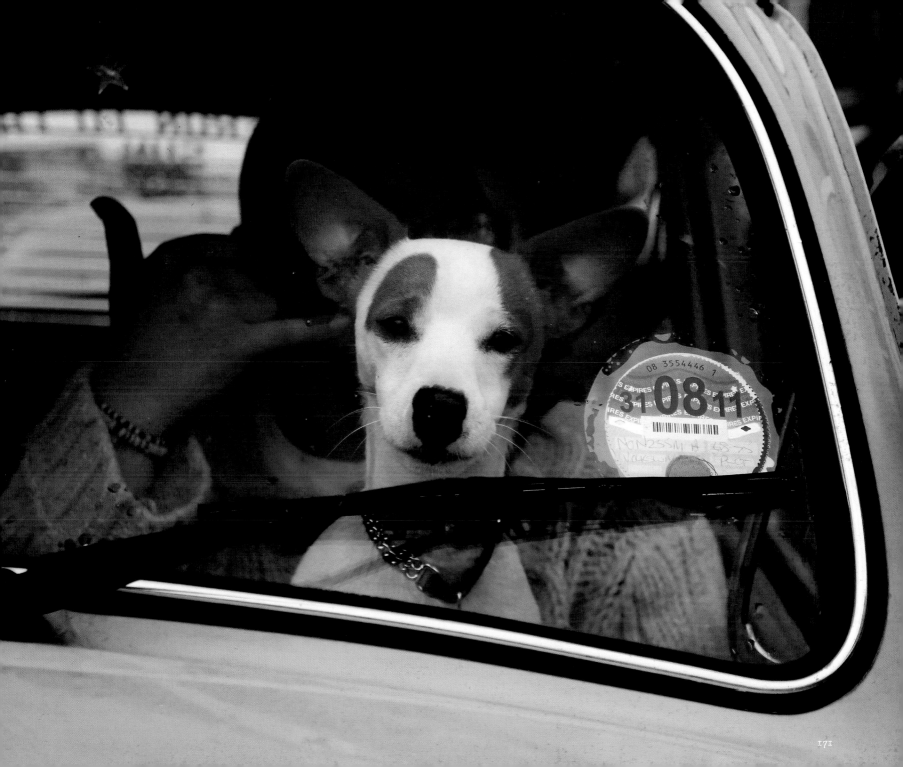

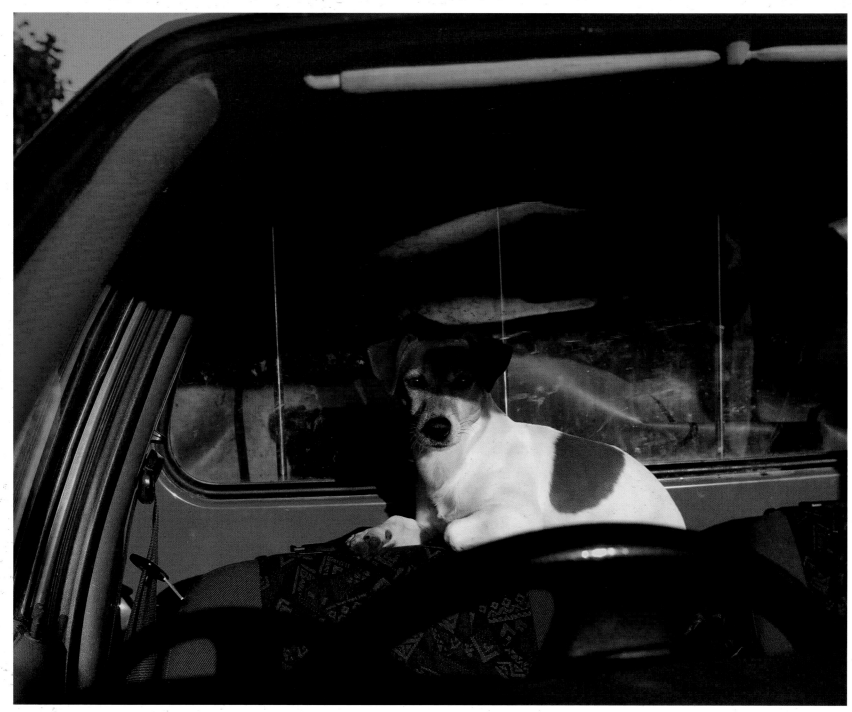

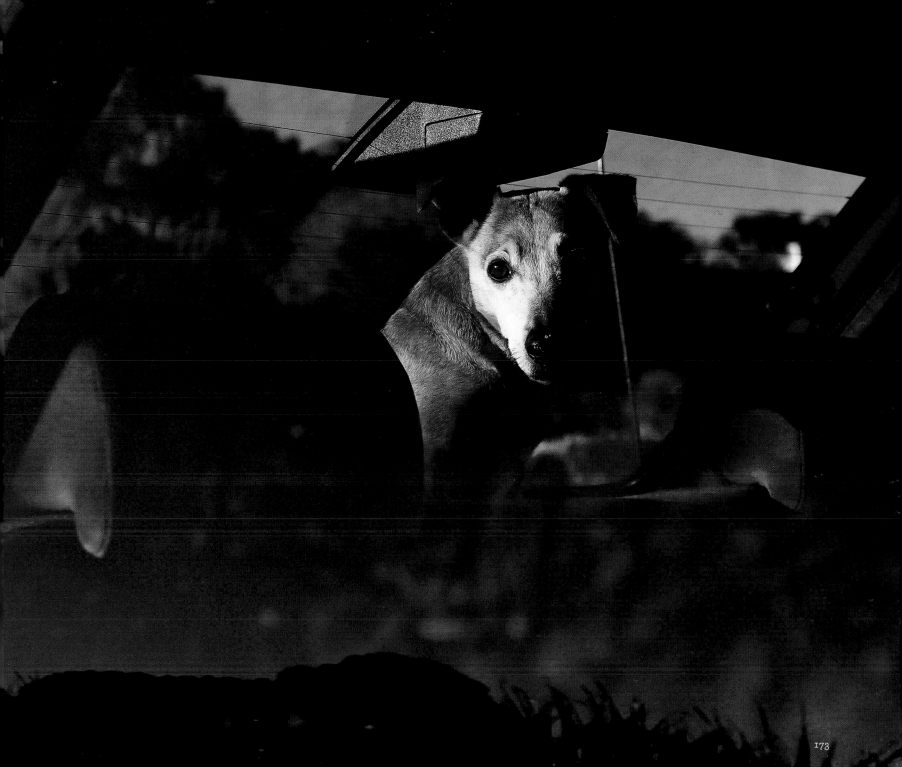

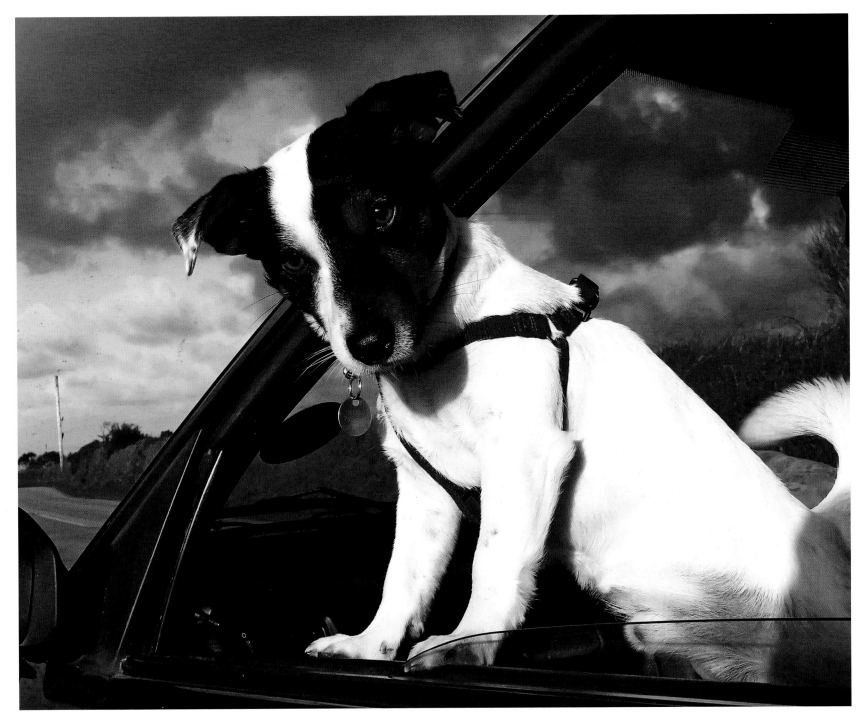

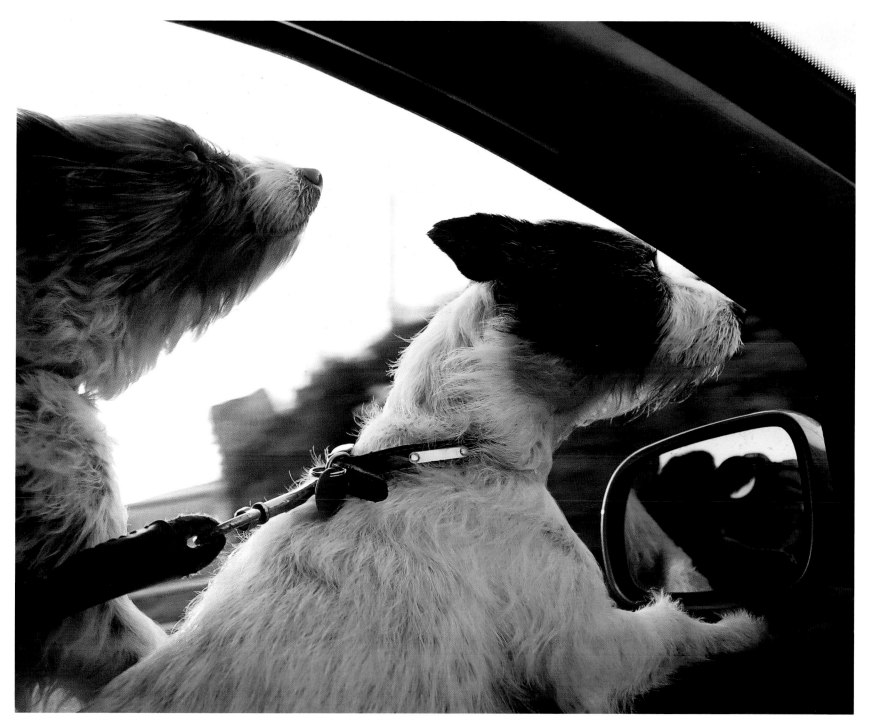

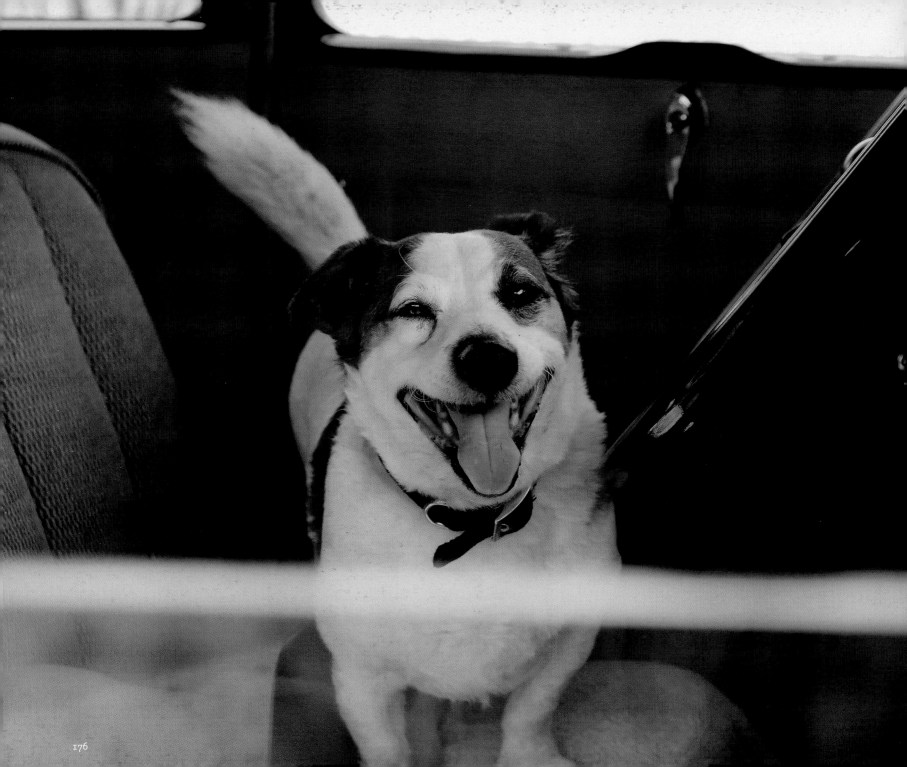

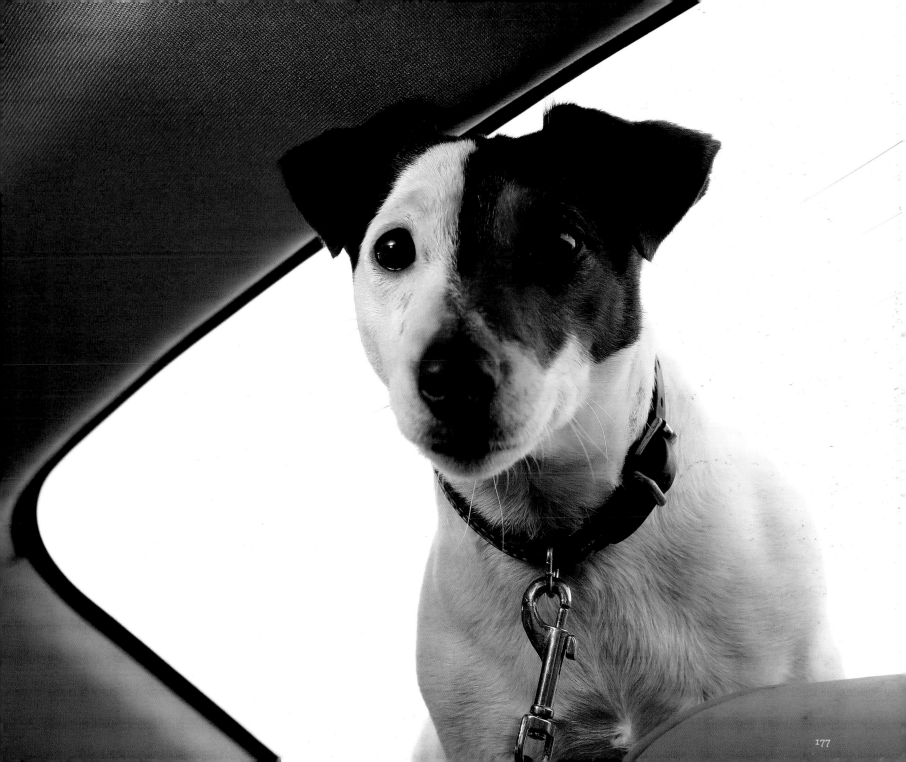

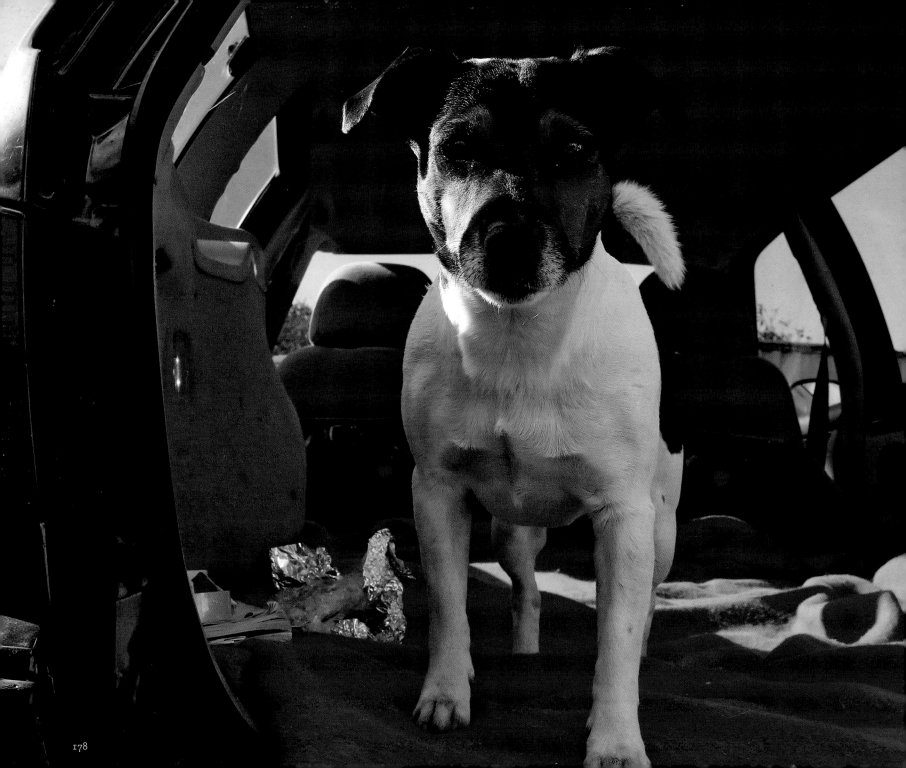

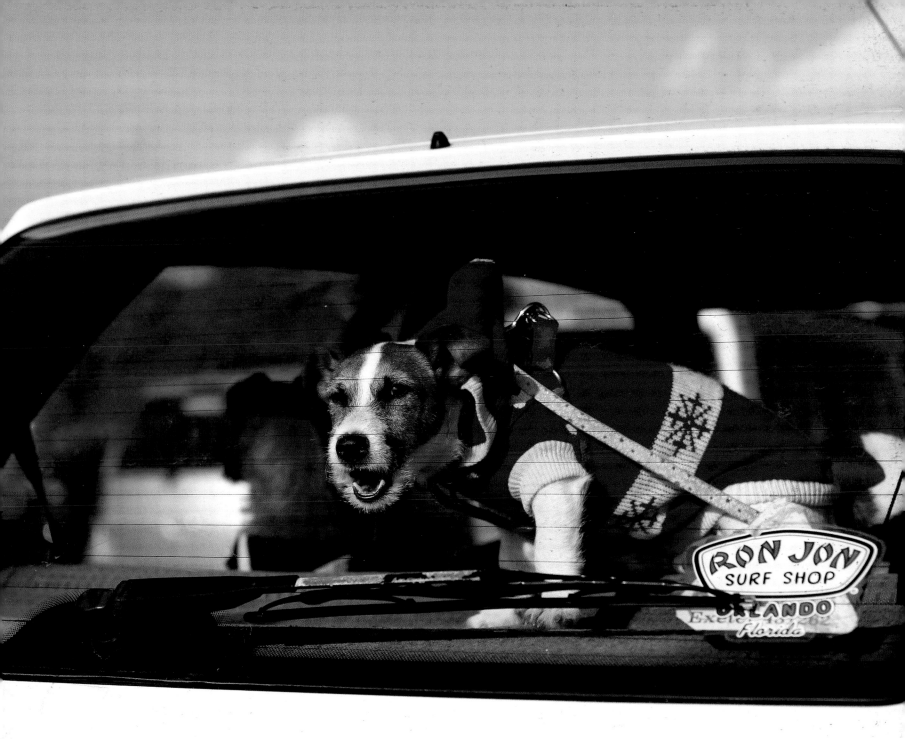

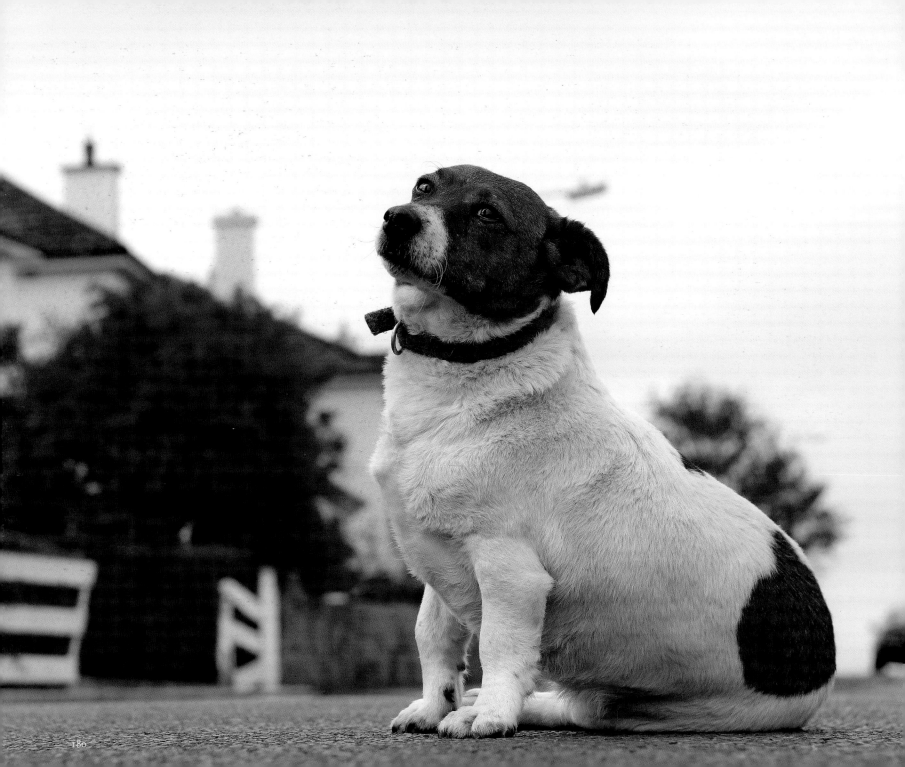

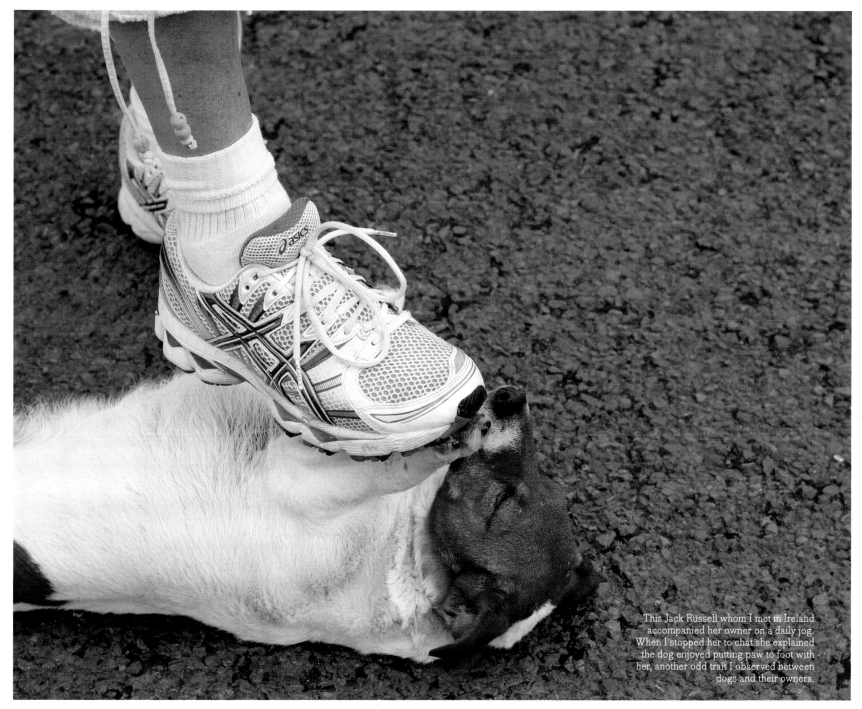

This Jack Russell whom I met in Ireland accompanied her owner on a daily jog. When I stopped her to chat she explained the dog enjoyed putting paw to foot with her, another odd trait I observed between dogs and their owners.

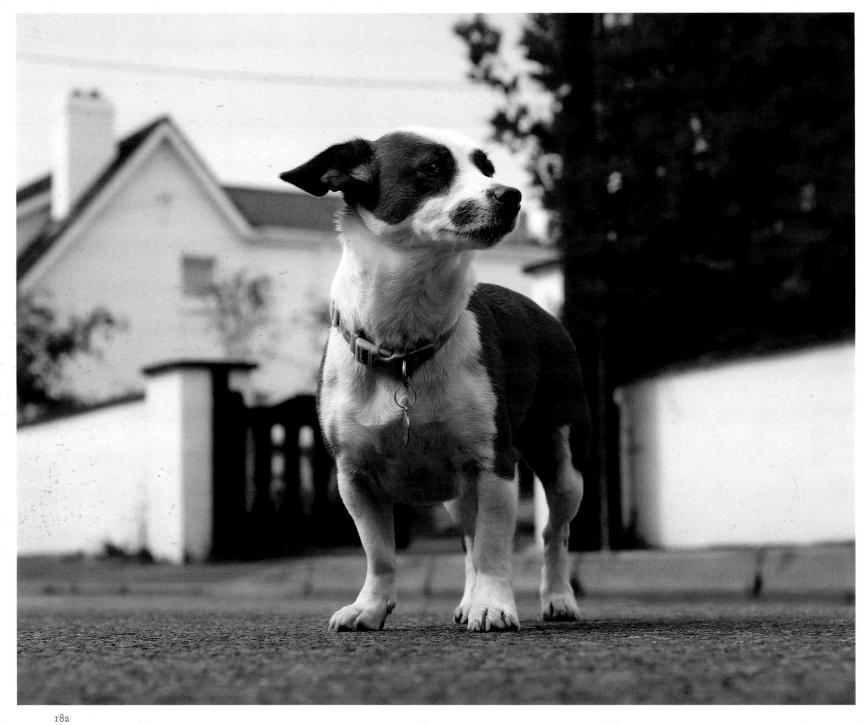

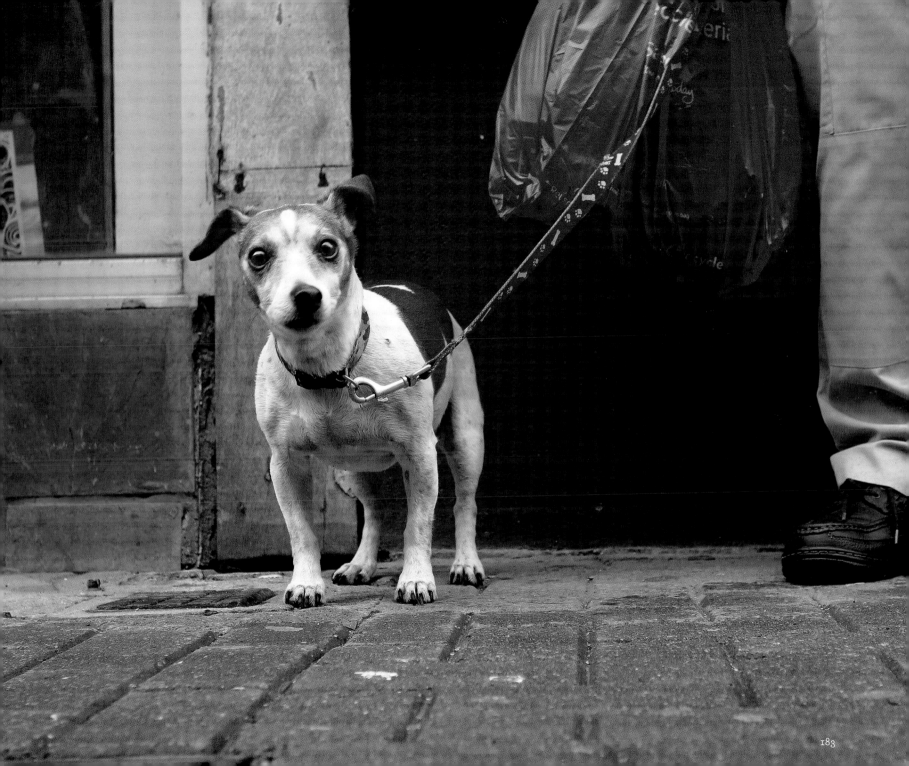

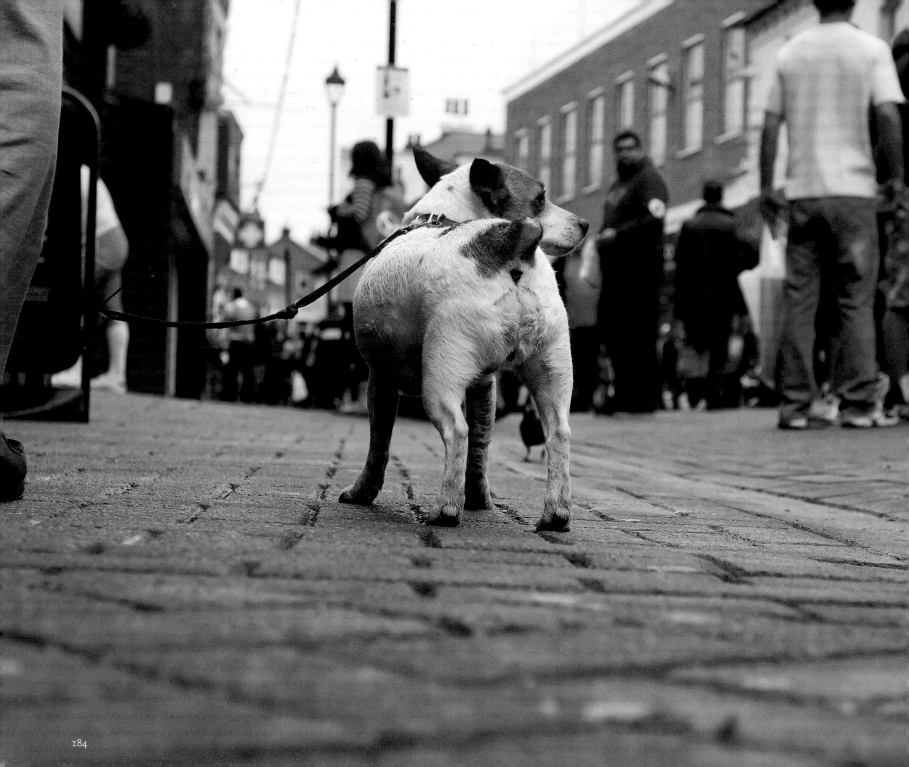

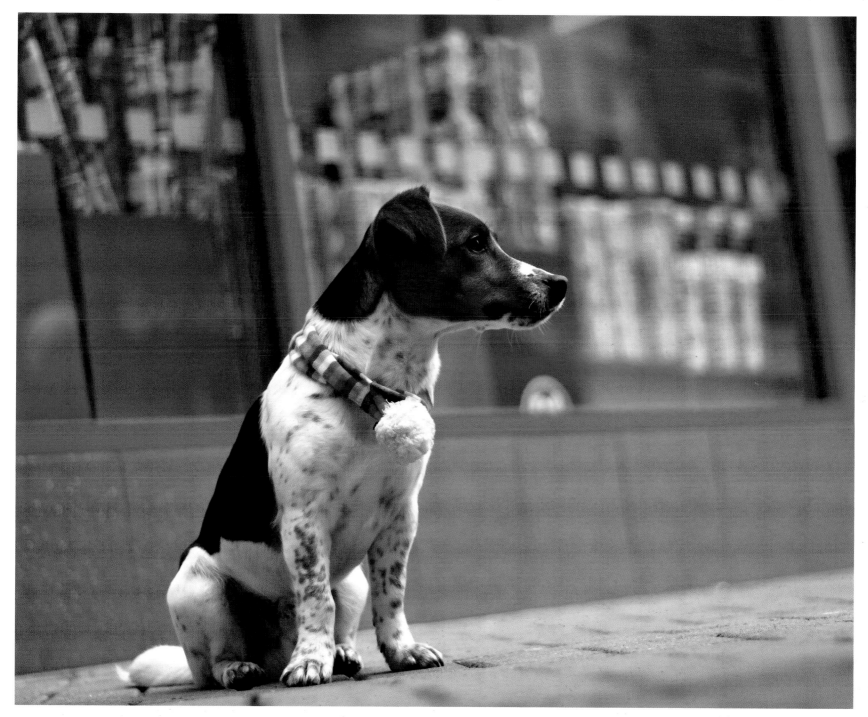

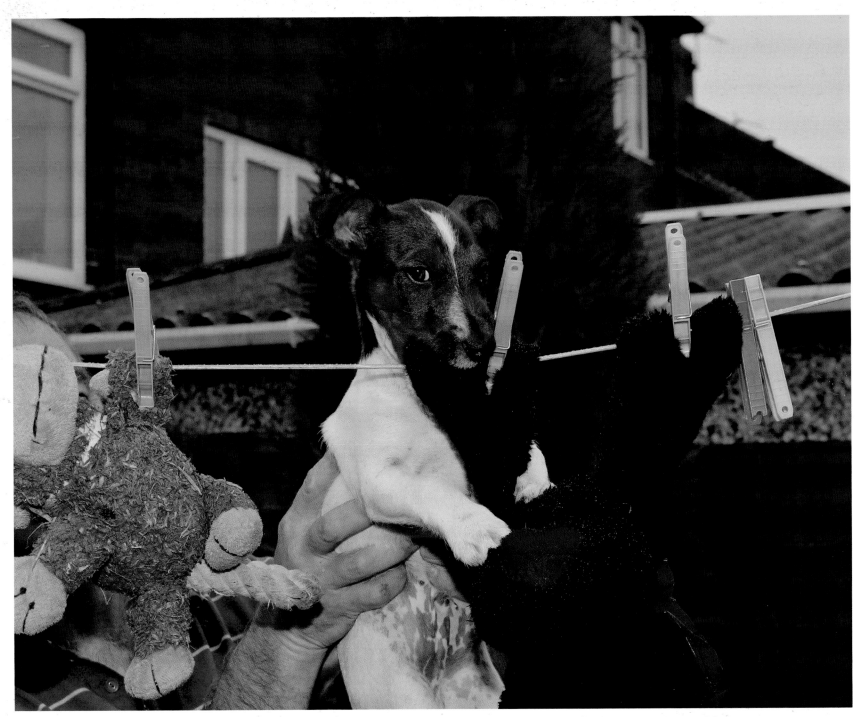

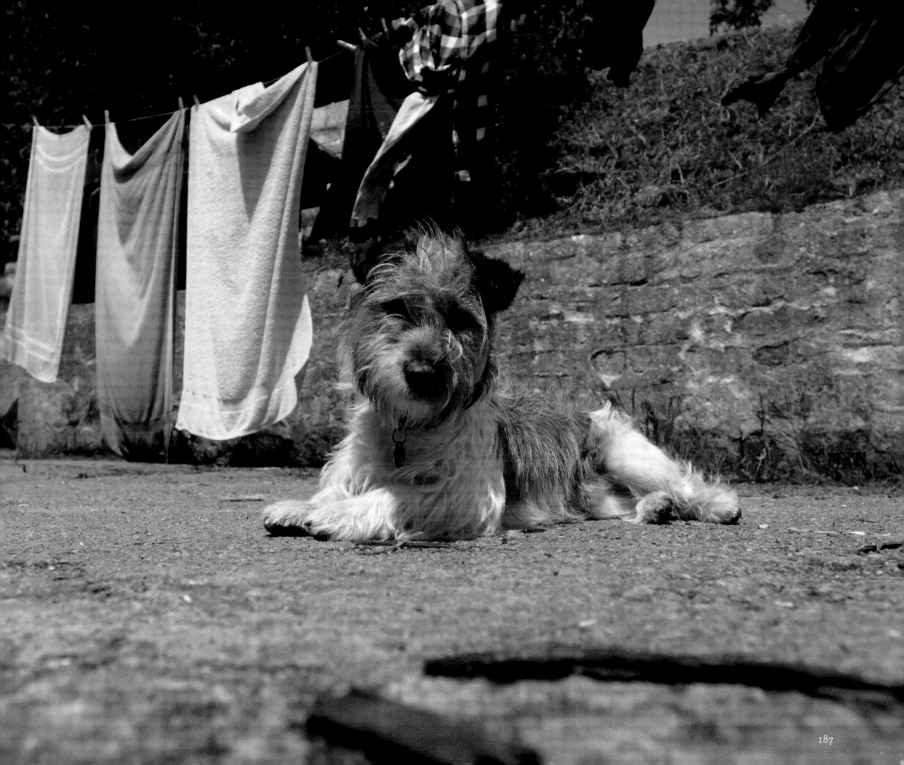

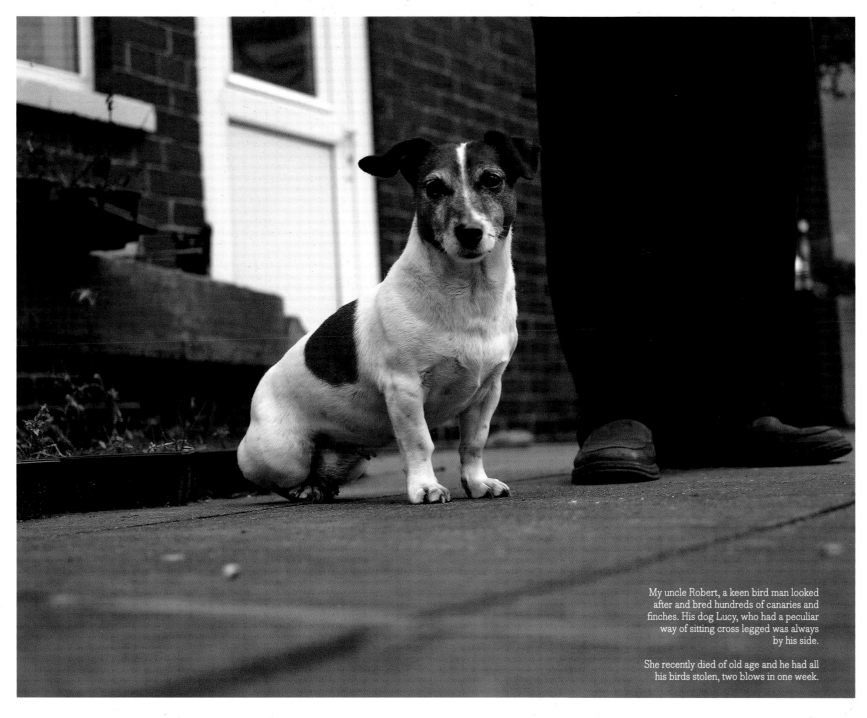

My uncle Robert, a keen bird man looked
after and bred hundreds of canaries and
finches. His dog Lucy, who had a peculiar
way of sitting cross legged was always
by his side.

She recently died of old age and he had all
his birds stolen, two blows in one week.

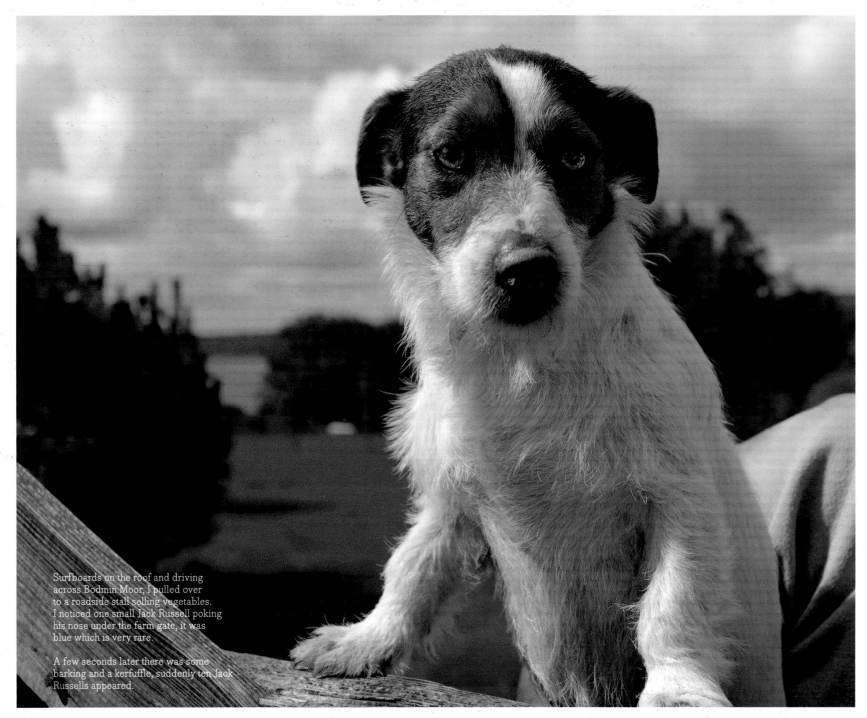

Surfboards on the roof and driving
across Bodmin Moor, I pulled over
to a roadside stall selling vegetables.
I noticed one small Jack Russell poking
his nose under the farm gate, it was
blue which is very rare.

A few seconds later there was some
barking and a kerfuffle, suddenly ten Jack
Russells appeared.

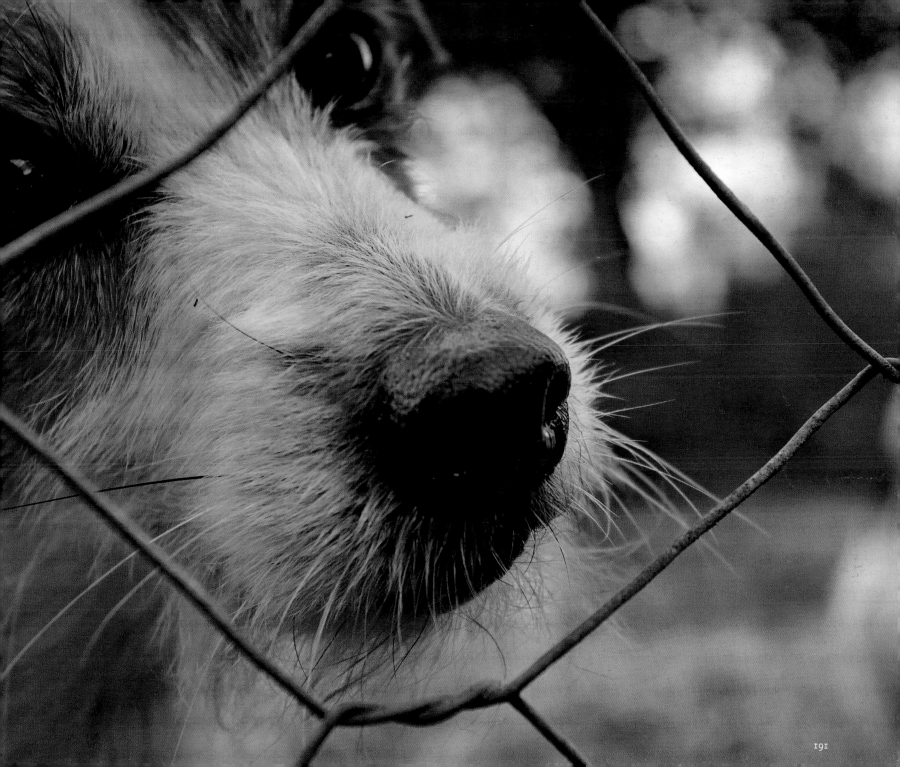

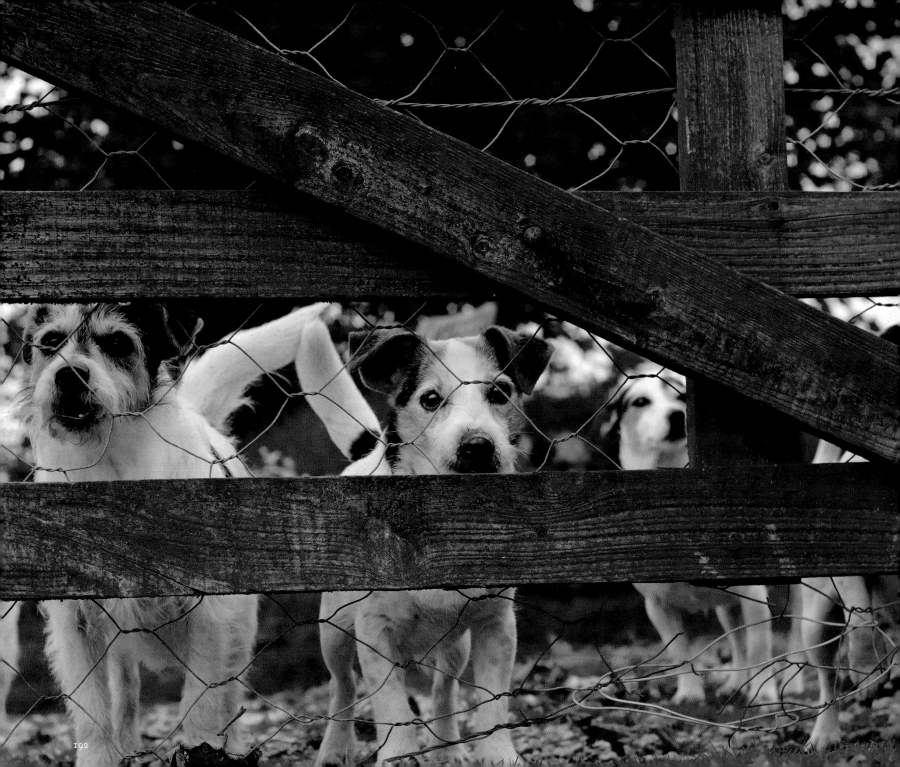

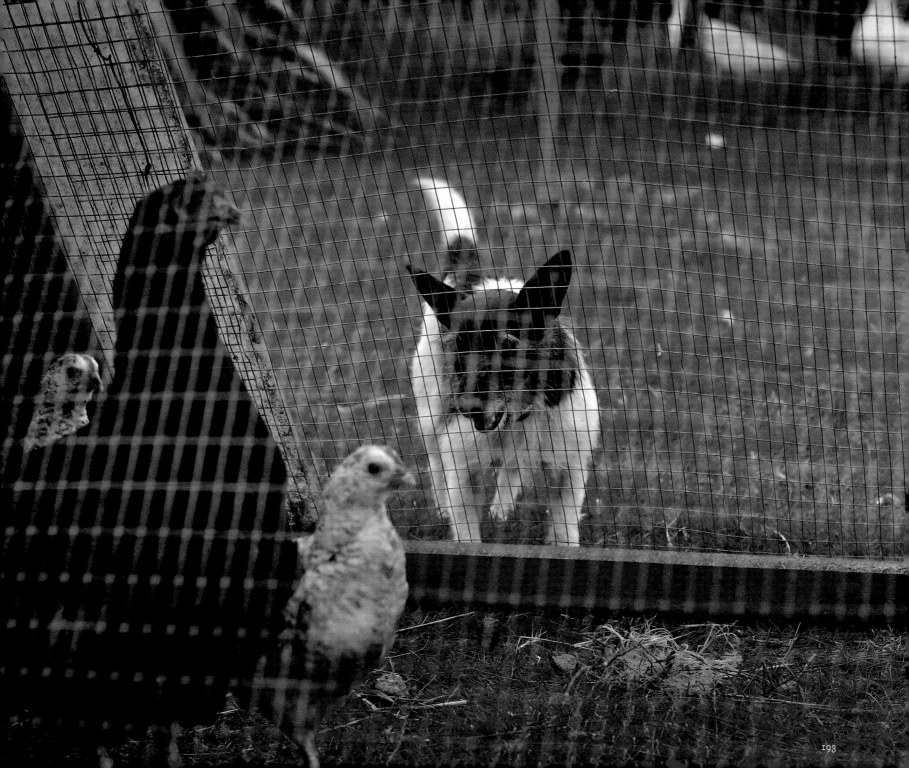

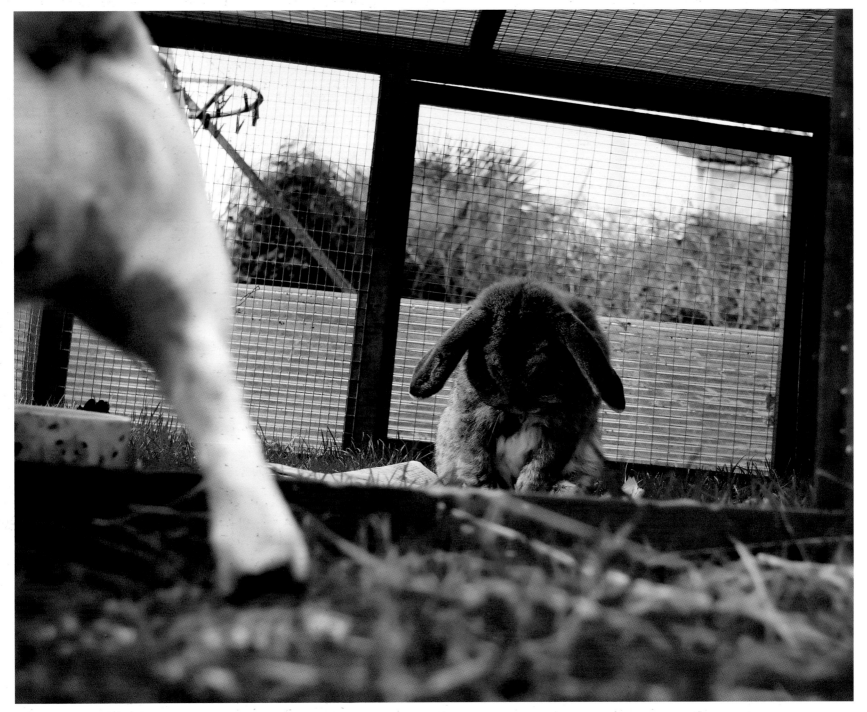

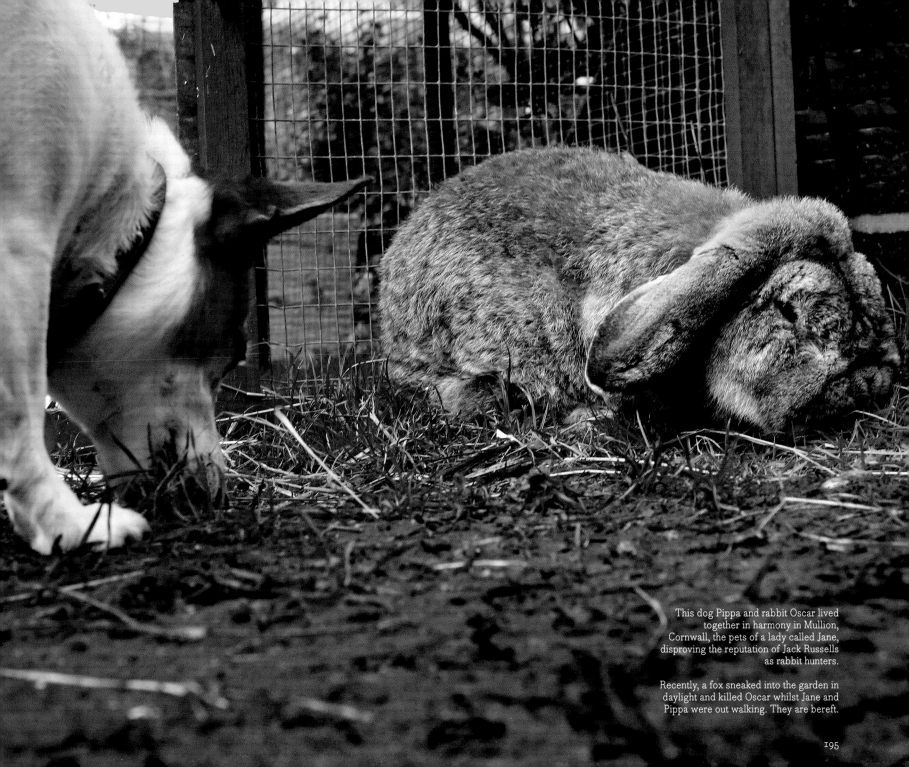

This dog Pippa and rabbit Oscar lived together in harmony in Mullion, Cornwall, the pets of a lady called Jane, disproving the reputation of Jack Russells as rabbit hunters.

Recently, a fox sneaked into the garden in daylight and killed Oscar whilst Jane and Pippa were out walking. They are bereft.

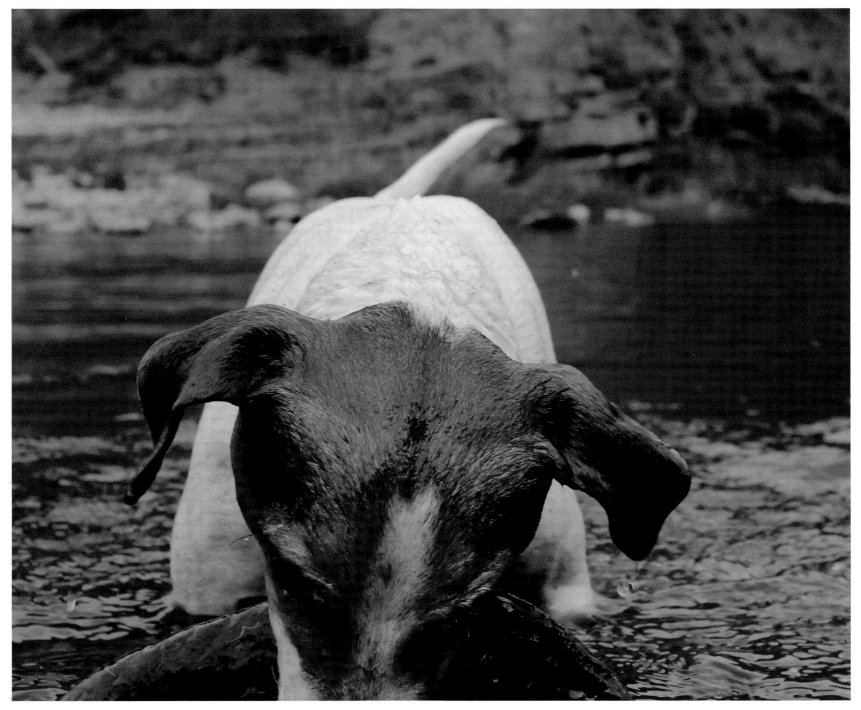

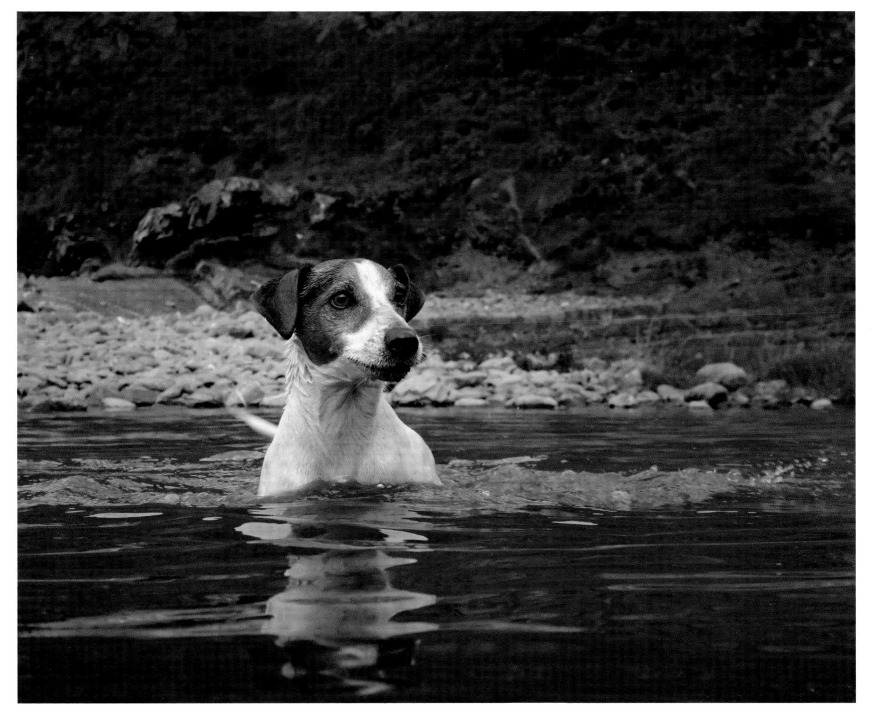

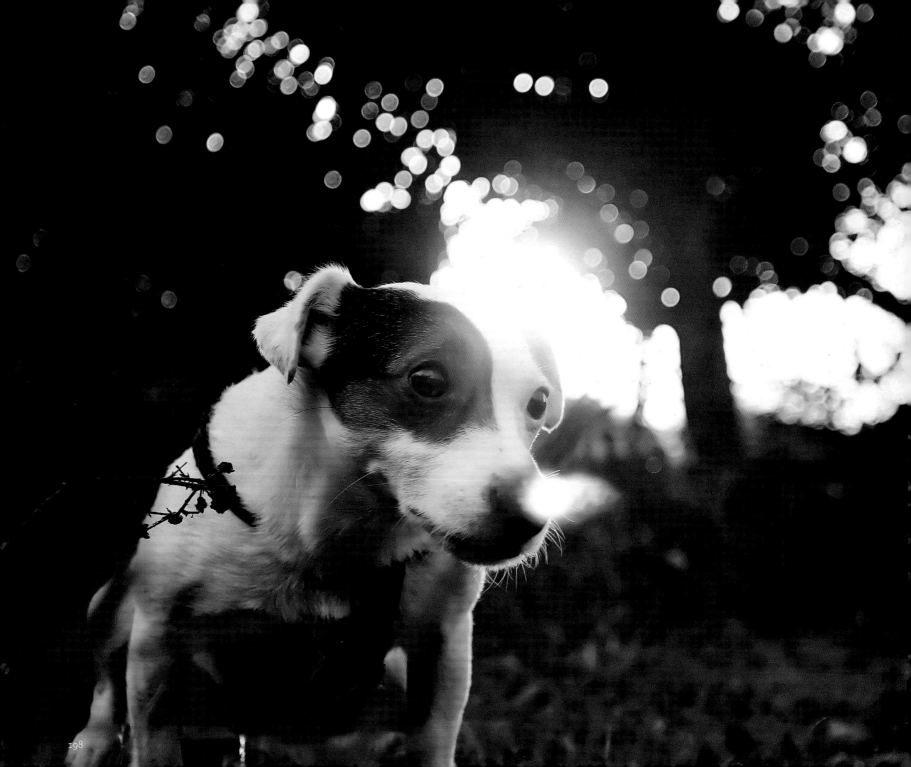

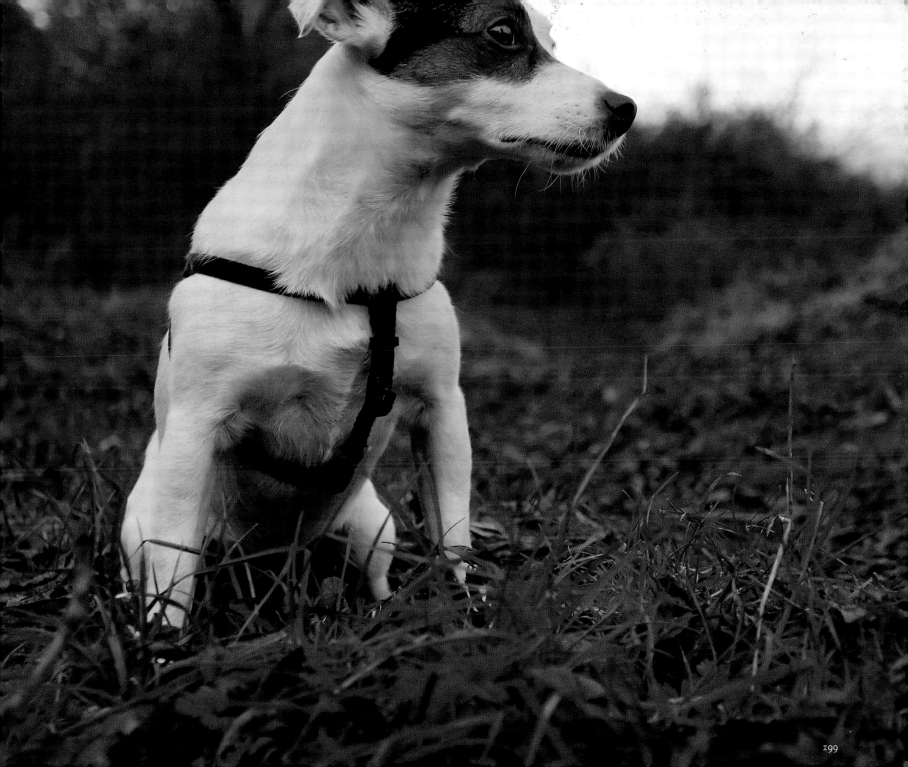

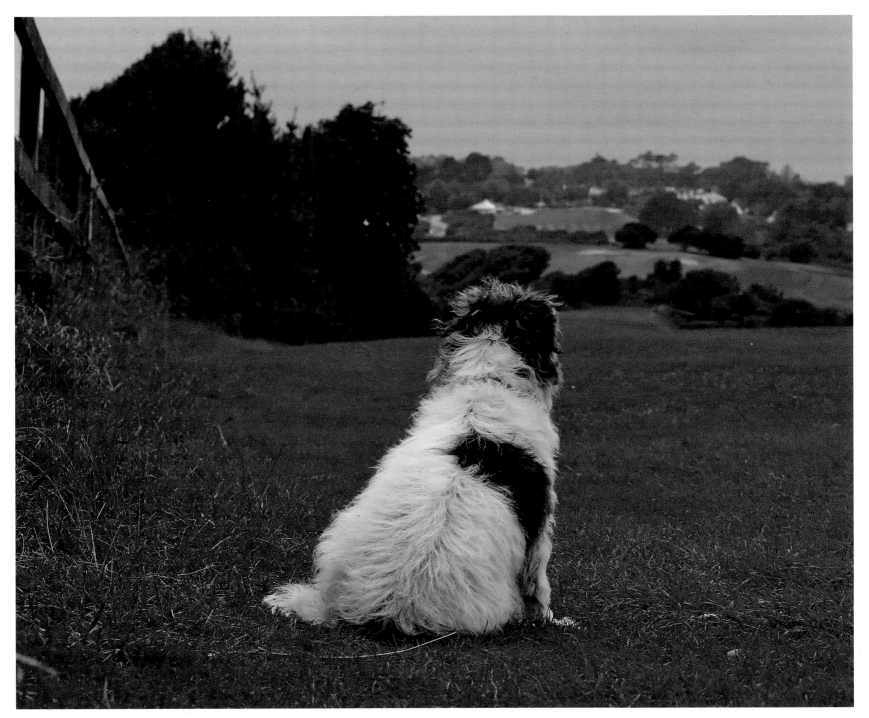

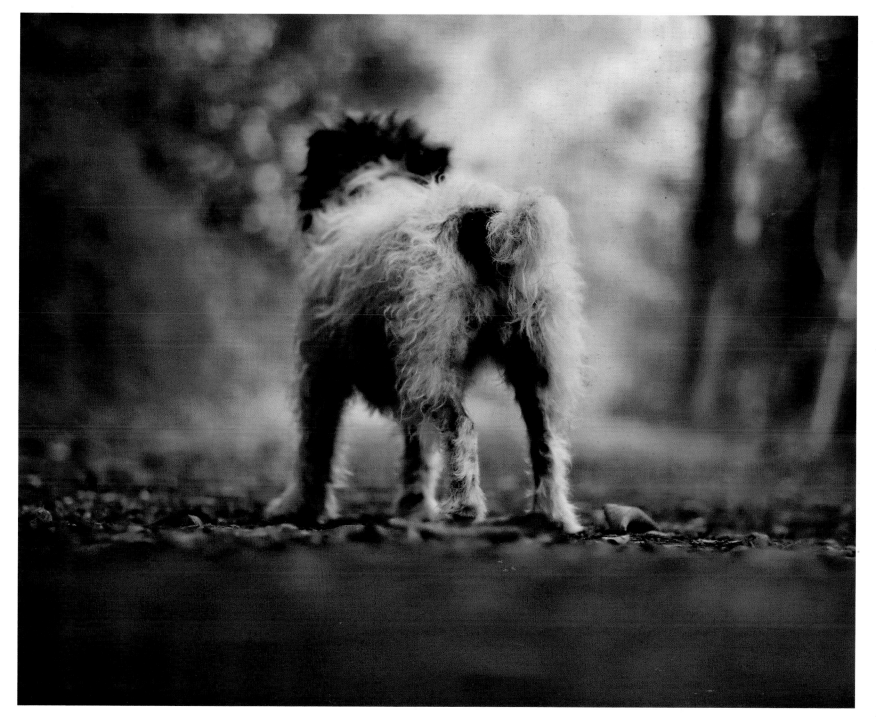

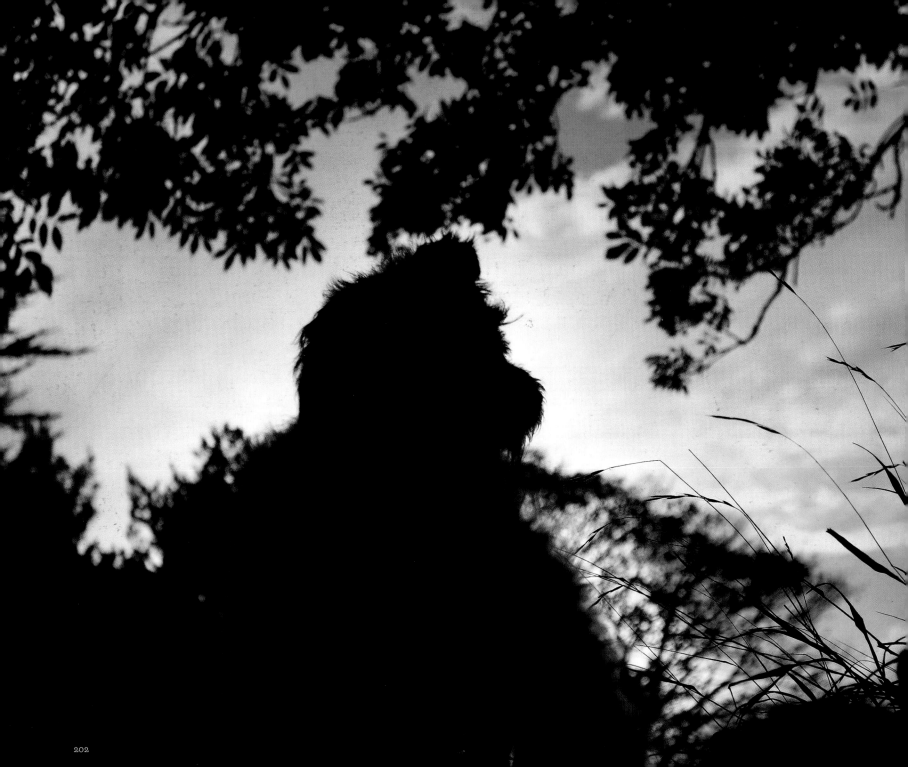

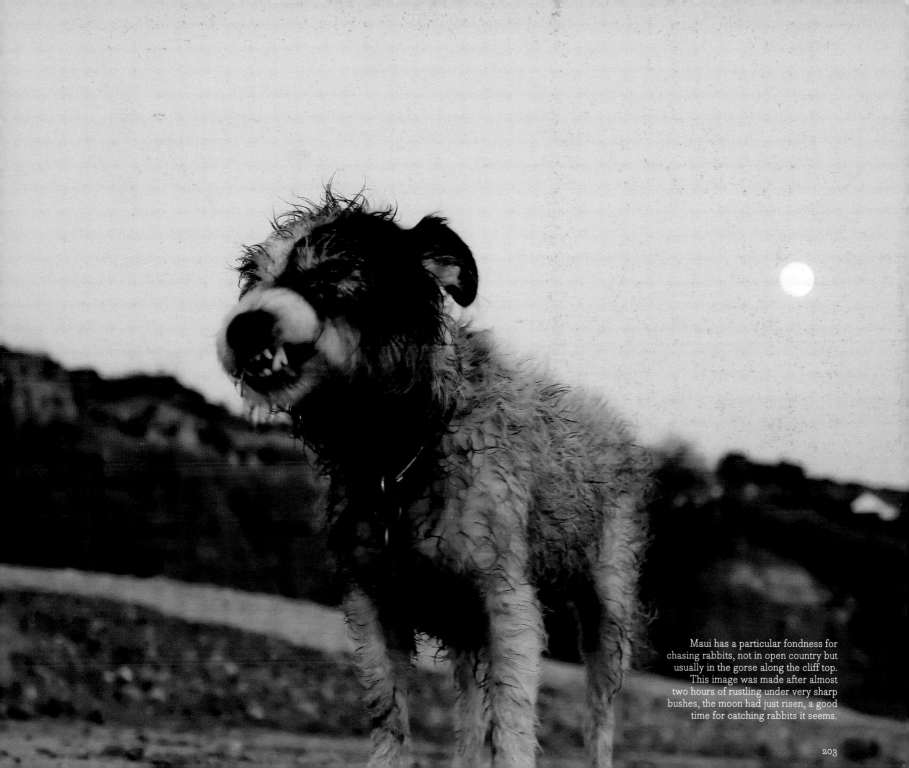

Maui has a particular fondness for chasing rabbits, not in open country but usually in the gorse along the cliff top. This image was made after almost two hours of rustling under very sharp bushes, the moon had just risen, a good time for catching rabbits it seems.

Dogs are our link to paradise. They don't know evil or jealousy or discontent. To sit with a dog on a hillside on a glorious afternoon is to be back in Eden, where doing nothing was not boring — it was peace.

MILAN KUNDERA, CZECH NOVELIST, PLAYWRIGHT AND POET.

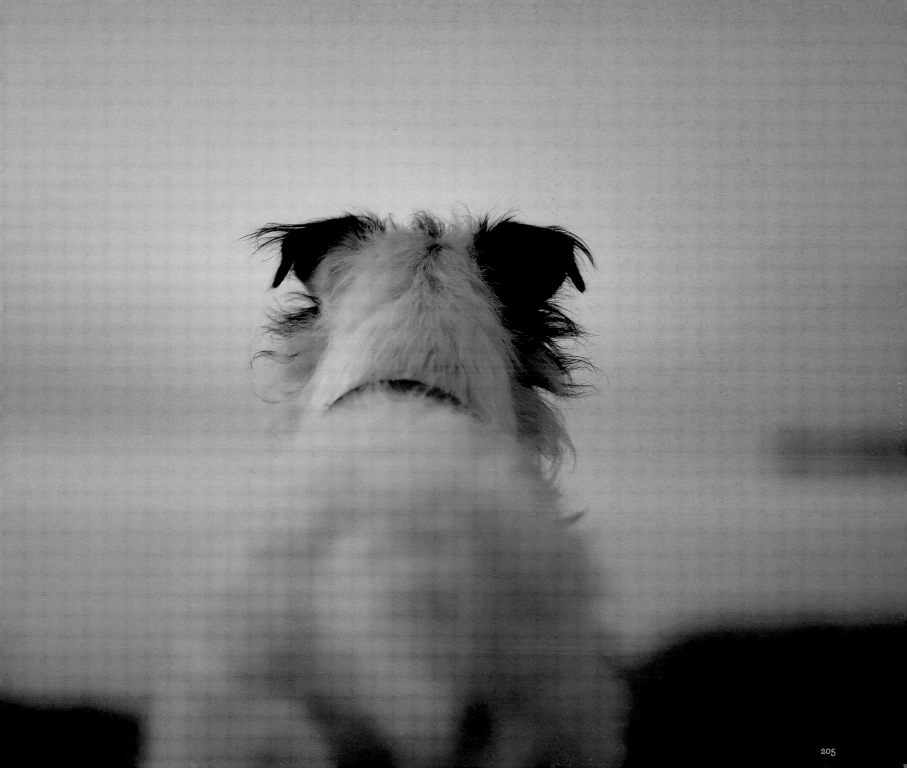

Acknowledgments

I have met many dogs along this journey, together with their human companions. I have heard many stories too, some humorous and some not so funny but nonetheless heart warming and testament to the incredible bonds between dogs and their owners.

My gracious appreciation goes to all whom I met at the Sunshine State Jack Russell Terrier Club (Florida). My visit to their Terrier Trial Event convinced me how much these feisty dogs are loved. The warmth and kind hospitality given to me whilst in Florida was unexpected and very welcome.

Whilst on one of a number of trips to the USA I met with many who are as enthusiastic about dogs and Jack Russells as me, in particular Michael Jacobs at Abrams, a fellow Jack Russell owner. I also met with Alexandra Horowitz who kindly gave permission for me to use a number of quotes from her fantastic book *Inside of a Dog*. I was extremely pleased that John Bradshaw could write the short essay *Does your dog love you?* this puts into context some of the thoughts I had whilst working on this book. The careful project judgments made by Edward Booth-Clibborn have been and are always invaluable. Thank you to Julia Booth-Clibborn for editing my texts. Thank you to Bruce Morgan for help with the design. And finally my thanks to all the many dozens of dogs [including their owners] I have photographed whilst making this book and to my current Jack Russells Lily and Maui, my constant companions.

Contributors

DR JOHN BRADSHAW is Director of the Anthrozoology Institute at the University of Bristol in the UK. He has conducted numerous studies of dog behaviour over the past 25 years, examining the unique way in which dogs perceive and interpret the world around them. He is the author of many scientific articles, research papers, and reviews, which have not only shed new light on the dog's abilities and needs, but have also changed the way that dogs are cared for all over the world. His recent book *In Defence of Dogs* published by Allen Lane (*Dog Sense* Basic Books in the USA and Canada) has been a best-seller on both sides of the Atlantic.

ALEXANDRA HOROWITZ teaches psychology at Barnard College, Columbia University. She earned her PhD in Cognitive Science at the University of California at San Diego, and has studied the cognition of humans, rhinoceros, bonobos, and dogs. Her book *Inside of a Dog: What Dogs See, Smell, and Know* is published by Simon & Schuster: New York.

Special thanks to all the dogs I met whilst making this book, some of them are listed here…

DC Flash	Phoebe
Riley	Simon
Winsome	Chic
Lucy	Sampson
Buddy	Roxie Abbey
Troublete	Pharaoh
Tootsie	Mystique
Mitch Miller	Amber
Spot	Cracker
Beasley	Siren
Rex	Indigo
Lucy	Rocky
Harry	Sparrow
Cooper	Poppy
Hairy	Dudley
Sparkle	Maxwell
Bob	Bert
Twinkle	Katie Sue
Sid	Missy
Freckles	Lily
Cookie	Maui
Mac	
Maddy	
Becky	
Winnie	
Sassy Pants	
Tammy Fay	
Fawn Hall	
Diva	
Baby Dell	
Will	

Book layout by Bruce Morgan
Consultant Designer Sean Murphy
Editor Julia Booth-Clibborn

ISBN 978-1-86154-321-9

Also by Andy Hughes
Dominant Wave Theory,
Booth-Clibborn Editions, 2006

www.booth-clibborn.com
www.ijackrussell.org
www.andyhughes.net